Encyclopedia
of **Practical**
Photography

Volume 4

Conte-Des

Edited by and published for
EASTMAN KODAK COMPANY

AMPHOTO
American Photographic Book Publishing Company
Garden City, New York

Note on Photography

The cover photos and the photos of letters that appear elsewhere in this encyclopedia were taken by Chris Maggio.

Copyright © 1978 by Eastman Kodak Company and
American Photographic Book Publishing Company, Inc.

Library of Congress Cataloging in Publication Data

Amphoto, New York.
 Encyclopedia of practical photography.

 Includes bibliographical references and index.
 1. Photography—Dictionaries. I. Eastman
Kodak Company. II. Title.
TR9.A46 770'.3 77–22562

ISBN 0–8174–3050–4 Trade Edition—Whole Set
ISBN 0–8174–3200–0 Library Edition—Whole Set
ISBN 0–8174–3054–7 Trade Edition—Volume 4
ISBN 0–8174–3204–3 Library Edition—Volume 4

Manufactured in the United States of America

Editorial Board

The *Encyclopedia of Practical Photography* was compiled and edited jointly by Eastman Kodak Company and American Photographic Book Publishing Co., Inc. (Amphoto). The comprehensive archives, vast resources, and technical staffs of both companies, as well as the published works of Kodak, were used as the basis for most of the information contained in this encyclopedia.

Symbol Identification

 Audiovisual

 Biography

 Black-and-White Materials

 Black-and-White Processing and Printing

 Business and Legal Aspects

 Chemicals

 Color Materials

 Color Processing and Printing

 Equipment and Facilities

 Exposure

 History

 Lighting

 Motion Picture

 Optics

 Picture-Making Techniques

 Scientific Photography

 Special Effects and Techniques

 Special Interests

 Storage and Care

 Theory of Photography

 Vision

Guide for the Reader

Use this encyclopedia as you would any good encyclopedia or dictionary. Look for the subject desired as it first occurs to you—most often you will locate it immediately. The shorter articles begin with a dictionary-style definition, and the longer articles begin with a short paragraph that summarizes the article that follows. Either of these should tell you if the information you need is in the article. The longer articles are then broken down by series of headings and sub-headings to aid further in locating specific information.

Cross References

If you do not find the specific information you are seeking in the article first consulted, use the cross references (within the article and at the end of it) to lead you to more information. The cross references can lead you from a general article to the more detailed articles into which the subject is divided. Cross references are printed in capital letters so that you can easily recognize them.
Example: *See also:* ZONE SYSTEM.

Index

If the initial article you turn to does not supply you with the information you seek, and the cross references do not lead you to it, use the index in the last volume. The index contains thousands of entries to help you identify and locate any subject you seek.

Symbols

To further aid you in locating information, the articles throughout have been organized into major photographic categories. Each category is represented by a symbol displayed on the opposite page. By using only the symbols, you can scan each volume and locate all the information under any of the general categories. Thus, if you wish to read all about lighting, simply locate the lighting symbols and read the articles under them.

Reading Lists

Most of the longer articles are followed by reading lists citing useful sources for further information. Should you require additional sources, check the cross-referenced articles for additional reading lists.

Metric Measurement

Both the U.S. Customary System of measurement and the International System (SI) are used throughout this encyclopedia. In most cases, the metric measurement is given first with the U.S. customary equivalent following in parenthesis. When equivalent measurements are given, they will be rounded off to the nearest whole unit or a tenth of a unit, unless precise measurement is important. When a measurement is considered a "standard," equivalents will not be given. For example: 35 mm film, 200 mm lens, 4″ × 5″ negative, and 8″ × 10″ prints will not be given with their customary or metric equivalents.

How Articles are Alphabetized

Article titles are alphabetized by letter sequence, with word breaks and hyphens not considered. Example:

> Archer, Frederick Scott
> Architectural Photography
> Archival Processing
> Arc Lamps

Abbreviations are alphabetized according to the letters of the abbreviations, not by the words the letters stand for. Example:

> Artificial Light
> ASA Speed

Contents
Volume 4

Contests and Competitions

There are two aspects of photographic contests and competitions. One is to enter your own work; the other is to organize and run successful competitions.

Entering Contests

People enter contests and competitions for many reasons. Among the most important are the desire to have one's work exhibited and to receive recognition of its quality. To do this, a number of important steps should be followed.

1. Determine the entry rules. Are you eligible? Can you enter several categories or only one? What format and style of presentation are required? When must work be submitted and where? How many pieces may you submit?
2. Note any restrictions. Must you pay shipping costs both ways, even if your work is accepted? Will your work be

This second-prize winner of the 1976 Kodak International Newspaper Snapshot Awards has a delicate simplicity that celebrates the beauty of things quietly seen and appreciated for their own qualities. The photograph was taken on Kodachrome film with a Pentax camera. Photo by J. Tait.

insured while in the hands of others? Will it be returned? Will you retain rights to the work if it wins, or does it become the property of the sponsor? The latter is often the case in commercial competitions.

3. Select only your best quality work. Even a few poor images can affect how an acceptance committee or the judges react to your other pictures if the pictures are being judged as a group.

4. Prepare your work exactly to specifications. If only 2″ × 2″ slides are acceptable, or prints up to 11″ × 14″ all on the same size mounts, make sure everything conforms. Do not include something else in the hope that its other qualities will let it pass. That is sometimes the case when an editor is looking for a picture, but it is not the case in competitions and exhibitions.

5. Mark every piece of work with your name and address on the slide mount or on the back of the mount board. If some pictures, such as abstract images, have no easily identifiable top, mark them on the back with an upward arrow and the word *Top* to avoid having them shown upside down.

6. Pack your pictures carefully. Use protective tissue over the face of prints and pack them with padding around the edges and protective boards over the face and the back of the stack. Place

This third-prize winner of the 1975 Kodak International Newspaper Snapshot Awards combines shallow depth of field with a hazy, light-filled atmosphere to produce an almost dreamlike quality of softly blended details and colors. The picture was made with a Konica camera and Kodachrome film. Photo by Toby Richards.

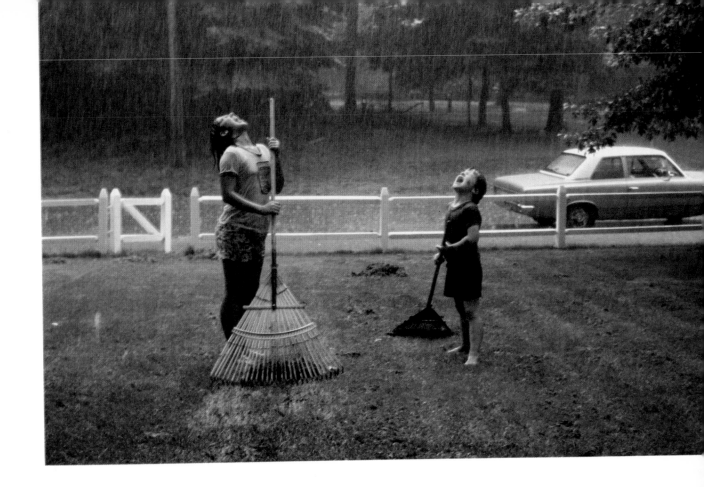

In this happy picture of youthful exuberance, the figures, their rakes, the trees, and the fence all help to define the ground plane and create the deep, light-filled space that extends from the foreground into the distance. The upward tilt of the faces and the verticalness of most of the objects in the picture move the space upward. The children have energy enough to fill it all. This first-prize winner of the 1976 Kodak International Newspaper Snapshot Awards was taken on Kodak Ektachrome film with a Mamiya camera. Photo by M. Richards.

them in a plywood container or fiberboard cases made especially for shipping photographs. Place slides in protective sheets or in double boxes. To mail a few prints or a sheet of slides, tape them in a sandwich between two thick pieces of corrugated board. The boards should be at least one inch larger around all edges than the material they protect so that corner dents will cause no harm. Cut the boards so the corrugations run at right angles to one another to add stiffness.

7. Include the destination and return address inside the package as well as outside. Include return postage, entry fees and papers, and anything else required. If the contest instructions say to send the entry form under separate cover, perhaps to a different address, of course do that, too.

8. Deliver or send the package in plenty of time. Insure it if you are not delivering it personally.

9. If you are to pick up the work, do so promptly at the appropriate time; being

The rather ambiguous nature of this image and the forced perspective produced by a wide-angle lens create the somewhat surreal feeling that the things in this picture are out of scale, as well as out of place. This first-prize winner in the black-and-white division of the 1976 Kodak International Newspaper Snapshot Awards was taken on Kodak Tri-X film. Photo by E. Gelabert.

late gives someone more time to lose track of your pictures.

Running Contests and Competitions

The mainstay of most camera clubs is the monthly competition. Print and slide contests and the subsequent exhibitions can be fun, exciting, and something to look forward to.

Promotion. A club should schedule and promote both print and slide competitions. Every effort should be made to get the club members enthusiastic about the coming event. A special notice about the competition can be sent out with the club bulletin, but on a separate piece of paper, preferably colored, so that it can be used as an eye-catching memo. Then, a week before the deadline, mail a postcard and have the competition committee follow it up by phone calls to all members. Ask each committee member to call a half dozen friends in the club. While this may seem like a lot of work, this personal touch, this extra effort to encourage *all* the members to take part, is well worthwhile to promote active participation.

Encouraging Participation. These competitions should be classified into beginner and advanced (and perhaps, expert) classes. It is a good idea to offer all

entrants a chance to choose the class they feel they fit into, but have all prizewinners (perhaps after winning several times) automatically advanced for future competitions. Once a member has decided, by entering the class, that he or she is "advanced," this person should not be allowed to revert to the primary group.

Most important, don't make competitions difficult to enter. For the beginners' class of a print competition, you can have a rule that the negative and print could be made by a photofinisher, for instance. Also, it's unnecessary to require all prints to be mounted on an expensive piece of 16″ × 20″ board, since this is unrealistic and discouraging for many kinds of contests. Beginners' classes could have a rule that all prints be unmounted with, for example, a maximum 5″ × 7″ size. This eliminates the impact of a 16″ × 20″ print that many members may feel they can't compete with. Not every snapshot is worth the price of a piece of 16″ × 20″ paper.

Let Members Judge. Because participation by all members in club activities is vital and because it has been proven successful many times, consider the idea that all members vote on all prints or slides. Probably the simplest method of judging by popular vote is for each voter to evaluate each photograph as it is shown. Here are the easy steps:

1. Distribute ballot sheets to all persons qualified to vote. It is best to make these sheets on ruled paper. Several vertical lines should be drawn to form pairs of columns. In the left-hand column, the member should write the number of the photograph; the evaluation should be written in the right-hand column. This evaluation should be based on an award of points. An analytical breakdown could be adopted. For example, a maximum of three points could be awarded for technical quality, three points for composition, and three points for subject matter and impact.

2. Before a vote is taken, show all photographs in quick succession so that the voters have an idea of the general level of quality.

3. Show all photographs again, and have each voter place his or her evaluation opposite the number of each picture. There should be someone to call out the number of each entry as it is shown.

4. When voting is completed, the president should have tellers count the ballots immediately so that the results may be announced before the close of the meeting. Naturally, the photograph with the highest total will have first

Humor is a quality that should not be overlooked in seeking successful contest pictures. This photograph, which won first prize in the black-and-white division of the 1975 Kodak International Newspaper Snapshot Awards, was made with a Nikkormat FTN camera on Kodak Tri-X film. Photo by Benner Greenberg.

Contests and Competitions

place, and so on. Ties may be broken by taking an additional vote, and if a sufficient number of photographs have been entered, it is a very good idea to give a few honorable-mention awards in addition to the first three prizes.

Recognize that the results of a popular vote are often more influenced by popular subject matter than by technical quality and artistic merit. For a more rounded rating of photographs, a group of qualified judges should be obtained. This becomes especially necessary when some of the competitors are exhibitors in salons. This will be discussed later in this article.

Special-Assignment Competitions

Specially assigned subject matter is sometimes a very good idea, once members have worked up enough interest and "go power" to actually shoot special pictures for a particular contest. The following subjects are of general interest: travel pictures; pets; family and personal pictures; summer or fall landscapes; sports; beach scenes; hands; texture;

Subtle changes of tone bring out the flowing contours of these dunes. The figure may be tiny, but the intense contrast of the red shirt stands out in the vast, monochromatic visual space presented here. This first-prize winner of the 1975 Kodak International Newspaper Snapshot Awards was photographed at Nag's Head, N.C., using Kodachrome II film in a Nikon F2 camera. Photo by Dr. Joe Atchison.

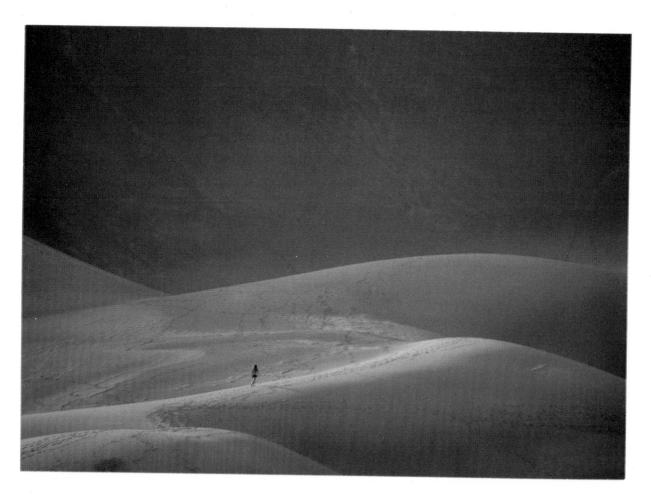

Contests and Competitions

SUGGESTED COMPETITION SUBJECTS

September	Skyscapes	Flower gardens and produce shots	Beach scenes
October	Summer or fall landscapes or seascapes	Study of roots	Sports
November	Architecture	Animal studies	Doorways
December	Christmas cards	Glass	Hands
January	Still life	Children	Texture
February	Snow scenes	Portraits (men)	Portraits (women)
March	Portraits (children)	Abstract design	Still Life
April	Rainy-day subjects	Illustrative	Curves
May	Outdoor night scenes	Spring flowers	Landscapes

portraits; still life; spring flowers; children; rainy-day subjects; outdoor night scenes; snow scenes; architecture; pictures of the newspaper type (picturing the decisive moment); pictures to illustrate speed, heat, humor, and similar difficult-to-illustrate subjects; reflections; abstractions; glassware.

Try a sequence competition—subject matter unlimited. Just tell the story with pictures. Special-subject competitions will naturally follow a particularly good lecture demonstration.

Judges

The right judge can make or break a competition. The PSA* offers member clubs a service that provides qualified judges for competitions. The Color Division Judging Service is designed to help camera clubs located in areas where there are not enough qualified judges to draw on. The service is limited to twice in any one calendar year. Because a taped commentary by the judge is offered, you can see what a valuable service this is for any club. Here's the procedure to be followed. (A club must belong to PSA.)

1. The club secretary should write to the current chairperson of the Color Division Judging Service. (Name and address will be found in the *PSA Journal.*)
2. The chairperson of the judging service will then write a letter of information or direct the club to an assigned judge.
3. Write directly to the judge when sending slides, and give full instructions as

*Photographic Society of America.

to the method of selection desired and the type of commentary preferred. If you want a tape-recorded commentary, send a blank reel of recording tape with the slides. Clubs should not ask for the judging of general pictorial color slides and nature slides in separate categories. If you're interested in nature-slide judging, contact the Nature Division of PSA. Judges for black-and-white or color prints are available through the Pictorial Division.

How To Run Monthly Print Competitions

The Print Committee should arrange to hold a regular monthly members' print competition and discussion. Unless the club is made up of all or nearly all beginners, or all or nearly all advanced workers, the members competing should be classified into two groups:

A. Beginners' Class (Limit print size?)
B. Advanced Class

The following rules and regulations could be applied to both classes.

Rules and Regulations

1. Competitions are to be held monthly from September to May, inclusive.
2. Subject of competition: One of the following sets of subjects could be the basis for the contests. Alternate assigned subject competitions with open competitions.
3. Only (number) prints may be entered in each month's competition by a single member.

4. The negative from which a print is made must be exposed by the contributor. In the Beginners' Class it is permissible to have the negative processed by a photofinisher. In the Advanced Class the negative must be processed by the contributor.

5. All prints must be made by the contributor personally (some camera clubs have a category for 8″ × 10″ color prints made by a photofinisher).

6. All prints (contacts or enlargements) must be mounted on suitable mounts. It is recommended that enlargements be mounted only on a standard-size mount. All mounts must be either white, ivory, or gray. Prints must be tightly secured to the mounts.

7. The title of the print should appear just below the left-hand lower edge of the print, in pencil, and must not be made too conspicuous.

8. All prints must bear, *on the back of the mount,* the name of the maker, the subject, and in the case of advanced workers, the process used, printed or written legibly. It is recommended for the sake of fairness in judging that the name of the photographer not appear on the print or on the front of the mount, especially if the club judges the prints by popular vote.

9. All prints to be entered in the monthly competitions must be turned over to a member of the Print Committee immediately upon arrival at the meeting during the course of which the competition is to be held. Competitors must refrain from showing prints to anyone at this meeting prior to their being turned over to the Print Committee.

10. No alterations in print or mount or title will be allowed after the print is in the hands of the Committee, except on unanimous consent of the Committee. The latter provision is to take care of accidental damage to either print or mount.

11. If a member submits a print to the Advanced Class, he automatically will be classified in that class and cannot return to the Beginners' Class thereafter, except upon unanimous consent of the Print Committee.

12. Points will be awarded in each month's competition to the five highest-ranking prints in the order of their standing—highest number of votes, 10 points; next highest, 6 points; third highest, 4 points; honorable mentions, 1 point each.

13. A suitable medal or other award should be given at the end of the season in each class to—

(a) the person receiving the highest number of points in his or her class;
(b) the person in each class whose print is judged the best of all the prints that received point awards during the season. To win this latter award, at least six prints must have been submitted during the season by the individual.

14. Persons who receive one of these major awards in the Beginners' Class will automatically be classed as Advanced workers in future competitions.

15. There will be a print critique following each monthly competition on all the prints submitted for that meeting, the leading critic to be selected by the committee.

16. All prints receiving point awards in the Advanced Class shall be used along with prints from the annual members' show for picking an interchange set of prints for exhibition exchange with other clubs.

17. Apart from end-of-year and special exhibitions, prizewinning entries are disqualified from future club competitions.

18. A violation of any of the foregoing rules or regulations automatically disqualifies the print or prints from the competition to which the rule applies.

These rules and regulations are subject to change by the Club or its Print Committee at the beginning of the season, but they should not be altered once the season has begun except by a two-thirds favorable vote of all those participating in the competition.

Prints should be placed on an easel or similar support and should be well-lighted. A desk lamp with reflector placed on a chair below and in front of the print usually works very well if a specially illuminated easel is not available.

How To Run Color Transparency Competitions

Classification of Contestants. In most clubs it is advisable to have two groups of contestants; they may be called Beginners and Advanced, or the terms Junior and Senior may be used. Some clubs prefer the latter two because of the undesirable connotation of the former pair.

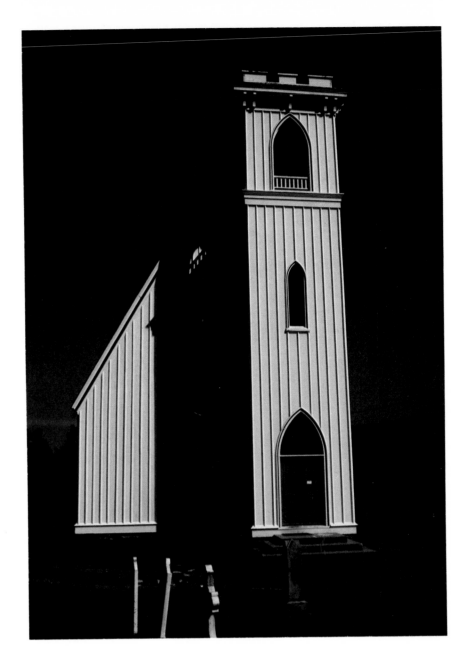

The parallel play of brilliant light and deep shadow on the vertical structure and details of this church in Nova Scotia produce a formality that is almost abstract. It is a subject that benefited from careful study, and from waiting for the sun to reach the most expressive angle. This second-prize winner of the 1975 Kodak International Newspaper Snapshot Awards was taken with a Konica Auto-reflex camera on Kodak Ektachrome-X film. Photo by Albert A. Kunigisky.

A Beginner or Junior participant may be defined as one who has never exhibited before, who has never exhibited in other than a beginners' exhibition, or who has not won a major award (first, second, or third prize) in any competition. A person classified as a Beginner should not be transferred to the Advanced group during the current season unless the Executive Committee or the Board of Directors, upon request of the Contest Committee, investigates and decides he is really an Advanced worker.

Frequency of Contests and Closing Dates. The contest calendar should clearly state the following information:

1. How often are the contests to be held?
2. What is the closing date for entries?

3. When is the judging to take place, and when and for how long will the selected transparencies be exhibited?
4. Will there be criticism and discussion at that time?
5. To whom are the entries to be submitted, and what are the addresses of these individuals?

Form in which Entries Should Be Submitted. Several different sizes of transparencies will probably be submitted. Most common is the 2″ × 2″ slide either glass-bound or in a mount such as a Kodak Ready-Mount.

There should be a specification that each slide have a thumb spot in the proper location. This spot should be in the lower left corner when the slide is held so that the picture is right side up, and right and left orientation is correct. When properly placed in the projector, the slide will have the spot in the upper right corner of the side facing the projector lamp. In addition, it should be required that the name of the contestant and the title of the slide appear on a label firmly attached to the slide in such a manner as not to interfere with its projection.

Time Limit. In general, a time limit stating the interval during which transparencies eligible for competition must have been made is a wise ruling after color transparency contests have become well-established in the club. However, at the beginning there should be no limit of this sort unless the members feel it is desirable.

Limit of Entries. The number of slides or transparencies that may be submitted by a member should be stated. A maximum number of three or four in any class is satisfactory when the contests are held frequently. As many as ten slides per member might be allowed if there are three contests or fewer per season. It is unwise to set no limit, since one or two very ambitious members may try to dominate the contest.

One effective method of clarifying this point and the matter of classes under which transparencies may be submitted is to provide entry blanks listing the classes and having spaces for the number and name of each entry. A record of this kind is valuable to the Contest Committee since it greatly reduces the possibility of losing slides or returning them to the wrong person.

Classes of Competition. The same subject classification employed in print competitions can be used in the slide contests. However, it should be remembered that for beginners there is a tendency in color work toward pictures of a documentary type rather than the pictorial or creative type. This should be kept in mind when establishing the classes of competition.

Awards. The system of awards will depend largely upon the frequency of the contests. If there is only one a year, the same system used for the annual print competition can be employed. If there are several during the year, awards in the form of points for the slides winning first, second, and third place should be made at each contest. The following point system is suggested:

First place	10 points
Second place	6 points
Third place	4 points
Honorable mentions at the discretion of the judges	1 point each

It should be noted that the points are awarded to individual slides; consequently, one member could acquire more than ten points in a contest by winning first place and second or third as well. The annual prizes are awarded on the basis of total number of points accumulated by each member during the contest year. No slide may be awarded prizes in two or more contests.

Basis of Judging. The points to be considered in judging and the importance placed upon each should be carefully considered and clearly stated. For instance, the judging might be based on the following:

1. Subject interest or human appeal.
2. Composition—general aspects and color composition.
3. Technical excellence—correctness of exposure, type of film, and type of illumination.

Accuracy of color rendition should be considered in judging only insofar as this factor is within the control of the photographer. It might be pointed

out that complete accuracy of color rendition is not always necessary or even desirable for maximum effectiveness in a color photograph.

Waiver of Responsibility and Statement of Acceptance. It is advisable to state on the entry blank that, while all possible precautions will be taken by the Exhibition Committee (or Contest Committee), neither they nor the club can assume responsibility for loss of, or damage to, transparencies submitted. The blank should also carry a statement to the effect that submission of transparencies implies acceptance of the rules and regulations published by the club.

Contrast

Contrast in a photographic image is both a visual impression and a measurable characteristic. Visually, contrast is the degree to which image tones and colors are distinctly and vividly separated from one another. The total impression is partly related to the intensity of the individual tones, and partly to the intensity of adjacent and surrounding tones. Contrast can be measured as the degree of difference between various silver densities in black-and-white images, or dye densities in color images.

When we speak of the "contrast" of an image, we usually mean the *overall contrast*—the difference between the maximum and minimum densities. This may be called "scale," or in measured terms, "density range." In a black-and-white print, contrast most often refers to the difference between pure white paper base and the maximum black that can be produced. However, not all prints include pure white tones, and very few prints contain maximum black areas. Consequently, the overall contrast of an image may be less than the maximum contrast that the print material can produce. In color images, overall contrast is the difference between the maximum and minimum added densities of each of the three image-forming dyes: cyan, magenta, and yellow.

In a negative, the overall density range is the difference between film-base-plus-fog density (the minimum) and the maximum highlight density. Other methods of measuring the contrast of film images are based on the characteristic curves of the films. The slope of the straight line portion of the curve is called "gamma" (λ). This is a measure of negative contrast commonly used in aerial photography. Another measure of contrast useful for negatives of ordinary subjects is called "contrast index," which is the slope of a straight line drawn through two specific points on a characteristic curve. (*See:* CONTRAST INDEX.)

An image is composed of a number of intermediate values between the overall contrast limits. The difference between any two adjacent intermediate values is called *local contrast.* As the illustrations of principles of contrast within this text show, two images may have the same overall contrast but distinctly different local contrast characteristics.

Overall contrast is related to the subject brightness range, the flare level in the camera, the inherent contrast characteristics of the negative and print materials, the printing method and equipment, and the processing. The major techniques for controlling contrast include:

1. Selection of materials.
2. Adjusting illumination to change subject brightness range.
3. Reducing the effects of non-image-forming light such as flare, or adjusting the development to compensate for flare.
4. Changing the spectral balance of the light entering the lens by means of filters. (This can increase or decrease the contrast between subjects of various colors.)
5. Adjusting exposure and development; the latter by the composition of the developer, or by adjustment of time, temperature, and agitation.

This article deals with measuring and controlling black-and-white negative and print contrast, and with some aspects of color contrast. There is important additional information in a number of other articles; they are referred to in the text and in the list at the end of this article.

Principles of Contrast
The most widely used measure of negative contrast is found on a characteristic curve of the film. A characteristic curve represents one emulsion re-

ceiving one development. Different development results in different curves, with changed contrast.

In the accompanying illustration, the response of the film is shown as increasing amounts of density with increasing amounts of exposure. The base-plus-fog density region shows where no exposure was given. This is the minimum density (D-min) of the film (with this development). The shoulder represents the region of maximum densities of the film

(with this development), and the top of the shoulder shows the maximum density (D-max).

The typical exposure range shows the region of a typical negative. The lowest density that will usually be printed as just lighter than black (shown as the minimum density of a negative) has a density somewhat greater than the base-plus-fog density, and is located on the toe of the characteristic curve. The maximum density of the negative usually falls

This characteristic curve of a black-and-white film represents one film emulsion that has had one development. It shows how increasing exposure results in increased density. The toe region is where the darkest subject tones are exposed, while the midtones and highlights are exposed on the straight-line section of the curve. Density range is usually measured from the minimum usable density point on the curve, about 0.10 density units greater than the base-plus-fog density, to the maximum density point, which is the density of a subject diffuse highlight. Specular highlights, usually quite small in area, have a higher density. The density range is a measure of the overall contrast of the negative, while local contrast is measured by the density difference between two local exposure levels, like two steps in a gray scale, or by the slope of the characteristic curve at that point. With less development, the slope of the curve would be less and the density range less, while with more development both would be greater. Most films shoulder off at such high exposure levels that they are not reached except in cases of extreme overexposure.

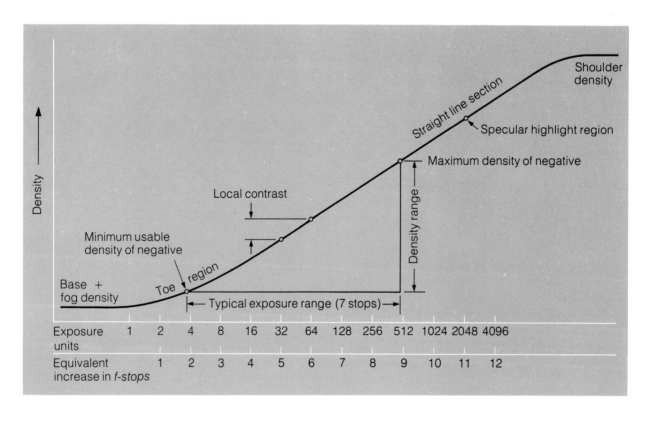

Contrast

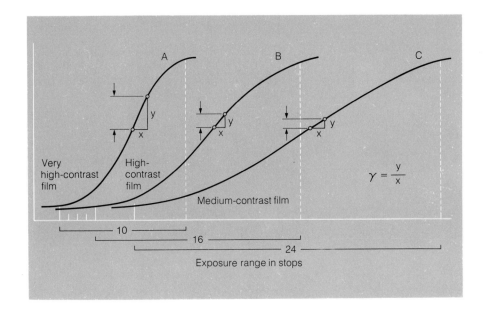

$$\gamma = \frac{y}{x}$$

Very high-contrast film
High-contrast film
Medium-contrast film
10
16
24
Exposure range in stops

on the straight-line portion of the curve. This is where diffuse highlights of the scene are recorded, and these densities are usually printed with a slight density. Specular highlights fall farther up on the curve, but their density is usually not measured—they are so dense in the negative that they print white. The density range of the negative, the most useful measure of contrast when it comes to making prints, is usually considered the difference in density between D-max and D-min of the negative.

The relationships between negative density ranges, the type of printing equipment, and paper contrast number grades are shown in a later section of this article.

Various emulsions may have the same overall contrast but different response. In the accompanying illustration, very high-contrast response (A) builds quickly to maximum density, accommodating a relatively small number of exposure increase steps. If the brightness range of a subject contained more exposure steps, they would not be recorded distinctly in the emulsion. Local contrast shows a larger density increase from step to step in high-contrast response. The curve of high-contrast response (B) rises less steeply, accommodates more exposure steps, and has less local contrast increase in each step. The medium-contrast response (C) en-

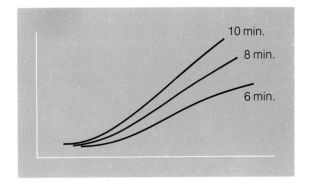

10 min.
8 min.
6 min.

compasses the greatest exposure range, but with least density difference from step to step. Process films are very high-contrast, aerial films are high-contrast, and most films used for regular photography are medium-contrast films. Extremely high-contrast films, such as films used in lithography, and low-contrast films, such as those used for photographic masking, are not shown in the illustration.

Development and Contrast. Development is a major contrast control for films. As negative development increases, contrast also increases, as shown in the accompanying graph by increasingly steep

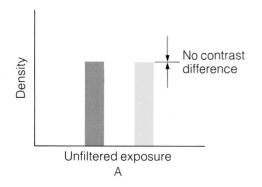

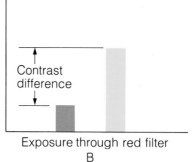

In black-and-white photography, contrast filters affect the densities produced by various colors. (A) Unfiltered exposure of a panchromatic film to given intensities of blue and yellow subject colors can produce equal densities. (B) Exposure through a red filter, which absorbs most of blue light, produces a significant difference in densities.

curves for a particular emulsion and different developing times with the same developer.

When the subject contrast (luminance range) is low, developing to a higher contrast gives a normal density range in the negative. If, on the other hand, the subject contrast is high (long luminance range), development to a lower contrast will prevent an excessively high density range in the negative.

Contrast Filters. Contrast filters in black-and-white photography affect the densities produced by various colors. In the accompanying illustrations, unfiltered exposure (A) of a panchromatic emulsion to given intensities of blue and yellow in a subject can produce equal densities. A print from this would be without contrast; both areas would be the same shade of gray. Exposure through a red filter (B), which absorbs most of blue light, produces a significant difference in densities. In a print, the "blue" area would be a much darker gray than the "yellow" area. The general rule is that a contrast filter causes a lighter rendition of its own or related colors and a darker rendition of opposite, or complementary colors.

Black-and-White Negative Contrast

The correct negative contrast is that which will produce the quality print you want when the negative is printed with your equipment, usually on medium-contrast paper.

There are a number of factors that determine negative contrast:

1. Subject luminance ratio (brightness range).

2. Inherent film contrast.
3. Subject conditions that contribute to camera flare.
4. Flare level of camera and lens.
5. Amount of film development:
 a. Developer formula, dilution, degree of exhaustion.
 b. Temperature.
 c. Frequency, duration, and degree of agitation.
 d. Time.

In general, the amount of development is used as the control to achieve the negative density range that will print well with the variable subject, film, and flare contrast factors that have been involved in the exposure of the film.

Methods of Finding Development Times. There are several methods of finding the amount of development; four of them are covered in the following sections.

1. The table development times.
2. A practical method based on ring-around tests.
3. The developing dial method given in Kodak publication No. R-20, KODAK Darkroom DATAGUIDE.
4. The contrast-index method. This is the most flexible method, and leads to more consistent negative density ranges under a variety of contrast conditions.

Table Development Times. There are development times tables in Kodak film data sheets and in the instruction sheets packaged with films. The times given are designed to produce average-contrast negatives with normal-contrast subjects. However, they are calculated on the specific basis of exposures made with moderate flare-level lenses, and for negatives to be printed on diffusion-type enlargers. Most negatives developed to the table times will likely be too contrasty (have too great density ranges) to print with condenser enlargers on medium-contrast paper. With contrasty subjects, the negatives may not be printable on even the softest available papers.

When films of a variety of subject contrasts exposed with a variety of camera lenses with different flare levels are all developed to the same time, the negatives will have a variety of density ranges. Nor-

Prints intended for reproduction should contain adequate detail in both highlight and shadow areas. Such prints can be obtained only from good negatives—those that have been sufficiently exposed for good contrast in shadow-area densities, and carefully developed to retain printable contrast in highlight-area densities. When negatives are produced that print best on a normal contrast grade of paper, it is easy to shift to paper of other contrast grades for special needs or expressive purposes.

Contrast

mally, such negatives can be printed satisfactorily by using lower or higher contrast grades of paper, or lower or higher numbered Kodak Polycontrast filters with a selective-contrast paper. Using the table development times, with films exposed to high-contrast subjects, may lead to negatives that are too contrasty to print with condenser enlargers, even on the softest grade of paper available.

Starting with the time-temperature table value, a series of tests can be run that will help find a development time for a given film-developer combination that will produce negatives whose contrast is more suited to a given set of contrast controlling factors.

A Practical Method of Finding Development Times. A good negative is one that makes high-quality prints. The aim is generally to get negative contrast of the typical subjects photographed that will print well (on a given type of enlarger) on medium-grade, contrast grade 2, or selective-contrast paper with a No. 2 filter. The correct development time for a film-developer combination is one that will produce this type of contrast. Lower or higher contrast subjects will, when the films are developed for the same time, produce negatives of lower or higher contrast. These can then usually be printed on higher or lower contrast paper to achieve the desirable print contrast.

There are two reasons to aim for negatives that will print on medium-contrast paper. The first is that there are papers of lower and higher contrast avail-able to print negatives of higher and lower contrast. The paper contrasts available provide a tolerance for the negative contrast variation.

The second reason is tone reproduction quality. When high-contrast papers are used to print low-contrast negatives, a larger percentage of the tonal scale is printed on the toe of the paper's characteristic curve, and a smaller percentage is printed on the relatively straight-line portion. This results in an uneven tone reproduction, with more compression of the light tones and a darkening of the middle tones. Development of negatives to print on a low-contrast grade paper gives slightly improved tone reproduction for most subjects, but eliminates the tolerance for high-contrast subjects provided by the method of aiming for negatives that will print on medium-grade paper.

Ring-around. The correct development time can be found by making a ring-around series of negatives of a typical full-scale subject. As the accompanying diagram shows, a ring-around is a series of negatives with exposure-development variations. By making a ring-around you should be able to determine the best-exposure, best-development negative for your purposes. If you take pictures under a variety of conditions, with several black-and-white films and with several camera lenses, you may find it desirable to run several ring-around series, one for each set of circumstances. For more detailed information, see the article RING-AROUND.

25% less development	Normal development	25% more development
−1 stop	−1 stop	−1 stop
Normal exposure	Normal exposure	Normal exposure
+1 stop	+1 stop	+1 stop

The results in a ring-around surround a print made from a negative that was exposed and developed normally. Other prints are from negatives made with variations in exposure and development. Finer distinctions can be produced by varying exposure up to two stops from normal, and varying development in 15-percent and 30-percent changes from normal.

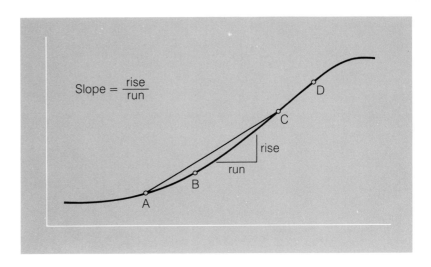

Contrast index and gamma are both expressions of average contrast, derived from the graph (characteristic curve) of a negative emulsion's response. Both are expressions of curve slope or slant, the degree of rise. Either is found by measuring a run horizontally to the right of any number of units, and then measuring the rise upward at right angles until the curve is encountered. Slope equals rise divided by run. Gamma is the slope of the straight-line portion (B–D) of the graph. Contrast index is more pertinent; it is the slope of a line that connects points of minimum and maximum printable density (A,C).

The Development Dial Method of Finding Development Times. A somewhat easier way to find a development time adjusted for many of the contrast controlling factors in the photographic process (except for that of subject contrast) can be found in the Kodak publication No. R-20, *KODAK Darkroom DATAGUIDE*. It utilizes development numbers, adjustments, and a developing dial to compensate for contrast and to find times for various film-developer combinations. Instructions for using the method are given in the *DATAGUIDE*.

This method results in a development time suited to the camera lens-flare level, enlarger type, method of agitation, and even for the small differences between paper types. It gives development times that will produce negatives whose contrast is nearly correct for the sets of conditions used in calculating the times. Minor adjustments in the times found will often have to be made, however, to get optimum results for a given set of conditions. The developing dial method permits the arrival at a time close to optimum much faster than the ring-around method, and is particularly useful when a variety of film-developer combinations is to be used.

Measures of Negative Contrast. There are several measurement methods of classifying negative contrast. Three that have been or are most useful are:

1. Gamma.
2. Contrast Index.
3. Negative Density Range.

The first of these is historically the oldest, and while it is still used as a valid measure in special types of photography such as aerial photography, it has largely been replaced by contrast index in general, medium-contrast photography. Contrast index and negative density range are both useful measures in the control of negative contrast.

The accompanying diagram briefly explains gamma and contrast index. They are treated more fully in individual articles.

Negative density range is determined by measuring the maximum and minimum densities in a negative *that contains printable detail*. (There may be greater and lesser densities, but they will not contain details of importance in the image.) The negative density range is the difference between the two. For example, if the maximum density is 1.85 and the minimum density is 0.6, the negative density range is 1.25. As explained in the later section on print contrast, the negative density range indicates what contrast grade of paper is required to obtain a print of normal contrast.

Uses of Contrast Index. The major value of contrast index is that it leads to film developing times that give consistent negative density ranges. If you find, for example, that negatives made on one black-and-white film developed to a CI = .56 print well on grade 2 paper in your diffusion enlarger, you can develop another film to the same CI = .56, and expect to get the same negative density range when the subject luminance range is the same. To find this

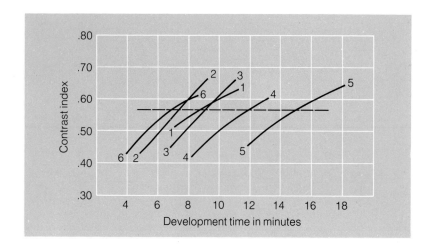

In this diagram, which shows typical contrast-index curves for Kodak Tri-X pan film, a contrast index of 0.56 produces negatives with density differences that will print well. The dashed line indicates the development times that will give a contrast index of 0.56 with various developers. The curves represent the following Kodak developers: (1) HC-110 (dilution B) at 68 F, (2) Polydol at 68 F, (3) D-76 at 68 F, (4) D-76 (1:1) and Microdol-X at 68 F, (5) Microdol-X (1:3) at 75 F, and (6) DK-50 (1:1) at 68 F.

information, you use time–contrast-index curves, or contrast-index curves, for short.

Contrast-Index Curves. The accompanying illustration shows some typical contrast-index curves for Kodak Tri-X pan film. Note that the curves are given for a number of Kodak developers. If a contrast index of .56 produces negatives with density differences that print well for you, then you can find the time for each developer by drawing a straight horizontal line at a CI value of .56 on the graph (dashed line in the illustration). The development time for Kodak Tri-X pan film in Kodak D-76 developer, for example, is 9 minutes with agitation at 1-minute intervals at 20 C (68 F).

As indicated above, a contrast index of about .56 produces negatives of full-scale subjects that usually print well on grade 2 paper in diffusion enlargers. These negatives have a density range of about 1.05. For condenser enlargers, a lower density range is required—about .80 is usually right. A contrast index of about .42 will produce negatives of full-scale subjects with this density range. These figures assume the exposures were made with a camera lens with a moderate flare level.

There are several types of diffusion enlargers, most of which print with approximately the same contrast characteristics. They include those with incandescent bulbs and opal glass or ground-glass diffusers, and color heads with integrator reflecting surfaces that diffuse the light from one or more incandescent or pulsed-xenon bulbs. Diffusion enlargers with fluorescent-type illumination are likely to have different contrast characteristics with different selective-contrast papers because the color characteristics of the light are different from that of incandescent light. The characteristics of this type of enlarger can be brought close to those of incandescent diffusion enlargers by suitable filtering.

The typical condenser enlarger whose contrast characteristics are used as the standard in this article has an opal incandescent enlarging bulb with condensers that have all polished surfaces. Some condenser enlargers have a condenser with at least one ground surface. The contrast characteristics of this type of enlarger will be somewhere between those of the typical condenser enlarger and a diffusion enlarger. Another type of condenser enlarger has a clear bulb with a small filament (point source), and prints with more contrast than the typical condenser enlarger. Negatives for this enlarger will require density ranges lower than those made for typical condenser enlargers.

There are darkroom conditions that lower the printing contrast of enlargers. Light leaking around the edges of a negative in the negative carrier increases the enlarger flare and reduces the printing contrast. A dirty enlarger lens or cigarette smoke in the air around the enlarger also reduces print contrast. An unsafe safelight or exposing the paper too long to safelight illumination can cause contrast reduction and poor print quality by latensification. White light leaking from the enlarger and bouncing off a wall can also reduce contrast and quality. The

procedures given in this article assume careful control of all such harmful variables.

The technical matching of negative density range and paper contrast is not the whole story in achieving good tone reproduction, of course. There are the visual judgment factors of what makes a good-quality print with a particular subject. For example, a certain subject may be reproduced best with increased midtone separation.

The Contrast-Index Method of Finding Developing Times

A typical front sunlit outdoor subject has a brightness range of about 7 to 7⅓ stops—or a lumi-

Print quality is seriously affected by a dirty or deteriorated enlarger lens. This print was made on a lens marked with a finger smudge; note the loss of contrast and definition, particularly in fine detail.

Cleaning the enlarger lens resulted in a print of markedly improved quality.

Outdoor subjects photographed with the camera facing into the sun have high flare levels, which may be increased by other conditions such as snow on the ground.

lenses, for higher flare-level lenses the contrast index is increased, and for low flare-level lenses the contrast index is decreased. This compensation for flare level is included in the contrast index nomographs in this article.

The actual flare level in the optical image varies with the lighting and subject conditions, as well as with the type of lens. The nomographs in the following section give adjustments for frontlit, outdoor conditions with some blue sky in the picture area. Backlit subjects with the sun shining on the lens will produce higher flare levels, for which additional adjustment may be required. The use of a properly designed lens hood is recommended.

In low-flare studio conditions, with no large bright areas, the flare level will be lowered somewhat, perhaps to the next lower table value. When large white backgrounds are used, or when photographing in white studios, use the daylight flare adjustments.

Small-Tank Contrast-Index Curves. To find a developing time for a particular film in a particular developer to get a desired contrast index, it is necessary to have a contrast-index curve. Most of the contrast-index curves given in Kodak film data sheets are for large-tank development with agitation at 1-minute intervals. Most roll film is developed by

nance ratio of about 128:1 to 160:1. Luminance is measured brightness. This means that if you measure (with an exposure meter) the luminance of a subject diffuse highlight—one that you want to be just slightly darker than white in the print—and if you measure a dark subject tone—usually an open shadow area that you want to reproduce in the print as just lighter than black—you will find there will be about 7 stops difference.

Camera Lens Flare. If you exposed the film directly to the subject, you could base the calculation of the required contrast index on this range. However, the film is exposed not to the subject but to the optical image of the subject formed by the camera lens. The brightness range of the subject is nearly always *lowered* by flare in the camera lens. How much the range is lowered is controlled primarily by the flare level of the lens and the lighting conditions of the picture area. The following camera lens-flare estimating table gives a method of estimating the flare level of a particular camera lens.

Adjustments can be made to the contrast index to which the film is developed to compensate for the lowered brightness range of the optical image caused by lens flare. Since the starting contrast index is based on images formed by moderate flare-level

Camera Lens Flare Estimating Table		
% Flare	Flare Level	Camera Lens Categories
6.5–10.0	Very high	Old uncoated lenses, zoom lenses at small apertures
4.5–6.5	High	Zoom lenses at higher apertures, older single-layer coated lenses, extreme wide-angle single-layer coated lenses
1.5–4.5	Moderate	Most single-layer coated lenses, multilayer coated extreme wide-angle and telephoto lenses
0.0–1.5	Low	Multilayer coated normal, moderate wide-angle, and telephoto lenses. All lenses in low-flare studio and interior conditions

the small-tank procedure, which produces a different CI curve. Likewise, some sheet film is developed in a tray with continuous agitation. Small-tank and tray contrast-index curves can be calculated from the large-tank curves given in the data sheets. A method for this procedure is provided in the article CONTRAST INDEX.

The basic contrast index of .56 for negatives to be enlarged with diffusion enlargers and .42 for condenser enlargers, corrected for lens flare, gives negatives of *full-scale subjects* that have about the right density range for printing on the various normal grade papers (grade 2, medium-grade, or selective-contrast paper with a PC2 filter). When the luminance range of the subject is not full scale (7-stop range), an adjustment can be made to the contrast index to which the film is developed to obtain the same density range normally achieved in negatives of full-scale subjects. For subjects whose luminance range is less than normal, a higher contrast is required, while for subjects whose luminance range is greater than normal, a lower contrast index is required. The following section provides a method of measuring the luminance range of the subject, and a method of determining the contrast index required to achieve the desired density range.

Adjusting for Subject Luminance-Range Variations. In many photographic situations, the subject contrast (subject luminance range) will be higher or lower than the 7-stop range that is considered normal. When sheet film is being used so that the sheets can be developed individually, or when entire rolls of film are exposed to the same unusual subject luminance range, the contrast index to which the films are developed can be changed to obtain negatives with more normal density ranges.

To find the subject luminance range, the subject is measured in two areas with a hand-held* reflection exposure meter, either averaging or spot. A diffuse highlight area is measured and an exposure calculated using the meter dial and some convenient shutter speed. The second area that is measured is a dark tone that will be reproduced just lighter than black, and the exposure for the dark tone is calculated at the same shutter speed. The number of stops difference between the *f*-numbers for the two

*Some averaging meters built into SLR cameras can give misleading results because of center weighting.

exposures is the luminance range in stops. This difference will usually be found to be about 7 stops with typical full-scale subjects.

Few subjects have luminance ranges less than 5 stops or greater than 9 stops. The maximum adjustments found by use of the nomograph provide negatives whose density ranges are within the printing contrast control available with different contrast grades of paper even though the subject luminance range may be beyond these limits.

Using the Contrast Control Nomographs. The following four factors are used to calculate a contrast index that is adjusted to produce negatives with relatively consistent density ranges:

1. The type of enlarger or the negative density range desired.
2. The subject luminance range in stops.
3. The type of film.

The use of these first three factors results in a contrast index adjusted for subject contrast when exposed by lenses of moderate flare level.

4. Camera lens flare level.

The use of this fourth factor further adjusts the contrast index in situations where the lens flare level is other than moderate.

There are just three steps in finding the contrast index by using the nomograph, and one additional step to find the developing time.

Step 1. Select the proper nomograph based on the film being used. The accompanying nomograph illustrations are based on Kodak films with short toe characteristic curves, Kodak films with long toe characteristic curves, Kodak Tri-X pan film, and Kodak Panatomic-X and Panatomic-X professional films.

Step 2. Place a straightedge between the left and middle scales. Adjust the straightedge so that it intersects the left scale at the enlarger type or the density range that you want to achieve. Line it up on the dot in the subject contrast

(luminance range) diagonal scale that identifies the measured subject contrast. Read the adjusted contrast index where the straightedge intersects the middle scale.

Step 3. Place the straightedge between the middle and right scales. Adjust the straightedge so that it intersects the middle scale at the adjusted contrast index found in Step 2. Line the straightedge up with the appropriate round or square dot (depending on type of enlarger and camera lens-flare level) in the diagonal scale labeled Camera Lens

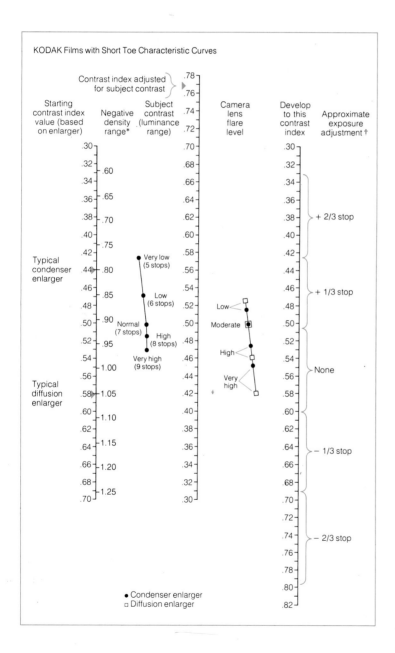

The contrast control nomograph on this page is for Kodak films with short toe characteristic curves, including Kodak Plus-X pan (35 mm), Kodak Plus-X pan professional (rolls), Kodak Super-XX pan 4142, Kodak Royal-X pan 4166, Kodak Royal-X pan (rolls), and Kodak Verichrome pan. The nomograph on the following page is for Kodak films with long toe characteristic curves, including Kodak Plus-X pan professional 2147 and 4147, Kodak Royal pan 4141, Kodak Tri-X pan professional 4164, Kodak Tri-X pan professional (rolls), Kodak Tri-X ortho 4163, and Kodak Ektapan 4162.

Flare Level. Read the final adjusted contrast index in the right-hand scale.

Step 4. On the contrast-index curve for the film-developer combination being used, find the development time that will give the final adjusted contrast index. Contrast-index curves for large-tank development are published in the data sheets in Kodak Data Book No. F-5, *KODAK Professional Black-and-White Films.* A method of calculating CI curves for small-tank development is given in the same publication. If small-tank processing of roll films is being done, a contrast-

The following notes apply to the nomographs on both this page and the previous page.

**These are the typical negative density ranges that result when normal luminance range subjects (7-stop range) are exposed with moderate flare level lenses and developed to the contrast index shown in the left scale.*

†Some film and developer combinations may require more or less exposure adjustment than the average values shown here, especially when the adjusted contrast index is less than 0.45 or greater than 0.65. Some of the finest-grain developers cause a loss in film speed that must be considered in addition to the losses caused by developing to a lower contrast index.

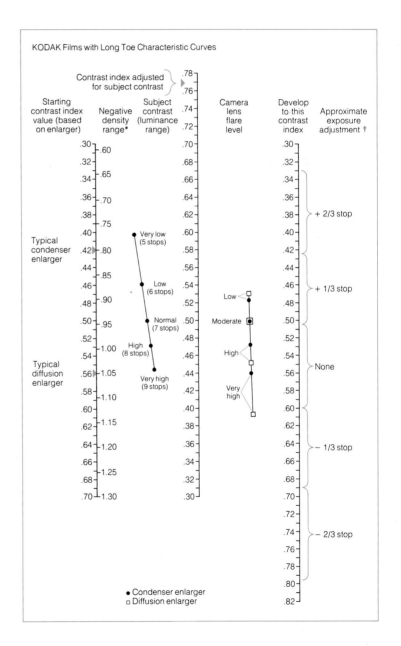

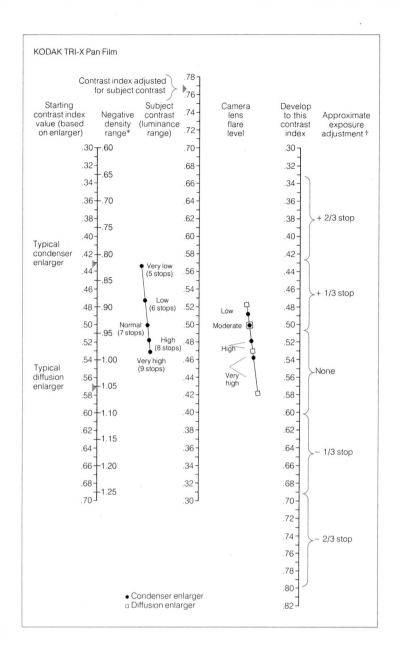

KODAK TRI-X Pan Film

Shown here are contrast control nomographs for Kodak Tri-X pan film (this page), as well as Kodak Panatomic-X and Kodak Panatomic-X professional films (next page).

index curve will likely have to be calculated; see CONTRAST INDEX.

The times found by using the contrast-index curves should be rounded off in the direction of the time that would produce a CI of .56. Fractional times less than that required for a CI of .56 should be rounded upward, and those that will produce a CI greater than .56 should be rounded downward. Times between 5 and 11 minutes should be rounded to the nearest half minute, and those above 11 minutes, to the nearest minute. Development times longer than twice the time recommended to produce a contrast index of .56 should not be used.

The nomographs are based on the technical as-

Contrast

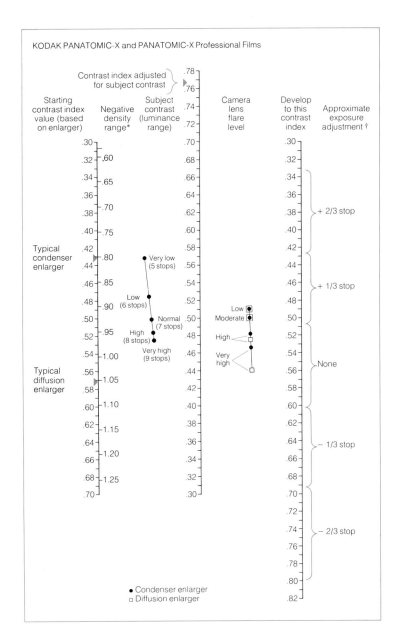

KODAK PANATOMIC-X and PANATOMIC-X Professional Films

The following notes apply to the nomographs on both this page and the previous page.

*These are the typical negative density ranges that result when normal luminance range subjects (7-stop range) are exposed with moderate flare level lenses and developed to the contrast index shown in the left scale.

†Some film and developer combinations may require more or less exposure adjustment than the average values shown here, especially when the adjusted contrast index is less than 0.45 or greater than 0.65. Some of the finest-grain developers cause a loss in film speed that must be considered in addition to the losses caused by developing to a lower contrast index.

pects of photographic tone reproduction. The long- and short-toe film nomographs represent averaged data for the films listed for each nomograph. All the nomographs are based on the use of standard developers such as Kodak HC-110 and D-76, typical optical image luminance ranges for lenses of the various flare levels, and typical printing characteristics of the two types of enlargers. Specific rolls of film can be expected to vary somewhat from the average values given by the nomographs, depending on the film type, the age and storage conditions of the film, the developer used, and processing variations. However, the results that will be obtained by using the nomographs should result in negative density ranges that

make printing to a high-quality level much easier than those achieved by the use of a single developing time for all negatives.

If more exacting results are desired, a large quantity of film of the same emulsion number can be obtained and tests can be run with a specific developer. When the desired results are achieved, the remainder of the film can be stored in a refrigerator or freezer until ready for use.

In any case, as with any process where there are variables, the results should be monitored and changes made to obtain optimum results.

For example, if all negatives appear to have a lower than aim density range, as would be evidenced by requiring a hard-contrast-grade paper, increasing the contrast index by about .15 will give negatives that will print on grade 2 or medium-grade paper. As a rule, this means that the enlarger has unusually low-contrast printing conditions, and a new starting contrast index should be found.

If the negatives from some lenses print well on grade 2 paper, but negatives from one lens require between grade 1 and grade 2 paper (or a PC1½ filter for a selective-contrast paper), then that lens probably has a lower flare level than had been rated in the calculations. A change in the calculations of one step lower in flare level for this lens will likely correct the situation.

When taking pictures on a roll film, there may be a mix of conditions in various exposures on the roll. Lenses of different flare levels may have been used, or subjects of various luminance ranges may have been exposed. When calculating the contrast index in such cases, in-between points on the scales can be used. For example, if shooting on an overcast day, the subjects range between 5 and 6 stops in luminance range. When finding the adjusted contrast index, use the normal starting enlarger or density range point and place the straightedge so that it intersects the luminance-range adjustment line halfway between the 5-stop and 6-stop dots.

If you find that your enlarger varies considerably from the two starting points given, adjustment should be made both in the starting scale and the camera lens-flare level scale. There are some condenser enlargers that have one surface of a condenser ground rather than polished. These enlargers print with a contrast partway between condenser and diffusion enlargers. The starting point could be

a contrast index of about .50, or a 0.95 density range. When adjusting for camera flare level, use a point on the scale line halfway between the condenser and diffusion enlarger points for each flare level.

There are also condenser enlargers with small filament bulbs (point source) that print with more contrast than the usual condenser enlarger with an opal bulb. A good starting point might be a CI of .38 or a density range of about 0.73. When adjusting the flare level, use a point on the line closer to the moderate point than the round condenser points given.

When the use of tables calls for an increase in contrast index to very high values, the exposure latitude is decreased and more contrast variability can occur. Unless tests can be run with all factors held under exact control, it is generally safer to develop to no higher CI values than are shown on the data sheet for the film-developer combination being used (or more than twice the time recommended to get a CI of .56), and to make up for the lower density ranges that can result by using a paper of higher contrast.

In some cases, the adjusted contrast index will be lower than the lowest CI value on the CI curves. It is not advisable to simply extrapolate from the given curve to obtain an estimated developing time. A practical test should be run; if the test does not produce satisfactory results, the development time and/or the film speed rating should be adjusted as necessary before any important negatives are processed.

Some CI curves become relatively horizontal at higher CI values. If high CI values are required, it is better to choose another developer whose curve does not show this characteristic.

Some film-developer combinations will give times shorter than 5 minutes when lower CI values are called for. Tank development times of less than 5 minutes are to be avoided because the negatives may show evidence of poor density uniformity. It is better to choose a film developer or dilution that will give times greater than 5 minutes.

Adjusting the Film Speed. The speed of films is measured under conditions that approximate a contrast index of .56. When the contrast index is changed, the position of the speed point on the characteristic curve changes, resulting in a change in the film speed. As the contrast index is lowered, the speed goes down; as the CI is raised, the speed is

increased. The approximate correction for the speed change is given on the nomograph opposite the final adjusted contrast-index scale. This film-speed adjustment scale is an average for Kodak black-and-white continuous-tone films with developers such as Kodak D-76 and HC-110 developers.

If you find that the overall density of processed negatives is somewhat low, with inadequate shadow detail, increase the exposure by lowering the film speed. If, on the other hand, the overall density is somewhat high, with more than adequate shadow detail, you can reduce exposure by using a higher film speed.

Some very fine-grain developers cause the film to lose speed. A correction of two-thirds to a full stop increase in exposure, in addition to other adjustments indicated by the nomograph, may be necessary when the film is to be developed in such a developer.

Increased Midtone Separation. The nomograph is designed to produce negatives whose density range matches the paper log exposure scale when printed in an enlarger of the type used to calculate the contrast index. This gives a typical tone reproduction.

Some workers find that they prefer prints with somewhat more midtone separation (increased local contrast) than this standard procedure gives. To accomplish this, a density range increase in the negatives is required that is approximately enough to print on soft-contrast-grade paper or contrast grade No. 1. The prints are then made on medium-contrast paper, or grade No. 2, and the detail is held in the highlights and shadows by burning-in and holding-back.

To accomplish this, use a starting density range of 1.25 for diffusion enlargers and 0.95 for condenser enlargers instead of the 1.05 (diffusion) and 0.80 (condenser) density range values given as starting points on the nomographs.

Artistic Considerations. The method of contrast-index adjustment assumes that the aim is to achieve negatives that will use the full scale of medium-contrast-grade paper with low- or high-contrast subjects, avoiding the low- or high-density range negatives that are difficult to print. In so doing, the tonal separation is increased with low-contrast subjects and lowered with high-contrast subjects. This is generally accepted as useful with most subjects—as the tonal separation is improved in the print.

However, there may be cases where, for artistic reasons, it is desirable to reproduce the contrast to much the same level as it was in the original. This can be accomplished with low-contrast subjects by developing to the contrast index used for normal-contrast subjects. In the case of extremely low-contrast subjects, a compromise CI part way between the CI used for normal subjects and the adjusted CI for very low-contrast subjects can be used. This will give some increase in tonal separation, but not as much as if the entire adjustment were used.

It is not as simple with extremely high-contrast subjects. Development to the same CI used for normal subjects, or even a compromise CI, is likely to produce negatives with density ranges beyond the scale of even low-contrast-grade papers. If this occurs, the negative can be balanced as described in a later section. It is safer to use the very high (9-stop) contrast-index adjustment with extremely high-contrast subjects.

Balancing a Negative

Under normal circumstances, any negative can be printed, and with proper selection of paper and perhaps dodging, a reasonable quality print can be made. There are some occasions, especially when a wrong developing time was used, a subject photographed with spotty lighting, or when a number of prints are required, that a negative can be *balanced* to improve print quality and to make it easier to obtain multiple matched prints. Another reason for balancing is to improve the tone relationships that exist in the subject and thereby make the picture more effective.

Balancing means locally changing the densities in a negative to improve its printing characteristics. When completely balanced, a negative will make high-quality prints without dodging. When only a few prints are to be made, it may be time-wise to stop with a partial balance, and to use dodging as the prime control.

Reduction. Reducing is a chemical method of lowering negative density. Farmer's Reducer is the most commonly used reducer. It may be purchased from a dealer or mixed from formulas.

If a negative is too dense overall, with about the right degree of contrast, it should be given overall reduction in a single-solution formula. If the density is too great and the contrast too high, the negative

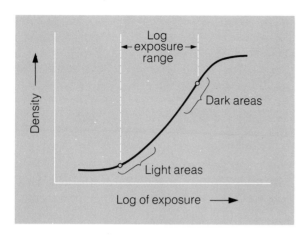

In the response graph (characteristic curve) of a print emulsion, the least densities of black, image-forming silver represent the highlights and light-toned areas of the original subject. The heaviest densities correspond to the darkest subject areas. This is the opposite of the subject-density relationships in a negative.

should be reduced overall in a two-bath formula. Follow the directions closely. *(See:* REDUCTION.*)*

Local reduction can be given to areas that are too dense. Single-solution Farmer's Reducer is used. Experience will be required both for controlling the area to be reduced and for the amount of reduction.

Intensification. When the negative is too thin overall, both the density and contrast need increasing. This is done by overall *intensification.*

Kodak intensifier In-6 can be used both as an overall and as a local intensifier for medium- and coarse-grain films; it is not suitable for fine-grain materials. The intensified image is of a brownish color that gives a good printing density, and, while not completely permanent, will remain in a satisfactory condition for several years.

When used for local intensification, this intensifier will increase the density level and the contrast in thin negative areas, thus improving the print rendition of shadow detail. Where highlight regions print with inadequate tone separation, as frequently occurs with copy negatives made on a regular film, local intensification with In-6 will increase separation.

Print Contrast

The contrast seen in a black-and-white photograph is a complex quality; the contrast of the paper used to make the print is only one factor among several. To use the word "contrast" in a meaningful way with black-and-white papers, it must be separated from the more subjective idea of contrast as seen in a finished photograph.

The contrast-grade numbers assigned to papers give an approximate idea of the inherent contrast of the emulsion. Different kinds and brands of paper bearing the same grade number may have different inherent contrasts. A skilled photographic printer who knows the characteristics of the papers can assess the density range of the negative and take the nature of the subject matter into consideration, and then can choose the contrast grade of a paper that will make a satisfactory print. There is also a more accurate method of fitting the density range of the negative to the contrast of the paper.

Negative densities and contrast are measured in terms of the amount of light transmitted by various parts of the image. Print densities and contrast are measured in terms of how much of the light striking an area is reflected back and how much is absorbed. In both cases, density reduces light intensity. (*See:* DENSITOMETRY.)

The *log-exposure range* of a print emulsion is the relationship between the exposure needed to give the faintest highlight tone and that needed to yield a full black density. Logarithmic units are used for expressing exposure because they relate directly to the density range of the negative. Density is also expressed in log units.

If the log-exposure range of the paper approximately equals the density range of the negative, the resulting print contrast will usually be satisfactory when contact printing or enlarging with a diffusion enlarger. When using a condenser enlarger, the negative's density range is approximately 75 percent of the paper's log-exposure range.

Factors That Affect Print Contrast. The contrast of a paper can be chosen by matching the density range of the negative to the log-exposure range of the paper. In practice, however, this method is only an approximation. The actual contrast obtained in a print from a given negative is affected by both technical and expressive factors. Such factors influence the choice of paper contrast that must be used to obtain a good print. The inherent contrast of the paper does not change, of course, but the effective printing contrast of the negative varies according to the type of illumination used in the enlarger, the color quality of the exposing light source, and

the quality or condition of the enlarger lens. In contact printing, contrast is uniform with most equipment, but when a small light source is used at a considerable distance from the negative, contrast is slightly higher than it is with a diffused light used close to the negative. Most diffuse-light enlargers yield a contrast similar to a diffuse-light contact printer. Modern condenser enlargers are usually of

a type known as semi-specular. They yield contrast about one grade of paper higher than the diffuse-light type.

Contrast Grade Names and Numbers. The contrast grade numbers and names are broad indications of the density ranges of the negatives that can be printed satisfactorily on each grade of paper. A high-density-range negative will generally print best

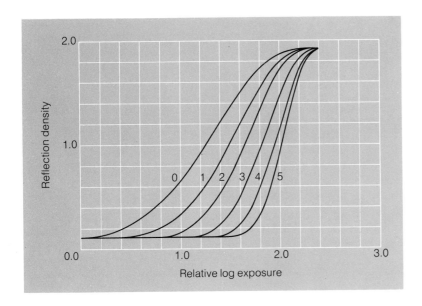

This graph shows a family of typical response curves for the six different contrasts found in Kodak papers. All of these curves are for papers having a glossy surface. The maximum shoulder density, representing the maximum black the paper can produce, tends to be the same for each paper, irrespective of the contrast or slope of the straight lines. Note that the gradient of the straight line for contrast No. 5 paper is much steeper than that for contrast No. 1, indicating higher contrast response. Kodak name-grade papers (soft, medium, etc.) and selective-contrast papers have similar characteristic curves.

Papers of the same contrast grade and emulsion type do not necessarily produce the same maximum black. The difference is due to the surface of the paper —the rougher the surface, the more it scatters and reflects light, which reduces the visual intensity of dark tones. A glossy surface produces the maximum black and has the greatest overall contrast (A). A matte surface has significantly less overall contrast (B), and its maximum "black" may be only a very dark gray. How black it seems visually also depends on the range of other tones in the print, and the psychological importance of the black areas in the total image.

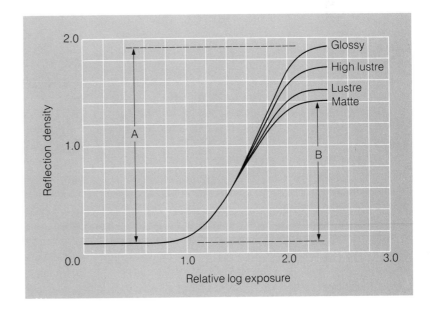

Contrast

The actual contrast obtained when printing from a given negative is a product of both technical and expressive factors, both of which influence what contrast grade of paper is used. This print was made on Kodabromide paper F, which has a particularly good development latitude. It permits extended development to bring out more highlight detail or tone without affecting print contrast adversely.

PAPER CONTRAST AND NEGATIVE DENSITY RANGE

Contrast Grade Number	Negative Density Ranges	
	Diffusion Enlarger	Condenser Enlarger
1	1.15 to 1.40	0.87 to 1.07
2	0.95 to 1.15	0.72 to 0.87
3	0.80 to 0.95	0.60 to 0.72
4	0.65 to 0.80	0.50 to 0.60
5	0.50 to 0.65	0.38 to 0.50

on grade 1 or soft-contrast-grade paper, both of which have long log-exposure ranges. Conversely, a low-density-range negative will print best on grade 5 of extra-hard-contrast-grade paper, both of which have short log-exposure ranges.

The type of enlarger used also affects the contrast of the print image. Condenser enlargers produce prints with higher contrast than those printed on diffusion enlargers. The accompanying table shows the approximate density ranges of negatives required to print on Kodak's various numbered paper grades with the two types of enlargers.

Measuring Negative Density Range

Experienced photographic printers can estimate exposure and select a suitable contrast of paper with reasonable accuracy. Beginners, or those who print only rarely, may have difficulty in making good prints without a good deal of trial and error, and a consequent waste of material. In these circumstances, on-easel photometry can be used to estimate exposure and to match the density range of the negative to a suitable contrast of paper. For this purpose, an electronic densitometer equipped with a probe is the most suitable instrument. When using an on-easel densitometer, use only the negative density

ranges given for diffusion enlargers. The contrast-enhancing effect of the condenser enlarger has already been compensated for because you are measuring the optical image, not the negative itself.

To find the density range of a negative, read and record a shadow area and a diffuse highlight area in the negative in which you expect detail to show in the print. The difference between the two readings is the density range. For example:

Highlight density 1.26
Shadow density 0.16
Density range 1.10

According to the log-exposure ranges given for Kodak papers, a negative with a density range of 1.10 will print satisfactorily on grade No. 2 paper or on a Kodak selective-contrast paper with a Polycontrast filter PC2 with a diffusion enlarger.

In reading the densities to determine density range, disregard specular highlights on polished metal, glass, and similar glossy surfaces. They contain no detail and so would give a false estimate of density range. In portrait negatives, select a skin tone in which some detail will appear in the print. Likewise, avoid selecting shadow areas where there is no apparent density greater than the film base.

Since contrast in a black-and-white print is partly subjective, the above method will not always yield the ideal contrast of paper; however, it provides a useful starting point.

In black-and-white printing, photometry is complicated by the use of papers with widely differing speed, and by the subjective nature of density and contrast in monochrome prints. Consequently, you must often override the exposure indicated by the instrument to obtain a desired result.

To set up a densitometer for black-and-white printing, first calibrate the instrument for the speed of the paper you are using, and then select a highlight density in the projected image; this density should be one that will contain some detail in the print. Place the aperture of the probe on the density you have chosen and then adjust the instrument until the needle or pointer reads at a midpoint on the meter scale. By trial-and-error, adjust the densitometer until correct exposure is obtained with a negative of normal contrast and density at an exposure of about 5 seconds. As far as possible, adjust exposure by altering the lens aperture to bring the pointer to a predetermined value on the scale. In effect, you are then reading the same light intensity for every negative. Since most modern densitometers are equipped with cells that are sensitive to the safelight, do not allow the safelight illumination to fall directly on the densitometer probe. Also, avoid letting stray white light from the enlarger head be reflected onto the easel.

Integrated-Light Reading. The above procedure makes use of what is known as spot reading. Another method is to integrate the light transmitted by the lens to obtain a mean value for all the densities in the negative. The light is integrated with an integrating cone on the probe of the densitometer or by placing a sheet of diffusing material over the lens. This method is simpler than spot reading, but it is prone to failure with negatives of unusual subject matter or of abnormal negative quality. For example, a print from a negative having a large amount of shadow area will often be underexposed, whereas a large amount of highlight area, such as the sky, will cause the instrument to indicate more exposure than necessary.

Other Controls of Print Contrast

The major contrast characteristics of a print are determined by the combination of negative contrast and the choice of paper contrast grade (or selective-contrast printing filter). Minor changes in contrast can, however, be accomplished by development, reduction, and intensification toning.

Development. Some paper emulsions respond to extended development by continuing to build image-forming densities in the very lightest areas. A development time two to four times longer than normal may be required to achieve any results. The effect is to add just enough density to create a sense of tone in otherwise blank areas, and to increase the density and local contrast of the faintest highlight tones so that they become more easily visible. This process slightly reduces the overall print contrast. It has no visible effect on the darkest tones and little or no effect on mid-range tones. Not all papers will produce improved images with extended development. Some emulsions will only build up chemical fog that grays out the highlights and reduces contrast in the light tones, and may lead to developer stain.

Reduction. A reducer removes silver densities. The faintest densities—in the highlights—will be erased, eliminating fine detail and slightly increasing overall contrast, before any effect is visible in other

The low natural contrast of this subject and the normal development given the film together produced a low-contrast negative. A fairly high-contrast paper was necessary to achieve a full-scale, quality print. A negative that requires an extremely contrasty grade of paper for an adequate print offers no leeway in interpretive printing and presents difficult problems for high-quality reproduction.

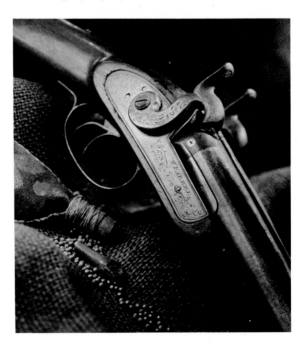

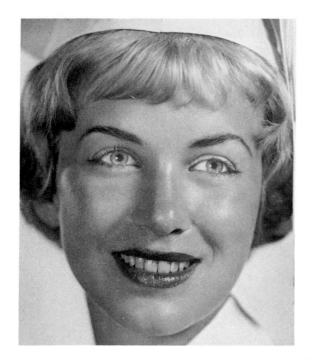 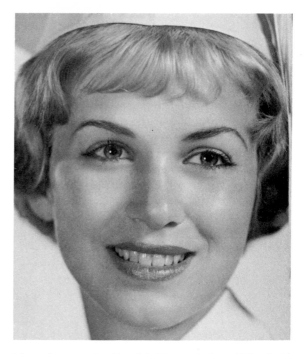

In paper emulsions, as in film emulsions, image contrast is related to spectral sensitivity. (Left) Black-and-white papers primarily have blue-sensitive emulsions, and so cannot translate the image from a color negative into gray tones with the best contrast characteristics. (Right) A paper with a panchromatic emulsion, such as Kodak Panalure paper, can produce high-quality black-and-white prints from a color negative. The image colors are translated into accurate shades of gray with proper contrast relationships.

tones. Thus, a print with slightly grayed highlights (for example, from overexposure or fog) can be made more brilliant by brief treatment, after fixing, in a solution such as Farmer's Reducer. Reducer can also be applied with a brush or a cotton wad to specific areas of a print in order to lighten their tones and thus increase their contrast with adjacent darker tones. (*See:* REDUCTION; BLEACHING.)

Intensification Toning. The usual function of toning is to change significantly the overall color of a print. However, some toners and related solutions can be used to add image density and contrast without causing a color change. The effect is most visible in dark areas, because density is added in proportion to the amounts already present. Visually, the dark tones are deepened slightly, and their local contrast is increased so that details are more clearly distinguishable. A gold chloride solution such as Kodak gold protective solution GP-1 can be used for this

purpose, as well as to increase image permanence, but it is relatively expensive to prepare. Most photographers find it easier, more economical, and equally effective to use Kodak rapid selenium toner at a dilution of one part toner to nine to twelve parts water or other solution. Water-diluted toner can be used as a separate bath after fixing and thorough washing, followed by treatment in a washing aid and further washing. It is simpler to add toner to a solution of washing aid in the regular processing sequence. Treatment takes anywhere from 3 to 10 minutes, depending on the emulsion and on the freshness and concentration of the bath. Too much toner will create pink and red colors in the print. Progress should be inspected at intervals by comparison with a duplicate print that is not being toned. Do not watch the print in the bath continuously; your eyes will adapt to the slow, subtle changes, and toning will proceed too far without your realizing it. Both methods result in prints with larger visual

scales and increased local contrast throughout the entire tonal range. Prints of most subjects are improved by such procedures. (*See:* PROCESSING FOR PERMANENCE; TONING.)

Color Contrast

Contrast in color images is a far more complex matter than in black-and-white photographs. Color is considered to have three attributes, whereas monochrome has only one. The three attributes of color are:

1. Hue.
2. Saturation (chroma).
3. Brightness (value).

While a black-and-white image has contrast only as a result of variations in brightness, a color image has contrast by variations in all three attributes, and in combinations of two or all three.

In color photography, the contrast of the image is primarily determined by the subject contrast, the exposure, and the inherent contrast (in all three attributes) characteristics of the emulsion, provided the illumination is matched with the color balance of the film, and if the film does not distort the colors. Color processing is essentially invariable for each film and paper, and it cannot easily be varied to achieve contrast control in the way that black-and-white development can.

Filters are the primary control in correcting color imbalance and emulsion response. They may be used when the picture is taken and again when prints are made. By absorbing certain colors, they allow others to be recorded and reproduced more distinctly. For example, if a red is contaminated with some blue, red filtration will absorb the blue and allow the red to be reproduced with greater purity.

However, things are not that simple because there are few pure colors in actual photographic subjects. Filtration used to adjust color in one area will also affect other areas where no change may be desired. And white or black mixed with a color cannot be affected by filtration.

Pure colors will have greater vividness and will contrast more sharply with other colors than those that have some contamination. Great visual contrast exists between a saturated color and its opposite (complementary) hue. The simultaneous contrast of colors is similar to the effects of simultaneous brightness contrast in black-and-white. If two colors—especially complementaries or near-complementaries—are present in adjacent equal intensities, a visual interaction or "color vibration" will arise between them because although there is hue difference, there is no contrast (intensity) difference.

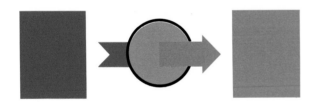

Filtration can remove an unwanted color from light passing through a lens, but all subject areas containing colors that the filter absorbs will be affected. One way to control a single area is to use a filter for burning-in or dodging the area during printing.

(A) The response graph of a color material has separate curves for each of the emulsion layers. Inherent contrast is the average slope of the three straight-line portions. Processing cannot be altered to increase contrast, because layers will respond differently (B), causing changed proportionate densities of image-forming dyes.

A

B

When one color surrounds another, the predominant hue and intensity affect the apparent color and contrast of the other. When one hue dominates an entire image, all other colors lose contrast with one another to the degree that they visually take on something of the dominant hue. Because of these factors and the inflexible nature of color processing, color contrast is determined primarily by the subject, and can be controlled in the final image essentially only by choosing an emulsion that has appropriate inherent contrast characteristics.

• *See also:* BLACK-AND-WHITE FILMS; BLACK-AND-WHITE PRINTING; BLEACHING; BRIGHTNESS; BRIGHTNESS RANGE; CALLIER EFFECT; CHARACTERISTIC CURVE; COLOR FILM PROCESSING; COLOR FILMS; COLOR THEORY; CONTRAST INDEX; DENSITOMETRY; DEVELOPMENT; EXPOSURE; GAMMA; HIGH CONTRAST; INTENSIFICATION; NEGATIVES; PAPERS, PHOTOGRAPHIC; PROCESSING FOR PERMANENCE; REDUCTION; RINGAROUND; TONE REPRODUCTION; TONING; VARIABLE CONTRAST.

Further Reading: Eastman Kodak Co. *Creative Darkroom Techniques,* pub. No. AG-18. Rochester, NY; Eastman Kodak Co., 1975;———. *Color As Seen and Photographed,* pub. No. E-74. Rochester, NY: Eastman Kodak Co., 1978;———. *KODAK Darkroom DATAGUIDE,* pub. No. R-20. Rochester, NY: Eastman Kodak Co., 1976;———. *KODAK Professional Photoguide,* pub. No. R-28. Rochester, NY: Eastman Kodak Co., 1975; Editors of Time-Life Books. *The Print.* New York, NY: Time-Life Books, 1971; Feininger, Andreas. *Darkroom Techniques,* Vol. 2. Englewood Cliffs, NJ: Prentice-Hall, Inc., 1974; Jacobs, Lou, Jr. *How to Use Variable Contrast Papers,* 3rd ed. Garden City, NY: Amphoto, 1970; Marx, Dick. *Printing with Variable Contrast Papers.* Garden City, NY: Amphoto, 1961.

Contrast Index

In black-and-white negatives, contrast is the range of densities produced by a combination of subject luminance ratio (brightness range) and the amount of development given to the negative. The luminance ratio of the subject can not be controlled outdoors and can only be controlled in limited ways in the studio. When the degree of development is controlled, however, one variable factor that affects negative contrast is practically eliminated. By developing negatives to a given value of contrast index, they can be made compatible with a particular printing system. Then, any variations in contrast caused by different subject luminance ratios can be adjusted in printing by the use of different paper contrast grades or, in the case of variable contrast paper, by the use of filters. Controlled negative development helps to produce a uniform standard of print quality, as well as making the printing operation easier and less costly in time and material.

For many years *gamma* was used as a measurement of the contrast obtained by development. However, gamma (the slope of the straight line portion of the characteristic curve of a photographic material) is not always an appropriate basis for selecting proper development times. Gamma often fails as a uniform measurement of development contrast when it does not take into account the fact that the toe of the curve is normally involved in the exposure of a typical continuous-tone negative. Also, D-log E curves for different emulsions have different toe lengths and toe shapes; consequently, negatives developed to a given value of gamma do not yield a sufficiently uniform density range for use in ordinary continuous-tone photography.

To provide a more uniform density range, a form of average gradient, called *contrast index,* was devised by scientists of Kodak's research laboratories. Contrast index is measured over that part of the D-log E curve normally used in correctly exposed continuous-tone negatives. In some applications, however, where the material has a long straight-line region, and the film is exposed so that the image is recorded wholly on the straight line, gamma is still a valid method of measuring density range. In these circumstances, there would be little difference between the values of gamma and contrast index. The difference between the contrast index values and gamma values for two films with different curve shapes is shown by Figures 1 and 2.

Figure 1. This illustration shows the characteristic curves of two films, one with a short toe and one with a long toe. Both films were exposed to an optical image with a log exposure range of 1.74 and developed to the same gamma. Film A, with a short toe, gives a negative density range of 0.98, while film B, with a long toe, gives a density range of 0.84. Figure 2. Both films were developed to the same contrast index and have the same density range.

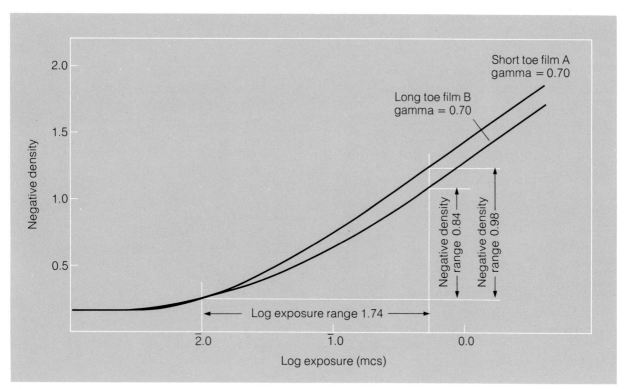

Figure 1.

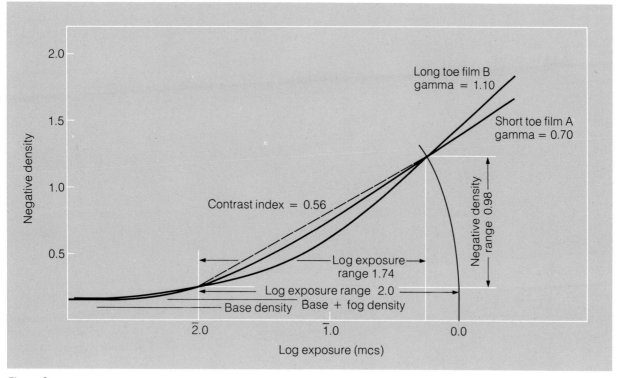

Figure 2.

Contrast Index

Measuring Contrast Index

Contrast index is the slope, or average gradient, of a straight line drawn between two points on the D-log E curve that represent the highest and the lowest useful densities in a continuous-tone black-and-white negative. The numerical value of contrast index is the slope of that straight line, or the tangent of the angle that it makes with the horizontal. '

The two points representing the highest and lowest useful densities are found by describing two arcs from a common center which lies on the base-plus-fog axis. The low-density point is at the point of intersection of an arc having a radius of 0.2 in log exposure units and the D-log E curve. The high-density point is at the point of intersection of an arc having a radius of 2.2 log exposure units and the D-log E curve.

To measure contrast index, you can construct a straight line connecting the appropriate low-density and high-density points on the characteristic curve and determine the slope of the line. Finding the density points is relatively simple with the aid of a strip marked at the edge with intervals of 0.2 and 2.0 log exposure units. (Figure 3 shows a transparent strip; while an opaque strip would work, the transparent one is easier to use.)

First, place the strip along the horizontal axis and make three marks: one at 0, the second at an interval of 0.2 log units from the first, the third at an interval of 2.0 units from the second. Then move the strip up to the characteristic curve and slide it up and down (B) until the three marks line up with (1) the base-plus-fog-density line, (2) a low-density point on the curve, and (3) a high-density point on the curve. All three points will fall exactly on the lines at only one position of the strip. When you have found the correct position, draw a line along the edge (C) and determine the slope of the line.

$$\text{Slope} = \frac{\text{Vertical Distance (Run)}}{\text{Horizontal Distance (Rise)}}$$

This is shown in Figure 3.

Using Contrast Index

In photographic work, it is clearly desirable to develop negatives to a uniform contrast within the

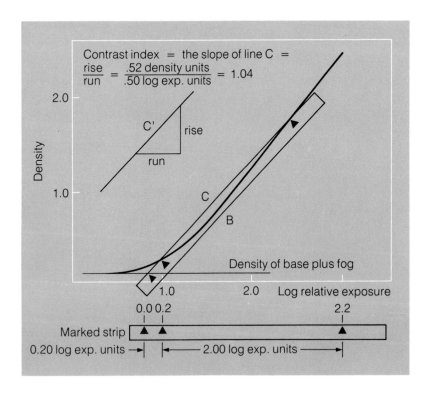

Contrast index = the slope of line C = $\frac{\text{rise}}{\text{run}} = \frac{.52 \text{ density units}}{.50 \text{ log exp. units}} = 1.04$

Figure 3. Construct a straight line connecting the low-density and high-density points on the characteristic curve and determine the slope of the line to measure contrast index. A transparent strip marked at the edge in intervals of 0.2 and 2.0 log exposure units will aid in finding the density points.

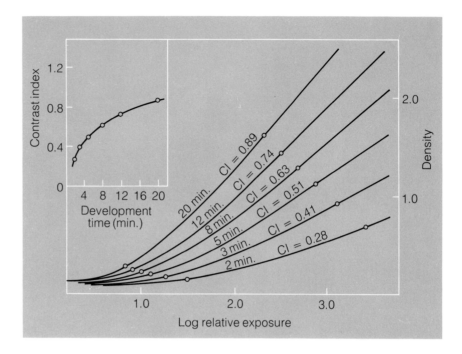

Figure 4. Illustrated here is contrast index as applied to a family of D-log E curves obtained by developing a negative material for a series of development times. The measured values of contrast index are plotted against development time in the upper left-hand corner of the diagram and the resulting curve is used in choosing the development time when the contrast index desired for a certain class of work is known.

limits imposed by subject luminance ratio. Variations due to the latter are nearly always within the range of a printing paper with several different contrast grades. It is rarely necessary for a photographer to plot D-log E curves and then measure contrast index. The time-contrast index curves published in the data sheets for Kodak continuous-tone films can be used. These curves are plotted from a family of D-log E curves obtained by developing the material for a series of increasing times. The measured values of contrast index are then plotted against developing time. A family of D-log E curves and the resulting contrast index curve are shown by Figure 4. Contrast index curves are particularly useful when a number of different films are being used. For example, when a negative developed to a certain contrast index is found to be suitable for a given printing system, all other negatives, regardless of the kind of film or the developer used, can be developed to the same contrast index by referring to the appropriate curves.

It is important to note here that the contrast obtained by development depends on the amount of development, rather than on the developing time alone. To obtain an accurate contrast index, there-fore, other variables, such as developer temperature, the condition of the developer, and the degree of agitation, must be carefully controlled.

Contrast Index and Luminance Range

Generally, in picture-taking, a contrast index of 0.56 has been found to be suitable for normal luminance-range subjects to produce negatives that are printed with diffusion enlargers that have incandescent bulbs. A contrast index of 0.43 has been found to be more suitable for condenser enlargers with opal incandescent bulbs. The most suitable value for a particular printing system can be found by practical tests.

The density range of negatives is usually the key to consistent quality in making prints, and controlling the contrast index is the chief control in obtaining negatives with a consistent density range. The contrast variables that need to be controlled by developing to different contrast indexes are the subject luminance range and camera lens flare.

For different camera lenses, the camera lens-flare level varies from less than 1 percent to over 15 percent and this affects the luminance range of the optical image considerably. A table for estimating lens flare is included in the article CONTRAST.

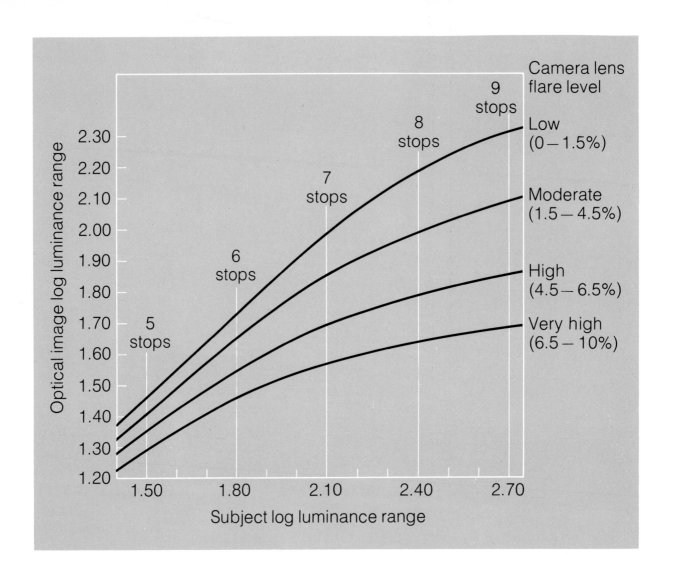

Figure 5. Shown here are subject luminance range–optical image luminance range curves.

Subject luminance range can be measured with a reflection exposure meter, either the averaging or spot type. A diffuse highlight is measured and the exposure calculated. A dark tone that is to be reproduced just lighter than black is also measured, and the exposure calculated. The difference in stops between the two exposures is a measure of the subject luminance range.

The optical image luminance range can then be found by use of the falling graph. (See Figure 5.) A typical seven-stop luminance-range subject imaged with a moderate-flare-level lens can be found to have a log luminance range of about 1.85.

With films that have differently shaped curves, it requires different contrast indexes to produce a given density range with a given optical image lumi-

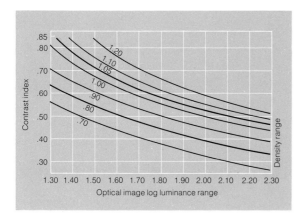

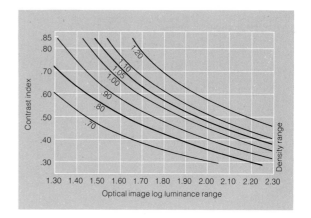

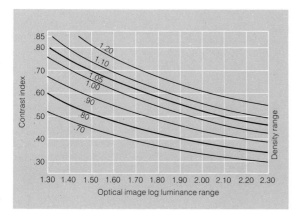

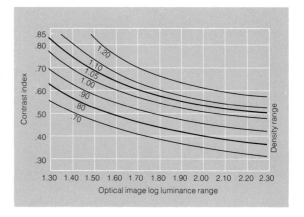

Figures 6 through 9. For films that have different curve shapes, different contrast indexes are required to produce a given density range with a given optical image luminance range. These four graphs represent the four basic curve shapes. (Top left) Average of films with short toe. Kodak roll films: Plus-X pan professional, Royal-X pan, Verichrome pan. Kodak sheet films: Super-XX pan, Royal-X pan. (Top right) Average of films with long toe. Kodak roll film: Tri-X pan professional. Kodak sheet films: Plus-X pan professional, Royal pan, Tri-X pan professional, Tri-X ortho, Ektapan. (Bottom left) Kodak Tri-X pan film (rolls), and (right) Kodak Panatomic-X and Panatomic-X professional films.

nance range. The accompanying four graphs (Figures 6 through 9) represent the four basic curve shapes. These curves can be used to find the contrast index that will produce a desired density range with a known optical image luminance range. As an example, if you want to have a negative density range of 1.05 (typical for a diffusion enlarger) when the optical image log luminance range is 1.85, and the

film used has a short toe characteristic curve, you find that the contrast index needed is about 0.56. With the same conditions, except that you want a density range of 0.80 (typical for condenser enlargers), you find that a contrast index of 0.44 is needed. (It should be noted that when contrast index is changed, the film speed changes. When a film is developed to a contrast index of 0.44, an additional

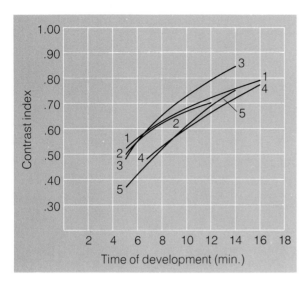

Figure 10. Contrast-index curves, like these for Kodak Plus-X pan film, can be used to find the developing time for a particular film in a particular developer. Times for the following Kodak developers are shown: (1) HC-110 (dilution B), (2) Polydol, (3) D-76, (4) D-76 (1:1), and (5) Microdol-X.

marked in contrast index units. Set up the horizontal axis in developing time with the units in minutes. From the curve given in the data sheet, locate the contrast index value at various development times. As an example, the time and contrast index values for Kodak Tri-X pan film developed in Kodak developer D-76 are as follows:

Time (minutes)	Contrast index
6½	.43
7	.46
8	.51½
9	.56
10	.61
11	.65

Plot these points on the graph and connect the points with a smooth, curved line. This is the solid line in the illustration.

To construct the small-tank curve, first find the percentage difference in time between large- and small-tank processing for the particular film-developer combination. Find this by first taking the recommended times at 20 C (68 F), and subtracting the small-tank time from the large-tank time. Divide this difference by the large-tank time and multiply by 100 to find the percentage difference. In the example shown in Figure 11, the large-tank time is 9 minutes and the small-tank time is 8 minutes. The difference is 1 minute. $1 \div 9 = .11 \times 100 = 11$ percent.

The small-tank curve is drawn at 11 percent less time than the large-tank curve. By using the large-tank times at the various contrast index values found earlier, the arithmetic for constructing the small-tank curve for Tri-X pan film in D-76 developer is as stated in the accompanying table.

Plot these values on the graph paper, and connect the points with a smooth curve. This is the *calculated small-tank, contrast index curve.* While

one-half to one stop exposure is needed to retain adequate shadow detail.)

Contrast Index Curves

Once the contrast index is known, the developing time for the particular film in a particular developer can be found by using a contrast index curve.

A family of contrast index curves for different developers is represented by Figure 10. Similar curves are given in the data sheets for most Kodak continuous-tone black-and-white films. Remember that these curves are based on a developer temperature of 20 C (68 F). To use the curves, select the required contrast index from the vertical column of figures on the left of the graph, and then read the development time needed from the times given just below the base line. These times are based on negatives made under average conditions; if the negatives thus developed are too low in contrast, choose a higher contrast index value. If the contrast is too high, choose a lower value.

Small-Tank Contrast Index Curves

Often the contrast index curves given in the data sheets are for large-tank development with agitation at 1-minute intervals. Most roll film is developed by the small-tank procedure, which produces a different contrast index curve. A small-tank curve can be calculated from the large-tank curve in the following way.

Use a sheet of graph paper to construct the curve. (See Figure 11.) Set up the vertical axis

tude. As a result, falloff in illumination at the edges of the focal plane may cause considerable variation in exposure between the center and the edges of a negative.

Lenses for Copying Colored Originals. In copying colored originals that contain fine detail or fine lines in various colors, and in three-color separation work, you need an apochromatic, or fully color-corrected, lens.

Focal Length of Lenses for Copying. The correct focal length of a lens for copying should be about equal to the diagonal measurement of the negative that you wish to make. If you must use a lens that is not made for use at normal copying distances, however, a lens of relatively longer focal length is preferable. You can then take advantage of the flatter part of the field that exists in the central area of the circle of illumination.

Effect of Flare on Negative Quality. Reflection of light from the internal glass surfaces of the lens and from the interior of the camera spreads uniformly over the film. This flare adds density, similar to fog, to the shadows.

In copying originals that have large areas of heavy shadow, detail is difficult to hold even under the best conditions; for this reason, flare should be kept to the minimum.

Control of Flare. A dusty or poor-quality lens is one of the most common causes of flare. Use a good-quality lens for copying, and keep it clean.

Cameras built specially for copying have a large-section bellows, the interior of which reflects a minimum of light toward the film. Many view cameras, on the other hand, have a tapered bellows little larger than the film size for which they are designed. If a camera of this type is used for copying, some

NEGATIVE DIAGONALS

Size of Negative	Diagonal Size in Inches (approx)	Diagonal Size in Millimetres (approx)
35 mm	1¾	45
2¼" × 2¼"	3¼	80
2¼" × 3¼"	4	100
4" × 5"	6¼	160
5" × 7"	8½	220
8" × 10"	12¾	325
11" × 14"	18	455

For copying work of a general nature, a vertical camera setup such as this, with a reflex hood, is most suitable. The reflex hood permits accurate framing and focusing from a normal working position. Photo courtesy Burke and James, Inc.

light may be reflected onto the film from the interior of the bellows. In this situation, flare can be reduced by using, say, a 5″ × 7″ camera to make 4″ × 5″ copy negatives.

If you copy an original on a large white mount, cover the mount with black paper. Turn off room illumination during exposure of copy negatives, and use a lens hood if the copying lights are not in deep reflectors.

Copyboards

A copyboard for occasional work can be made from a sheet of soft board. The surface should be painted black. It should never be white because that part of the board not covered by the original will reflect too much light into the lens. As a result, the copy negative will lack sufficient contrast and troublesome reflections may be introduced.

Holding the Original in Place. Originals can be held in place with pushpins. However, it is not always permissible to make pinholes in the edges of a picture or a valuable document. Double-sided adhesive tape is an alternative, or you can use a sheet of steel as a copy board and hold the original down with small bar magnets.

In copying with a vertical camera, the problem of holding the original in position is simplified. If the copy is free from curl, you can just place it in the center of the copyboard; nothing is needed to hold it down. If the original does not lie flat, you can hold it down with a sheet of plate glass. The glass must, of course, be clean and free from defects. If the glass is not "water white," you will have to use filtration to counteract its color tinge when making copies on color film.

Copyboard Illumination

One of the most important operations in copying is to get correct illumination over the entire area of the original. Incorrect illumination yields negatives of uneven density, which are difficult to print.

When an original is illuminated uniformly over its whole surface, it does not necessarily follow that a negative from it will be exposed uniformly over its whole surface. Generally, this is not so, particularly when a lens of relatively short focal length is used. The circle of illumination formed by a lens falls off in intensity toward the edges. As a practical matter, this means that the negative gets less exposure at the corners. This situation is improved by using a lens of relatively long focal length so that only the central part of the circle of illumination is used. If you can't use such a lens, however, you must adjust the copyboard illumination to give a little extra light at the corners of the original. The evenness of the focal-plane illumination should be checked on the ground-glass of the camera back. This is best done with a sensitive light meter or the probe of a photometer. Be sure to stop the lens down to the aperture you intend to use before taking the measurements. When the best or most even illumination has been found, mark or record the position of the lights so that you can repeat the conditions when necessary.

Lighting Setup. Small originals, say, up to 8″ × 10″, can be illuminated with two lamps placed about 30 inches from the center of the copyboard and at an angle of 45° to the lens axis. (See the accompanying diagram.) A two-lamp setup, however, gives less light at the top and bottom of the copyboard. For this reason, you should place an oblong original horizontally on the board.

Four lamps, one at each corner of the copyboard, provide a good spread of light that gives a little extra intensity at the corners of the original, where it is generally needed to offset the effect of lens falloff.

Small originals can be illuminated by placing two lamps at an angle of about 45 degrees to the lens axis.

Light Sources for Copying. Ordinary tungsten (3200 K) lamps provide suitable illumination for normal black-and-white copying. Reflector-type bulbs give good results without the need for external reflectors. Use a lens hood with reflector bulbs; their built-in reflectors do not entirely mask the lamp surfaces.

Photolamps (3400 K) can be used for copying, of course, but due to their relatively short life (four to six hours), they are somewhat uneconomical for this work.

Fluorescent Tubes. The diffuse nature of fluorescent lighting makes it particularly suitable when the grain in copies from textured-surface prints must be eliminated. Four tubes, in suitable reflectors, are arranged to form a square, the sides of which are parallel to the edges of the copyboard. The length of the tubes and their distance from the board depend on the size of original to be copied. Since this type of lighting is not easy to adjust, it is most useful when originals do not vary much in size.

Light Sources for Color Copying. Color copy negatives and transparencies made from color prints, colored artwork, or paintings are usually made on films balanced for use with tungsten light having a color temperature of 3200 K. Color slides, however, are often copied or duplicated on copiers that employ electronic flash illumination. In this case, a daylight-type film is used.

The color quality of some light sources can be changed to suit a particular color film by light balancing filters.

Lamp Replacement. When one lamp in, say, a set of four copying lights burns out, a new replacement lamp will usually be brighter than the remaining three. To avoid adjusting the new lamp to get uniform illumination, you can replace all four lamps and then keep the three older ones for future replacements. In copying with color films, it is especially important to follow this procedure, because new lamps have a higher color temperature than those that have been burning for some time. Such variations in color temperature would, of course, be reflected as an uneven color quality over the picture area.

Voltage Fluctuation. Variations in the voltage of electric current also affect the color temperature of the copying lamps and lead to changes in the color balance of color materials. If your voltage varies, consult an electrician or your electric supply company to trace the source of the fluctuation and to find the best method of overcoming the difficulty.

Control of Reflections. Unwanted reflections that originate in several ways are often troublesome in copying. Generally, careful placing of copying lights is sufficient to eliminate normal reflections. However, you should work in subdued room illumination when you are focusing or making the exposure. Cover any large white areas, such as the border of mounts, with black paper. In this way, reflections from the glass in the copyboard are either reduced or eliminated.

The most troublesome reflections are caused by buckled or cracked glossy prints and by the grain in textured-surface originals. Buckled glossy prints can be wetted and redried so that they remain flat. Remember that wetting may remove the original spotting, so that you may need to respot the print before copying. If it is undesirable to wet the print, you can often flatten it in a dry-mounting press. A *little* moisture applied to the back of the print before it is put into the press often helps to remove creases.

The granular appearance of copy negatives from textured-surface originals is more difficult to deal with. Always use four lights to illuminate this type of original: Two lights tend to accentuate a granular surface. Keep the lights as near to the lens axis as is practicable; that is, a little less than the normal 45° angle. When it is possible, prints with textured surfaces may be copied under water with a vertical camera to minimize the copying of the texture. Use of dark-colored or black photographic trays with about a centimetre (a half inch) of water usually proves satisfactory. (This method is likely to remove the spotting.)

Reflection Control with Polarized Light. The most satisfactory way to eliminate unwanted reflections in copying is by use of polarized light. In ordinary photography, a polarizing screen is often placed over the camera lens to subdue reflections. In copying, however, you must put screens over the lights as well as the lens. When the plane of polarization of the lamp screens is at right angles to that of the lens screen, reflections are at the minimum. This 90° position of the screens should be used to subdue surface reflections from glossy prints, reflections in the copyboard cover glass, and granular reflections from textured paper. In copying an oil painting, on

the other hand, it is not usually desirable to remove reflections completely. Brush strokes, which are often characteristic of an artist's technique, can be shown to advantage by crosslighting the original and then subduing reflections by partial polarization.

Adjusting the Polarizing Screens. For the most complete reflection control, the polarizing screens at the lens and lights must be adjusted precisely in relation to each other. If two lights are used, the following adjustment method is recommended.

Place a small, shiny, nonmetallic object, such as a saucer, at the center of the copyboard. Turn on one light only, and rotate the polarizing screen in front of it to the horizontal position (this position is usually indicated by an arrow or some other mark at the edge of the screen). Then rotate the screen on the front of the lens until the reflections from the saucer, as seen on the ground glass, are at a minimum.

Turn out the first light and turn on the second one. Without disturbing the screen at the lens, rotate the screen in front of the second light until the reflections from the saucer are again at a minimum. The lighting setup is then adjusted for the best control of reflections.

Exposure Increase for Polarized Light. A considerable increase in exposure is necessary when polarizing screens are used on both lights and lens. This increase is between 10 and 16 times the normal exposure with the same lights and lens without polarizers. The exact increase in exposure is best determined by a series of tests at various exposures.

Contrast of Pictures Copied with Polarized Light. Because surface reflections are eliminated, copy negatives made with polarized light have contrast that is higher than normal. With black-and-white negatives, this effect is best compensated by a reduction in developing time, say, 25 percent. In color copy negatives, the effect appears as greater color saturation.

Kodak Pola-Lights. Each Kodak pola-light, model 2, is a self-contained unit that consists of a circular Kodak Pola-Screen mounted in a light baffle. The baffle is attached to a hinged bracket, which allows the lamp to be tilted to any desired position. A rigid gooseneck and socket hold a reflector-type floodlamp in the correct position behind the Pola-Screen.

Polarizing screens for use over the lens are available from suppliers of photographic accesso-ries. These screens are mounted in front of the lens so that the screen can be rotated to obtain either total polarization or any degree of polarization that may be required.

Exposing and Processing Copy Negatives

Exposure for copy negatives can be calculated from a known standard exposure, provided that the lighting is not changed and that the processing conditions remain constant.

To determine a standard exposure, make a series of test exposures on the film or films you intend to use. For this test, use typical originals, such as a continuous-tone photographic print of normal depth and contrast or, for line work, an original with black lines on clean, white paper.

From the test series, choose a negative that makes a good reproduction of the original on a normal grade of paper. Make a record of the position of the lights, the reproduction size, the lens aperture, the kind of film, and the exposure time. Other things being equal, the exposure for line originals will be constant. Very dark continuous-tone originals need more exposure; very light ones need less. The amount of this exposure compensation depends on the density of the original. Generally, a dark print will not require more than 100 percent over the standard exposure, and a light print will not require less than 50 percent of the standard exposure.

Exposure compensation for changes in reproduction size (lens extension) can be calculated mathematically or from a table. When filters are used, the necessary increase in exposure can be obtained by multiplying the known exposure by the filter factor given in the appropriate film data sheet.

Use of Exposure Meters in Copying. A photoelectric exposure meter is particularly useful when the copying lights must be moved or changed, or when originals must be photographed on location. Good results can be obtained by measuring the illumination on the copyboard or original, either directly, with an incident-light meter, or indirectly, with a reflected-light meter by taking a reading of a card of known reflectance.

With materials for copying continuous-tone or line originals, the recommended film speeds or exposure indexes can be used directly with incident-light meters held in the plane of the original being copied. The hemispheric light collector on certain incident-

light meters should be replaced by the disk collector for exposure determination in copying. The speeds also apply directly to reflected-light meters when the reading is taken from a surface having a reflectance of 18 percent, such as the gray side of the Kodak neutral test card. In the absence of the proper gray card, a reflected-light reading can be made on a matte-white surface of approximately 90 percent reflectance, such as the back of double-weight, white photographic paper. Compensate for the higher reading by dividing the film speed or exposure index by five and rounding to the nearest figure on the meter calculator.

The indexes for high-contrast materials for line work are intended merely for trial exposure. This is because these materials have inherently short exposure latitude, and because the exposure should be adjusted to the maximum that can be given without causing filling in or veiling the lines.

Exposure Correction for Lens Extension. When the lens extension is longer than the focal length of the lens—as is usually the case in copying—the exposure calculated for an object at infinity must be increased. In other words, the f-number indicated by your calculations is no longer effective.

A simple way to find correct exposure in this situation is to use the effective aperture computer in the KODAK Master Photoguide. Alternatively, you can use the formula given below to find the effective f-number.

$$\frac{\text{Indicated}}{f\text{-number}} \times \frac{\text{Lens extension}}{\text{(lens-to-film distance)}} = \frac{\text{Effective}}{f\text{-number}}$$

To get correct exposure, the effective aperture must be opened up by an amount equal to the difference between the indicated f-number and the effective f-number. For example, when a 10-inch lens has been extended 10 inches beyond the infinity setting, the lens extension is 20 inches. Suppose the calculated exposure for an object at infinity is 4 sec. at $f/16$, and the above formula gives an effective f-number of $f/32$. The correct f-number to use would be $f/8$, or two stops more than the indicated f-number.

Lens Extension Exposure Factors. In some instances, it may be necessary to increase the exposure time to compensate for lens extension. The lens factor is the amount by which the exposure time must be multiplied to get correct exposure. The factor can be calculated from the effective f-number since opening up the lens aperture by one stop doubles the exposure. In the above example, therefore, the factor is 4 and the exposure time required is 16 sec.

The following table gives factors for some typical reproduction sizes.

LENS EXTENSION EXPOSURE FACTORS

Percent of Original Size	25% (¼×)	50% (½×)	100% (same size) (1×)	150% (1½×)	200% (2×)	300% (3×)
Multiply Calculated Exposure by:	1.6	2.2	4.0	6.5	9.0	16.0

Processing Copy Negatives. Black-and-white copy negatives can be processed in trays or tanks. Automatic processors are useful for a high volume of work.

DEVELOPERS FOR COPY NEGATIVES

Kodak Developer	Properties and Uses
D-8	Very high contrast. Line and continuous-tone copying.
D-11	High contrast. Continuous-tone copying.
D-19	Moderately high contrast.
HC-110	Liquid concentrate. General purposes.
D-76	Low activity, moderately fine grain.
DK-50	Medium activity, general purpose.
Polydol	Medium activity, long tank life.
Kodalith	Extremely high contrast. Line work on *Kodalith* films.
Kodalith fine-line	Extremely high contrast. To preserve fine lines on *Kodalith* films.

An enlarged copy (right) from an old snapshot (above) often yields a pleasing result. The large negative size simplifies corrective retouching, if necessary. Some finishing on the print may also be required to improve quality.

Varying Negative Contrast by Development. In some cases, copy negatives on films not specifically designed for copying may yield negatives that are too high in contrast when they are developed for the recommended time. You can reduce negative contrast by shortening the developing time. The developing computer included in the *KODAK Darkroom DATAGUIDE* provides an excellent way to find a suitable developing time for higher or lower contrast with different Kodak film-developer combinations.

Copying Techniques

Photographers are called upon to make copies of many different kinds of originals, and since originals of each kind often vary in character, the following remarks are necessarily of a general nature. They are intended to provide you with a starting point from which you can make adjustments to get the kind of negative you need.

Copying Continuous-Tone Originals. Most originals in this class are photographic prints. However, you will sometimes be asked to reproduce other types of continuous-tone material that require a special technique to get a good copy negative. The following notes will suggest a suitable approach in most situations.

Creased or Wrinkled Prints. A print that shows reflections due to creases or wrinkles can be mounted on a card for copying. If the print is not badly buckled, it can often be flattened in a dry-mounting press. Alternatively, you can wet the print, squeegee it face downward on a sheet of glass, and then make the copy negative through the glass before the print dries. Remember to strip the original from the glass immediately afterward, otherwise it will stick.

Restoring Old or Damaged Pictures. If you are skilled in negative retouching and print finishing, you can undertake this work. If not, farm it out to a specialist.

Stained Prints. As a rule, stains on prints and documents can be made invisible by copying the original on panchromatic film with a filter of the same color as the stain. However, if the stain is a faded, yellow patch within a black image, use a blue filter over the lens so that the stain is rendered as a dark tone.

Daguerreotypes. A daguerreotype is a mercury image on a silvered copper plate. This image is delicate. If the surface is touched with the fingers, a permanent mark will be made.

To control the reflections from the shiny surface of a daguerreotype, hang a black-velvet screen in

front of the camera and cut a hole in the velvet to fit over the lens barrel. In this way, most reflections are eliminated.

Faded Prints. Photographs sometimes fade to a pale yellow image. If this fading is uniform over the whole surface, such prints yield excellent reproductions on a high-contrast, continuous-tone film. A blue-sensitive film, such as Kodak commercial film, is suitable for the majority of faded prints, but if the image is very weak, use Kodak contrast process ortho film (Estar thick base) with a blue filter on the lens.

Ambrotypes. These pictures are sometimes mistaken for daguerreotypes, but they consist of a whitish silver image on a glass plate backed with a black material. If the backing can be removed without damage to the plate, replace it with a piece of glossy photographic paper developed to a jet black.

To copy an ambrotype, use a high-contrast continuous-tone film and develop it to a moderate contrast. If the image is weak, however, you may need to develop for maximum contrast.

Tintypes. These pictures are sometimes called ferrotypes. They are similar to ambrotypes, but the whitish silver image is on a black-lacquered metal plate. Tintypes require a high-contrast continuous-tone film for copying. Dents in the metal backing and scratches on the surface are the main difficulties. Reflections can be minimized in the same way as described for daguerreotypes, but copying with polarized light is the most certain method if defects are serious.

Halftone Originals. Photoengravings showing a dot pattern can be treated as line copy. However, good reproductions for photographic use can be made on high-contrast continuous-tone films.

Oil Paintings. Copy these on panchromatic film. If reflections from the varnished surface or the brush marks are troublesome, use partially polarized light for copying. You can compensate for the extra

An old and damaged picture (left) may be restored through skillfull retouching on a print made from a copy negative (right). Retouching should never be attempted on the original, and should not be undertaken at all without proper understanding of the techniques involved. Restoration by Joseph Valenti.

exposure needed with polarizing screens by using a fast film.

Old paintings often contain very dark shadows. Detail in these areas can usually be improved by giving the negative more exposure and reduced development. Filters can be used to alter the tone rendering when necessary.

In making color copy negatives from oil paintings, the basic technique is the same as for black-and-white. Exposure is critical, and the color quality of the copying illumination must be the same as that for which the film is designed.

Watercolor Paintings. Copy these pictures on panchromatic film. Some watercolors are painted in a high key; they usually need a little less than normal exposure and more development to increase contrast. An example of an original in this class is an architect's impression of a proposed building. This type of picture often contains a color wash that is difficult to hold in a reproduction. Use of an appropriate filter will help to accentuate the wash slightly so that it appears as a pale tone on the print.

Etchings, and Pencil and Crayon Drawings. Although these originals are made up of lines, to copy them as line drawings would result in a harsh reproduction. This type of art is best copied on continuous-tone film of moderately high contrast. Kodak contrast process ortho film (Estar thick base) exposed and developed for medium contrast is excellent for the purpose because it gives good background density but preserves the varying density and thickness of the lines.

Copying Line Originals. A true line original has no intermediate tones between the lines and the background. Consequently, line originals are copied

(Left) This old, faded print was copied on a blue-sensitive film developed for high contrast. The dark area in the center of the picture was caused by a yellow stain on the original print. (Right) To eliminate the yellow stain, a copy negative was made on a contrast process panchromatic film with a yellow filter over the lens.

This old photograph had faded to a pale yellow image. A copy negative made on ordinary film was too flat.

A better result was obtained by making the negative on a blue-sensitive emulsion, Kodak commercial film 6127, developed for maximum contrast.

on film of extremely high contrast, which yields clear lines on a dense background. Kodalith films are designed for this kind of copying. Because these films have a limited exposure latitude, they must be exposed correctly. Overexposure tends to fill in weak or very fine lines, and the result is an imperfect reproduction. Underexposure yields low-contrast negatives that print with a patchy gray background instead of white. Also, an underexposed line negative needs an excessive amount of spotting to remove

pinholes and dust spots. Line-copying films do not always reproduce both broad and fine lines correctly at the same exposure level. In this situation, expose for the fine lines and develop the film in Kodalith fine-line developer.

Although pencil drawings, handwritten manuscripts, etchings, and the like, are made up of lines, they cannot be copied as linework. This is because pencil lines, the strokes in handwriting, and the impression made by an etching plate are not uniform

Copying

(Left) This effect is typical of handwriting copied on high-contrast line film. Some of the letters appear broken and detail in the stamp has been lost. (Right) A copy negative on a high-contrast, continuous-tone film gave a more legible result. Detail in the stamp was also retained.

in density. They contain intermediate tones that would be filled in if copied on line film.

Originals of the type just described are best copied on a high-contrast continuous-tone film, such as Kodak contrast process ortho film (Estar thick base). A degree of contrast that suits the particular original can then be obtained by varying the development time or by using a developer with high or low activity.

Printed Matter. Copy printed matter on any of the films recommended for line copying. If the original is on thin paper, and the printing is on one side only, put a sheet of white card behind it during the exposure. If there is printing on both sides of the original, back it with a sheet of black paper to keep the lettering on the back from showing through.

Drawings. Treat drawings in the same way as printed matter, but if the lines are weak and are smudged or broken by handling or folding, treat them as high-contrast continuous-tone work.

Typewritten Originals. If the lettering is uniform in density, copy as linework. If the lettering is broken—as it may be if the typewriter ribbon was worn or the type was clogged—copy as high-contrast continuous-tone work.

When typewritten sheets are copied for slide projection, do not crowd the material on the slide. The readable limit is a 3¼″ × 5″ sheet with double-spaced lines.

Blueprints. These are best copied on panchromatic film through a red filter—a Kodak Wratten filter No. 25 or 29 is suitable. The red filter absorbs blue light so that the blue background records as black, while the lines remain white.

Handwritten Manuscripts. The strokes in handwriting vary greatly in density and thickness. The writing may be in faint pencil, in black ink, or in colored ink. To preserve legibility, copy handwriting as continuous-tone work. Generally, high-contrast continuous-tone film developed to a moderate contrast is suitable. With colored inks, use panchromatic film and choose a suitable filter from the accompanying table.

In copying pencil writing, avoid a dense black background on the negative. A thin negative printed on a high-contrast paper yields a legible result.

Colored Line Originals. In making black-and-white copies of colored line originals, the problem is to secure contrast between the subject and the background. This can usually be accomplished by means of high-contrast panchromatic film and a filter. If the subject is to be rendered light against a dark background, the filter should transmit the color of the subject and absorb the color of the background. If the subject is to be rendered dark against a light background, the filter should absorb the subject color and transmit the background color.

Filter recommendations are given in the table on the following page.

Checks. Checks, money orders, and the like can be copied on Kodak contrast process pan film (Estar

FILTERS FOR COPYING COLORED LETTERING ON WHITE OR COLORED PAPER ON PANCHROMATIC FILM*

Paper Color	Ink Color	Kodak Wratten Filter No.
White or yellow	Blue	25
White	Red	47
White or yellow	Blue or red	58
White or yellow	Purple	58
Green	Black, blue, or red	58
Blue	Black or red	47
Pink	Black or blue	25

*For filter factors, see film data sheets.

thick base). The ink is usually dark enough to record properly without a filter.

Documents on Yellowed Paper. Yellowed documents printed with black or gray ink require a high-contrast orthochromatic or panchromatic film and a deep-yellow contrast filter, such as a Kodak Wratten filter No. 15. This filter freely transmits the yellow light reflected from the yellowed paper so that the paper records as white, the ink as black.

Faded Manuscripts and Documents. When the ink on a manuscript or document has faded to yellow or brown, best contrast is usually obtained on a non-color-sensitive film. With panchromatic film, a blue filter should be used.

FILM AND FILTER COMBINATIONS FOR COPYING COLORS IN BLACK-AND-WHITE

Color of Original	To Photograph as Black on—			To Photograph as White on—		
	Blue-Sensitive Material	Ortho Material	Panchromatic Material	Blue-Sensitive Material	Ortho Material	Panchromatic Material
	Use These *Kodak Wratten* Filters			Use These *Kodak Wratten* Filters		
Magenta	Not recommended	Yellow (No. 9) Green (No. 58)	Green (No. 58)	None	Blue (No. 47) Magenta (No. 30)	Red (No. 25) Magenta (No. 30) Blue (No. 47)
Red	None	None or Green (No. 58)	Green (No. 58) Blue (No. 47)	Not Recommended	Not Recommended	Red (No. 25)
Yellow	None	Blue (No. 47) Magenta (No. 30)	Blue (No. 47)	Not Recommended	Yellow (No. 9) Green (No. 58)	Yellow (No. 9) Green (No. 58) Red (No. 25)
Green	None	Blue (No. 47) Magenta (No. 30)	Red (No. 25) Blue (No. 47) Magenta (No. 30)	Not Recommended	Yellow (No. 9) Green (No. 58)	Green (No. 58)
Cyan	Not recommended	Not Recommended	Red (No. 25)	None	None or Green (No. 58) Blue (No. 47) Magenta (No. 30)	Green (No. 58) Blue (No. 47)
Blue-Violet	Not recommended	Yellow (No. 9) Orange (No. 16) Green (No. 58)	Green (No. 58) Red (No. 25)	None	Blue (No. 47) Magenta (No. 30)	Blue (No. 47)

NOTE: These are not the only filters which can be used to produce the desired effects. Practical experience will show which variations of the suggested filters can be used with certain hues of the original color.

SUMMARY OF FILMS, DEVELOPERS, AND FILTERS FOR COPYING

Type of Original	*Kodak* Film	*Kodak* Developer	*Kodak Wratten* Filter	Remarks
Continuous-tone black-and-white	Professional copy, commercial, or *Ektapan*	*HC-110* (Dilution D) *DK-50*	None	—
Prints faded to overall yellow	Commercial or contrast process ortho	*D-11, D-19 HC-110* (Dilution B)	None Blue (No. 47)	If original image is faint, develop for high contrast
Black-and-white image with faded yellow patches in black	*Ektapan*	*HC-110 (Dilution B) DK-50*	Blue (No. 47)	—
Black-and-white combined line and continuous-tone	Professional copy	*HC-110* (Dilution B)	None	—
Prints stained with colored material, such as ink or dye	*Ektapan*	*HC-110* (Dilution B) *DK-50 Polydol*	Use filter of same color as the stain	—
Daguerreotypes	Contrast process ortho	*D-11 D-19*	None	Develop for medium contrast
Ambrotypes (collodion positive on black background) Tintype or ferrotype	Contrast process ortho	*D-11 D-19*	None	Develop for medium contrast
Oil paintings (black-and-white prints)	*Ektapan* or *Tri-X* pan professional	*HC-110* (Dilution B) *DK-50 Polydol*	None	—
Watercolor paintings	*Ektapan*	*HC-110* (Dilution B) *D-19*	None	—
Halftone engravings	Contrast process ortho	*D-19 D-11 D-8*	None	Develop for moderately high contrast
Black-and-white line	*Kodalith* ortho, type 3	*Kodalith*	None	—
Black-and-white line with smudged or broken lines	Contrast process ortho	*D-19*		
Handwritten manuscripts	Contrast process ortho	*D-19 D-11*	For blue ink use yellow filter (No. 9)	Develop for medium contrast
Blueprints	Contrast process pan	*D-8 D-11*	Red (No. 25)	Develop for high contrast
Printed matter and drawings with clear black lines	*Kodalith* ortho, type 3	*Kodalith*	None	—
Drawings with smudged or broken lines	Contrast process ortho	*D-19 D-11*	None	Develop for medium contrast
Documents on yellowed paper	Contrast process pan	*D-8*	Yellow (No. 9)	Develop for high contrast

SUMMARY OF FILMS, DEVELOPERS, AND FILTERS FOR COPYING (continued)

Type of Original	*Kodak* Film	*Kodak* Developer	*Kodak Wratten* Filter	Remarks
Documents with faded, yellow writing or printing	Contrast process ortho	*D-8* *D-11*	Blue (No. 47)	Develop for high contrast
Etchings and crayon drawings	Commercial or contrast process ortho	*D-19* *D-11*	None	Develop for medium contrast
Pencil drawings or manuscripts written in pencil	Contrast process ortho or commercial	*HC-110* (Dilution B)	None	Develop for medium-low contrast and print on hard paper
Printed matter and drawings with colored lines	*Kodalith* pan or contrast process pan	*Kodalith* *D-8*	See filter recommendation table	Develop for high contrast
Tapestry and textiles	*Ektapan*	*HC-110* (Dilution B) *DK-50* *D-19*	Usually none	Crosslight if it is desired to show texture of the material
Colored originals to be copied in color	*Ektacolor* ID/copy 5022 or *Ektacolor* internegative	Process C-22 Process C-22 (modified)	See instruction sheet with the film	——
Colored artwork with white background to be copied in color	*Ektacolor* ID/copy 5022 or *Ektacolor* internegative	Process C-22 (modified)	See instruction sheet with the film	——

Copying Combined Line and Continuous-Tone Originals. When an original contains both line and continuous-tone material, separate negatives of the two subjects should be made and combined in printing. Kodak commercial film 6127 or professional copy film 4125 can be used for the continuous-tone negatives; Kodalith ortho film 6556, type 3 or Kodak contrast process ortho film 4154 for the line negatives. The negatives can be cut and spliced together or printed separately with suitable masks.

In copying combined line and continuous-tone originals on the same film, a white background usually prints as a gray tone—an effect often seen on composites of school pictures. You can avoid the gray background on a composite by making low-contrast (flat) fairly dark prints for the paste-up. Then by increasing the contrast of the copy negative, you can restore the continuous-tone pictures to a normal contrast and at the same time increase the background density sufficiently to prevent it from printing through.

• *See also:* ART, PHOTOGRAPHY OF; BLACK-AND-WHITE SLIDES AND TRANSPARENCIES; COPY STAND; DOCUMENT EXAMINATION BY PHOTOGRAPHY; DUPLICATE BLACK-AND-WHITE NEGATIVES; DUPLICATE SLIDES AND TRANSPARENCIES.

Further Reading: Croy, Otto R. *Camera Copying and Reproduction.* Garden City, NY: Amphoto, 1964; Eastman Kodak Co., ed. *Copying,* rev. ed. Rochester, NY: Eastman Kodak Co., 1974.

Copyright

Copyright is that area of the law concerned with the exclusive right of authors, artists, photographers, and others to use and reproduce that which they have created. When one is entitled to such protection under the law, he is said to have a copyright. To the photographer this means that others cannot publish or otherwise reproduce his pictures without first securing his consent. Such a right must be valued very highly. Without it, anyone can reproduce a valuable picture without paying for the privilege.

Who May Copyright

The owner of the copyright is called the copyright *proprietor*. Ordinarily, the photographer, since he or she is the person who "creates" the picture, will be the copyright proprietor. The situation is different, however, when the photographer is hired to make pictures for a customer. Although the photographer in this instance has been held in some jurisdictions to have a restricted ownership in the negatives or plates, it is safe to say that the customer, and not the photographer, is entitled to the copyright.* However, where a photographer takes a picture gratuitously and at his own expense, he owns the negative and photograph outright. Under such circumstances, he alone is the copyright proprietor. Who has the right to copyright can, of course, be changed in any particular instance by an agreement between the parties.

Copyright Infringement

Subject to the doctrine of fair use, a copyrighted photograph may not be copied or reproduced without the copyright owner's permission. A violation of this rule subjects the infringer to suit for damages on copyright infringement.

There is a vast difference, however, between copying a picture and photographing the same subject matter. A copyright on a picture does not prevent another person from independently photographing a similar subject. Another photographer may even take a picture of a subject in exactly the same manner as did the first photographer as long as the second picture has been made independently of the first, and provided the photo was not taken with the idea of duplicating the first one (e.g., same pose, same background, same color scheme, and other features, leading to the conclusion that there was an intent to copy the original).

The Highlights of the New Law† as Summarized in an Announcement from the Copyright Office, Library of Congress

On October 19, 1976, President Gerald R. Ford signed the bill for the general revision of the United States copyright law, which became Public Law 94-553 (90 Stat. 2541). The provisions of the new statute, with particular exceptions, entered into force on January 1, 1978. The new law supersedes the copyright act of 1909, as amended, which remains in force until the new enactment takes effect.

The following are some of the highlights of the new statute:

Single National System. Instead of the present dual system of protecting works under the common law before they are published and under the Federal statute after publication, the new law establishes a single system of statutory protection for all copyrightable works, whether published or unpublished.

Duration of Copyright. For works already under statutory protection, the new law retains the present term of copyright of 28 years from the first publication (or from registration in some cases), renewable by certain persons for a second period of protection, but it increases the length of the second period to 47 years. Copyrights in their first term *must still be renewed* to receive the full new maximum term of 75 years, but copyrights in their second term between December 31, 1976 and December 31, 1977, are automatically extended up to the maximum of 75 years without the need for further renewal.

For works created after January 1, 1978, the new law provides a term lasting for the author's life, plus an additional 50 years after the author's death. For works made for hire, and for anonymous and pseudonymous works, the new term is 75 years from publication or 100 years from creation, whichever is shorter. For unpublished works that are already in existence on January 1, 1978, but are not protected by statutory copyright and have not yet gone into the public domain, the new Act generally provides automatic Federal copyright protection for the same life-plus-50 or 75- to 100-year terms prescribed for new works. Special dates of termination are provided for copyrights in older works of this sort. The new Act does not restore copyright protection for any work that has gone into the public domain.

Termination of Transfers. Under the previous law, after the first term of 28 years, the renewal copyright reverted in certain situations to the author or other specified beneficiaries. The new law drops

*Lumiere v. Pathe Exchange Inc., 275 Fed 428.
†It should be noted that the following is an interpretation of the United States copyright law.

the renewal feature except for works already in their first term of statutory protection when the new law takes effect. Instead, for transfers of rights made by an author or certain of the author's heirs after January 1, 1978, the new Act generally permits the author or certain heirs to terminate the transfer after 35 years by serving notice on the transferee within specified time limits.

For works already under statutory copyright protection, a similar right of termination is provided with respect to transfers covering the newly added years, extending the present maximum term of the copyright from 56 to 75 years. Within certain time limits, an author or specified heirs of the author are generally entitled to file a notice terminating the author's transfers covering any part of the period (usually 19 years) that has now been added to the end of the second term of copyright in a work already under protection when the new law comes into effect.

Government Publications. The new law continues the prohibition in the present law against copyright in "publications of the United States Government" but clarifies its scope by defining works covered by the prohibition as those prepared by an officer or employee of the U.S. Government as part of that person's official duties.

Fair Use. The new law adds a provision to the statute specifically recognizing the principle of "fair use" as a limitation on the exclusive rights of copyright owners, and indicates factors to be considered in determining whether particular uses fall within this category.

Reproduction by Libraries and Archives. In addition to the provision for "fair use," the new law specifies circumstances under which the making or distribution of single copies of works by libraries and archives for noncommercial purposes do not constitute a copyright infringement.

Copyright Royalty Tribunal. The new law creates a Copyright Royalty Tribunal whose purpose will be to determine whether copyright royalty rates, in certain categories where such rates are established in the law, are reasonable and, if not, to adjust them; it will also in certain circumstances determine the distribution of those statutory royalty fees deposited with the Register of Copyrights.

Sound Recordings. The new law retains the provisions added to the present copyright law in 1972, which accord protection against the unauthorized duplication of sound recordings. The new law does not create a performance right for sound recordings as such.

Recording Rights in Music. The new law makes a number of changes in the present system providing compulsory licensing for the recording of music. Among other things, it raises the statutory royalty from the present rate of 2 cents per recording to a rate of 2¾ cents or ½ cent per minute of playing time, whichever amount is larger.

Exempt Performances. The new law removes the present general exemption of public performance of nondramatic literary and musical works where the performance is not "for profit." Instead, it provides several specific exemptions for certain types of nonprofit uses, including performances in classrooms and instructional broadcasting. The law also gives broadcasting organizations a limited privilege of making what is termed "ephemeral recordings" of their broadcasts.

Public Broadcasting. Under the new Act, noncommercial transmissions by public broadcasters of music and graphic works will be subject to a form of compulsory licensing under terms and rates prescribed by the Copyright Royalty Tribunal.

Jukebox Exemption. The new law removes the present exemption for performances of copyrighted music by jukeboxes. It will substitute a system of compulsory licenses based upon the payment by jukebox operators of an annual royalty fee to the Register of Copyrights for later distribution by the Copyright Royalty Tribunal to the copyright owners.

Cable Television. The new law provides for the payment, under a system of compulsory licensing, of certain royalties for the secondary transmission of copyrighted works on cable television systems (CATV). The amounts are to be paid to the Register of Copyrights for later distribution to the copyright owners by the Copyright Royalty Tribunal.

Notice of Copyright. The old law required, as a mandatory condition of copyright protection, that the published copies of a work bear a copyright notice. The new enactment calls for a notice on published copies, but omission or errors will not immediately result in forfeiture of the copyright, and can be corrected within certain time limits. Innocent infringers misled by the omission or error will be shielded from liability.

Deposit and Registration. As under the present law, registration will not be a condition of copyright protection but will be a prerequisite to an infringement suit. Subject to certain exceptions, the remedies of statutory damages and attorney's fees will not be available for infringements occurring before registration. Copies or phonorecords of works published with the notice of copyright that are not registered are required to be deposited for the collections of the Library of Congress, not as a condition of copyright protection, but under provisions of the law making the copyright owner subject to certain penalties for failure to deposit after a demand by the Register of Copyrights.

Manufacturing Clause. Certain works must now be manufactured in the United States to have copyright protection here. The new Act would terminate this requirement completely after July 1, 1982. For the period between January 1, 1978 and July 1, 1982, it makes several modifications that narrow the coverage of the manufacturing clause, will permit the importation of 2,000 copies manufactured abroad instead of the present limit of 1,500 copies, and will equate manufacture in Canada with manufacture in the United States.

Excerpts from the New Copyright Law

The actual text of some sections of the new law with which photographers should be familiar are as follows:

§106 Exclusive rights in copyrighted works. Subject to sections 107 through 118, the owner of copyright under this title has the exclusive rights to do and to authorize any of the following:

1. To reproduce the copyrighted work in copies or phonorecords.
2. To prepare derivative works based upon the copyrighted work.
3. To distribute copies or phonorecords of the copyrighted work to the public by sale or other transfer of ownership, or by rental, lease, or lending.
4. In the case of literary, musical, dramatic, and choreographic works, pantomimes, and motion pictures and other audiovisual works, to perform the copyrighted work publicly.
5. In the case of literary, musical, dramatic, and choreographic works, pantomimes, and pictorial, graphic, or sculptural works, including the individual images of a motion picture or other audiovisual work, to display the copyrighted work publicly.

§107 Limitations on exclusive rights: Fair use. Not withstanding the provisions of section 106, the fair use of a copyrighted work, including such use by reproduction in copies or phonorecords or by any other means specified by that section, for purposes such as criticism, comment, news reporting, teaching (including multiple copies for classroom use), scholarship, or research, is not an infringement of copyright. In determining whether the use made of a work in any particular case is a fair use, the factors to be considered shall include:

1. The purpose and character of the use, including whether such use is of a commercial nature or is for nonprofit educational purposes;
2. The nature of the copyrighted work;
3. The amount and substantiality of the portion used in relation to the copyrighted work as a whole; and
4. The effect of the use upon the potential market for or value of the copyrighted work.

This publication is designed to provide accurate and authoritative information in regard to the subject matter covered. It is sold with the understanding that the publisher is not engaged in rendering legal, accounting or other professional service. If legal advice or other expert assistance is required, the services of a competent professional person should be sought.

—From a Declaration of Principles
jointly adopted by a Committee of the
American Bar Association and a
Committee of Publishers and
Associations.

• *See also:* BUSINESS METHODS IN PHOTOGRAPHY.

Further Reading: Cavallo, Robert M., and Stuart Kahan. *Photography: What's the Law?* New York, NY: Crown Publishers, 1976; Chernoff, George, and Hershel B. Sarbin. *Photography and the Law,* 5th ed. Garden City, NY: Amphoto, 1977.

Copy Stand

Copy stands for use with 35 mm cameras are obtainable from most camera stores. They are useful for amateur photographers who occasionally need a few copy negatives, and also for small microfilming jobs or similar work. This kind of stand is usually an upright column mounted on a copyboard. The camera is attached by means of its tripod socket to an arm-and-collar assembly, which slides up and down the column. A pair of lamps to illuminate the original are also mounted on the column at a suitable distance from the copyboard. Some stands can be disassembled and carried in a case so that copying can be done anywhere. You can also make a simple stand. (See the accompanying illustration.)

A 35 mm single-lens reflex is the most suitable camera for use on a small copy stand. The type of camera that can be fitted with a ground-glass focusing screen is the most convenient because the image can be brought to size and focused visually.

If you use a rangefinder-type camera, you cannot place the image correctly with the normal viewfinder. This is because the camera lens and the viewfinder lens do not have the same field of view in close-up work. However, the image can be placed and focused by opening the camera back and placing a piece of fine ground glass, smooth side up, in the position normally occupied by the film. Set the shutter for a time (T) exposure and open the lens. Darken the room, and then you can see the image clearly enough to focus it.

A Simple Wooden Copy Stand

The simple copy stand shown in the accompanying illustration is used to hold a 35 mm or a lightweight roll-film camera when photographing materials by reflected light. To construct the stand, you will need:

1 piece plywood, ¾″ × 24″ × 24″
4 flathead bolts, ¼-20 × 2″
1 carriage bolt, ¼-20 × 4″
5 washers, ¼″ I.D.
5 wing nuts, ¼-20
glue
finishing nails, 4d
lacquer or enamel, matte black

The construction of a simple wood copy stand is illustrated here. Code letters guide assembly.

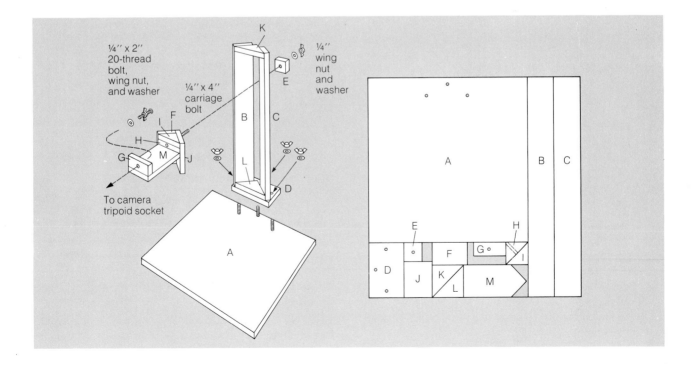

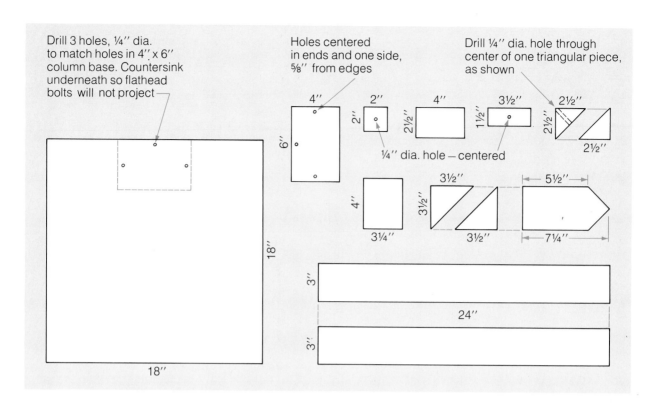

Drill 3 holes, ¼" dia. to match holes in 4" x 6" column base. Countersink underneath so flathead bolts will not project

Holes centered in ends and one side, ⅝" from edges

Drill ¼" dia. hole through center of one triangular piece, as shown

¼" dia. hole — centered

The dimensions of the pieces of plywood to be used and the holes to be drilled when building the copy stand are shown in this illustration.

Constructing the Stand

All of the wooden parts can be cut from a single piece of plywood, as indicated in the accompanying illustration. The dimensions given are not critical and can all be reduced by the width of the saw cut. Right-angle cuts should be as accurate as possible so that the camera will be properly positioned in relation to the reflection copy.

For rigidity, glue and nail all permanent joints. If you do not have to disassemble the stand for storage or portability, you can glue and nail the camera-support column to the base and thereby eliminate the need for the three bolts, wing nuts, and washers.

Paint the entire stand matte black to minimize light reflections.

Crabtree, John I.

(Born 1891)
Research chemist for Eastman Kodak Company

John I. Crabtree, a photographic scientist, was employed by the Eastman Kodak Company for 43 years, from 1913 to 1957.

On August 15, 1913, Crabtree was first employed as a research chemist in the Kodak Research Laboratories. He founded the department of photographic chemistry in 1913. From 1916 to 1928 he was in charge of the motion-picture film developing department. In 1929, he was appointed assistant superintendent of the Kodak Research Laboratories in charge of the photographic chemistry department, and, in 1955, he was appointed assistant divi-

Copy Stand

sion head, applied photography division, in charge of photographic chemistry. This was the title he held until his retirement.

After joining the Research Laboratories at the Eastman Kodak Company, Crabtree conducted and supervised an extensive program of research in many fields of photographic chemistry and motion-picture processing.

He has published the results of many of his researches. All told, he has been author and co-author of some 150 papers and has been granted about 35 United States patents. His articles have been published in many countries and several have been reprinted in handbooks. He co-authored two books with G. E. Matthews, *Herstellung Photographischer Losüngen* (W. Knapp, Halle, Germany, 1929) and *Photographic Chemicals and Solutions* (American Photographic Publishing Co., Boston, 1939). A number of his papers have proven so useful that they have been revised and reprinted many times. For example, his article "Stains on Negatives and Prints" has been in constant demand for 35 years.

Many of the proprietary packaged chemicals sold by Eastman Kodak Company are based on formulas worked out under Crabtree's supervision. In the field of photographic equipment, he has shown leadership in fostering basic, practical design for application of photographic chemical and motion-picture processes.

Crabtree is a Fellow of the Royal Photographic Society of Great Britain, of the Society of Motion Picture and Television Engineers, of the American Association for the Advancement of Science, and of the Photographic Society of America, besides holding membership in several other technical societies. He was President of the Society of Motion Picture Engineers in 1930–31 and assisted in the establishment of its monthly journal. He was a member of the Board of Governors of that society for many years.

Numerous honors have been awarded Crabtree, including the Progress Medal of the Société Française de Photographie (jointly with Dr. M. L. Dundon), the Journal Award of the Society of Motion Picture Engineers (jointly with G. T. Eaton and L. E. Muehler), the Henderson Award of the Royal Photographic Society, the Progress Medal of the Society of Motion Picture and Television Engineers, and the Journal Award of the Photographic Society of America.

Crime Photography

The need for photography in law enforcement has long been established. As a tool for investigation, for identification, and for record-keeping, photography provides a visual link with oral and written testi-

Photography is an invaluable tool in the investigation of criminal activities. Used in conjunction with other testimony, photographs record and describe scenes and situations with greater precision, accuracy, and detail than would be possible through oral or written description alone. This photograph of a murder scene, taken after removal of the body, shows the relationship of objects in a manner difficult to otherwise describe. It also stands as a permanent record of the scene.

mony. It can record the visible evidence of a crime. Special techniques employing infrared, ultraviolet, and x-ray radiation can record evidence that is not visible. Photographic evidence can be stored indefinitely and retrieved when needed. In short, there is no other process that can find, record, and recall criminal evidence as well as photography.

Few police agencies do without photography completely. Those who do not have their own laboratory, equipment, or trained personnel frequently hire a professional photographer as the occasion arises, or rely on a nearby city or county police agency for assistance. Crime photography is not confined to police work. Insurance companies constantly conduct investigations and collect evidence where they suspect fraudulent claims, arson, or suspicious deaths. Large businesses maintain security and investigation staffs to protect the corporation from internal crime, as well as crime aimed at it from the outside. Independent security and investigatory agencies maintain photographic staffs to support their investigators.

Functions and Quality of Crime and Police Photographs

The major functions of crime photography are:

1. To provide coverage of every accident or investigation that requires it.
2. To produce pictures that are relevant to an investigation.
3. To present credible testimony when it is necessary to bring the photographs before the court.
4. To make identification photographs routinely.

Photographs identify people, places, and things. They record the condition or state of things at the time the pictures were taken. Photographs tell something about the objects photographed or the scene of a crime or an accident that is helpful in clarifying the issues when testimony is given to a jury.

Photographs by themselves are not substantive evidence. All photographs accepted in court must be

Photographs, when used in court as evidence, must record a situation as it was originally found; nothing must be moved or otherwise altered. When arson is suspected, a photograph such as this, showing burn and char characteristics, debris, and containers can help establish evidence, provided a reliable witness can testify that the photograph is completely accurate.

attested to by someone who saw the scene and can truthfully state, under oath, that the photograph accurately represents what he or she saw when he or she arrived at the scene. To be legally meaningful and useful, photographs must portray a situation as it would be observed by anyone who stood in the same position as the camera and viewed the scene from where the photograph was made.

Because the photographer may not be called to testify, it is essential that all photographic procedures conform to accepted standards. In ordinary photography, only the finished print is of interest; in legal work, all procedures are subject to review and inspection and in some cases may be attested to in court. (*See:* TESTIFYING IN COURT.)

All negatives, prints, and slides must be of good technical quality—and excellent quality if possible. If a significant amount of corrective work was needed to make an acceptable print from a poor negative, the photograph may be challenged in court and ruled unacceptable as evidence. The probable grounds would be that the print does not straightforwardly reproduce what the camera recorded, and that the efforts to improve the picture have introduced distortions of the reality of the scene. It would not be necessary to prove any distortions; the likelihood that they exist could be sufficient grounds for rejecting the picture. This is a critical matter, especially for the photographer who is not routinely involved in crime photography as a career. There is no need for pictures with artistic quality at the expense of accuracy. Straightforward, clearly understandable, true representations of the subject have the greatest value.

It is very important that tone or color relationships be as accurately reproduced as possible. This is primarily a matter of adjusting exposure so that normal processing can be used. With subjects of average brightness and contrast, normal exposure is called for. But a blond head against a crumpled white bedsheet might require less exposure than an average subject. Conversely, black, charred wood in an area where arson is suspected could require at least two and possibly three more stops than an average subject in order to obtain shadow detail.

Psychological Factors

In addition to being an honest and straightforward representation of the subject, a photograph must look natural. The sizes and shapes of elements in the picture must be in the proper scale and proportion, and so must the apparent distances between elements. This is called perspective.

Natural perspective in a photograph is the recreation, without noticeable distortion, of a three-dimensional scene. *It is the most important single element in crime photography,* yet it is the major cause for rejection of photographs in many courts.

The impression of perspective in a photograph is dependent on three factors: focal length of the camera lens, degree of enlargement of the print, and viewing distance. (This is explained fully in the article PERSPECTIVE; perspective considerations in viewing projected slides and movies are also discussed.) For most work, it is sufficient to know that the normal viewing distance of material held in the hand, as a print would be, is about 380 millimetres (15 inches). To find the proper degree of enlargement to make a print look normal, divide that distance by the lens focal length in millimetres (or inches).

For example, with a 50 mm (2-inch) lens: 380 ÷ 50 = 7.6 (or 15 ÷ 2 = 7.5); an enlargement of 7.5× is required. Or, if a 125 mm (5-inch) lens is used, a 3× enlargement would produce natural-looking perspective.

Surveillance photos, made with very long focal-length lenses, are ideal for identification purposes. These three photos demonstrate the field of view for lenses mounted on a 35 mm camera; the girl in the car is 300 feet from the camera. (Near right) Photo made with 85 mm lens. (Center) Photo made with 180 mm lens. (Far right) Photo made with 300 mm lens. Note, however, that the space between distant objects seems increasingly compressed as the lens focal length increases.

This simple rule applies to all camera lenses. It is of special importance when a wide-angle lens or a telephoto lens is used. When improperly viewed, a print from a wide-angle lens tends to increase the depth between objects in a scene, and a print from a telephoto lens tends to compress the depth between objects in a scene.

There are exceptions to this rule. Two-dimensional subjects, such as checks and fingerprints on a flat surface, can be photographed head-on with any lens and viewed at any distance without danger of distortion. However, if the picture cannot be taken head-on, shapes and the spacing between elements may be distorted and—especially in close-ups—part of the subject may be thrown out of focus. One solution is to use a camera equipped with lens board and back movements to adjust the placement of focus and to correct distortion. (*See:* CAMERA MOVEMENTS; VIEW CAMERA.)

Surveillance photographs, which are used primarily for establishing identification, made with extremely long-focal-length lenses cannot be viewed in proper perspective for the same reason that the original subject could not be seen without optical magnification.

Another subject allied with perspective is the camera height above ground. In order to avoid misrepresentation of fact, all scenes should be photographed at average eye level whenever possible.

Basic Camera Equipment

Most departments and investigators should consider standardizing on the 35 mm film size and going to larger equipment only where they have special needs. There may well never be any need to use larger film sizes. Any consideration of the 35 mm film size should also include 126-size cartridge-load films (for Kodak Instamatic ® cameras), which have the same width as 35 mm films and can be processed in the same equipment.

Versatile 35 mm or 126-cartridge-load cameras with suitable flash equipment can (with proper processing) produce negatives of crime or accident scenes under virtually any conditions. Enlargements of these negatives to 8″ × 10″ for courtroom presentation are seldom distinguishable from those made from 4″ × 5″ negatives. Compact, interchangeable lenses increase the utility of the 35 mm camera. Special-purpose lenses, such as macro lenses, can also be added as the skills of the photographer increase.

If there is a definite need for a larger format, it is not necessary to go to the bulky and cumbersome 4″ × 5″ press camera. Roll-film cameras with a 2¼″ × 2¾″ format combine economy with rapid and versatile operation. The negative is of ample size to give a high-quality enlargement. These cameras accept interchangeable lenses, and most have leaf shutters that synchronize with flash at all speeds. Rapid film change is made possible in many models by use of preloaded roll-film camera backs. Sheet film or 70 mm film backs can also be used on many of the cameras.

A twin-lens reflex camera produces a 2¼″ × 2¼″ square negative. Such a camera is easy to handle and relatively inexpensive. These cameras have between-the-lens shutters that synchronize with flash at all speeds. Only in more expensive cameras of this type can the lenses be interchanged, and it is difficult to use them for precisely framed close-ups. Single-lens reflex cameras that produce a 2¼″ × 2¼″ negative do have interchangeable lenses,

Crime Photography

and are quite versatile. Most such cameras are relatively expensive and would not usually be considered when acquiring basic equipment.

The square format of the 2¼″ × 2¼″ negative may seem less acceptable than a rectangle because of the resulting square print when the full frame is enlarged. The objection is aesthetic, not legal. The square format can be a positive advantage: Enlarging the negative on 8″ × 10″ paper with a uniform border on three sides leaves a wide fourth margin for identification notes, punching or stapling, and attachment of original negatives or contact prints. The same approach can be used in printing 126-size negatives, which are also square. When it is not required that the full negative be enlarged, the square negative can be printed to an appropriate vertical or horizontal format.

Examples of Basic Camera Equipment. The following basic equipment may be used for crime photography:

> Camera—35 mm single-lens reflex or 2¼″ × 2¼″ twin-lens reflex.
> Lenses. For single-lens reflex: standard lens, 50 mm; wide-angle lens, 35 mm; telephoto lens, 135 mm. For twin-lens reflex: standard lens, 80 mm.
> Lens hood.
> Filters.
> Tripod.
> Electronic flash unit (at least 3000 beam-candlepower-seconds rating).

Flash bracket, flash cords, etc.
> Kodak Ektagraphic visualmaker, model 2 (for close-ups with Kodak Instamatic cameras) or accessory bellows or extension tubes (for close-ups with other cameras).
> Camera for ID—35 mm with longer-than-normal lens (about 85–90 mm).
> Electronic flash units (two 500-BCPS for ID setup).
> Kodak Instamatic cameras of the "X" series (126 film size).
> Magicubes (flash for above).

Supplementary Picture-Taking Equipment

In addition to the basic camera for overall on-scene coverage, special equipment based on the 35 mm film size will increase the efficiency of the photographer. Accessories such as a bellows, or extension tubes or rings may be valuable for close-ups. They are not required if the basic equipment includes at least one macro-focusing lens.

For 126-size film, there is a completely self-contained, close-up camera unit. The Kodak Ektagraphic visualmaker, model 2, can produce moderate or extreme close-ups of flat or three-dimensional objects on horizontal or vertical surfaces. This unit includes a 126-cartridge-loading Kodak Instamatic X-35 camera, a 3″ × 3″ copy stand and an 8″ × 8″ copy stand (both equipped with built-in close-up lenses and flash reflectors), and a pistol grip for hand-held close-ups. With this close-up camera, the

Crime Photography

Carefully made close-ups can be of great assistance in analyzing how a crime was committed and exactly what occurred. They may also be used later to confirm identification of other objects, and as evidence in court. (Left) An officer photographs a strip of auto trim using the Kodak Ektagraphic Visualmaker. The evidence will be used in a hit-and-run investigation. (Right) Shown is a full-frame enlargement of the negative produced by the visualmaker.

photographer can make pictures of small bits of physical evidence, copies of forged documents, record shots of fingerprints before they are lifted by other means, or any investigation where a close-up photograph would help to give more complete understanding of the evidence.

In addition to basic camera equipment, a photographer will need supplementary lighting equipment, a sturdy tripod, camera filters, and possibly, a close-up lens attachment. These are basic requirements. Other equipment can be added to the kit as the photographer increases his or her skill and perceives the need for further accessories.

An essential addition to the camera is good flash equipment. This should include either a battery-powered flash holder for bulbs or an electronic flash unit with power pack. Flashbulbs yield the greatest light output for the size and weight of the equipment. They do, of course, also require changing the bulb after each shot and carrying a supply of bulbs. An electronic flash unit is far more practical and convenient. It can provide all of the light usually needed for police work. The units are reliable and

there are no expendable bulbs. In addition, most units provide a means for monitoring the state of the battery. This is vital to a photographer who *must* return with pictures, no matter what the conditions. Whatever flash equipment is used, batteries, connecting cords, plugs, and contacts must be maintained constantly. In addition to the basic unit, one or more extension or "slave" units will provide the additional light that may be needed for night auto accidents, arson investigations, or other extended, dark subjects.

Color Photography

The trend in crime photography is to the use of color photographs because they represent the subject more accurately and more realistically than black-and-white. With new, faster color films available in inexpensive 35 mm size, acceptable color photographs can be made under all conditions for little more than the cost of black-and-white.

Most people—including judges and jurors—normally see their surroundings in color. Based on this simple premise, color photography has become completely acceptable for courtroom use. Color pic-

Crime Photography

tures convey to judge and jury a more accurate representation of the facts.

Equally important, color is vital to accurate identification: hair color, skin color, color of eyes, and, in some cases, color of clothing or automobiles.

The ultimate purpose of virtually all police photography is to produce a fair and accurate record of the facts. Without color, the record cannot be wholly realistic or complete. Consequently, more and more agencies use color film for identification, accident, and evidence pictures, reserving black-and-white for those situations where it is adequate —such as copying signatures and documents or photographing fingerprints.

An important consideration is the versatility of color negative film. A color negative can be used to make contact or enlarged prints in either color or black-and-white. If projection transparencies are required, for courtroom use for example, they can be made from the negative by using a film such as Kodak Ektacolor slide film. Color negative films have speeds as high as ASA 400. As a result, these kinds of film can meet virtually all requirements for color photography.

Color photographs may be vital to accurate identification of suspects and evidence. This photo of a pair of paint chips shows how well surface color and layer sequence match up. Black-and-white film would have made the identification extremely difficult.

Flame color may vary considerably depending on the causative material and type of fire. Color photographs are essential for recording such variations, which may reveal arson.

Techniques of Crime Photography

The following sections describe various aspects of identification photography, photographing specific crimes, preparing court exhibits, and using motion pictures or video recordings. There are separate articles on fire and arson, fingerprint, surveillance, and traffic accident photography. Many of the photographic techniques of use in crime investigation are explained in more technical articles, such as CLOSE-UP PHOTOGRAPHY and ULTRAVIOLET AND FLUORESCENCE PHOTOGRAPHY. The most important related articles are listed at the end of this article.

Identification Photography. An identification photograph must serve to identify the subject beyond any reasonable doubt. The photographer is not concerned with producing a flattering picture; on the contrary, he or she must reproduce every freckle, mole, scar, and blemish that might aid in identifying the subject. Close-ups of head and shoulders—so-called "mug shots"—taken with generally flat front-lighting will accomplish this.

Cameras. Several identification cameras are available that use medium- or large-format film. However, other cameras can be adapted for identification photography with a sliding back that is used in order to obtain two views, front and profile, on one piece of film.

Color photography has influenced the use of 35 mm cameras in making not only mug shots, but other evidence photographs where the final photograph can be projected for viewing. Several police agencies use the split-frame, 35 mm-size picture, which means that both the front and profile view can be made in the standard 24 × 36 mm area of the 35 mm film. Each view is 18 × 24 mm, thus using the whole 24 × 36 mm area. The split-frame negatives are enlarged to 3″ × 5″ and filed in the standard 3″ × 5″ file card system.

Lighting. In identification work, it is very important to standardize all photographic procedures. Changing the lighting arrangements, for example, can produce markedly different facial contours. A standard lighting arrangement should be selected for all identification photographs. In this way, lighting, image size, and exposure can be fixed for standard poses with a great saving of time. Thus the operation can easily be a routine procedure in exposing, developing, and printing the negatives. It is also essential to use a background that is neutral gray or a cool color such as light blue or a pastel green.

A Simple Identification Setup. To produce professional results without the expense of a commercial ID camera, a 35 mm camera and two properly placed electronic flash units will serve as well. Most small departments do not have a need for highly

FILM SIZES FOR IDENTIFICATION PHOTOGRAPHS

Film Size	Picture Size	Recommended Lens Focal Length (For good portrait perspective)
35 mm	18 × 24 mm (split frame)	45–50 mm
35 mm or 126	24 × 36 mm	85–90 mm
70 mm	36 × 48 mm (split frame)	90 mm
70 mm	48 × 72 mm	127 mm
2¼″ × 3¼″	2¼″ × 3¼″	6 in.
4″ × 5″	2¼″ × 4″ (split frame)	7 in.
4″ × 5″	4″ × 5″	10 in.

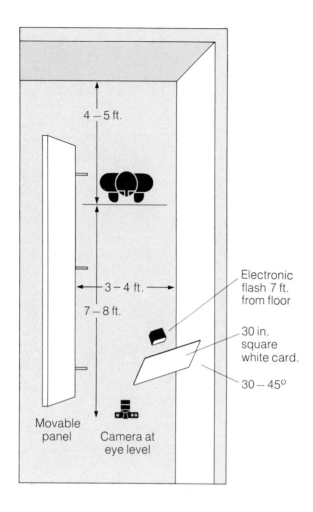

4 – 5 ft.

3 – 4 ft.

7 – 8 ft.

Electronic
flash 7 ft.
from floor

30 in.
square
white card.

30 – 45°

Movable
panel

Camera at
eye level

*In an ID studio, the light from one electronic flash unit can be
bounced from a white card and the walls of a white-painted
"tunnel" to give shadowless photographs. The corner of a
room can be used to construct a studio such as this.*

mechanized cameras capable of using long rolls of
film. In fact, where only a few bookings are pro-
cessed each day, or over a period of a few days, a
short roll of film is more desirable. These can be
made by using bulk rolls of 35 mm film and reusable
magazines that can be loaded with lengths for any
number (up to 36) of exposures.

Shown in the accompanying diagram is the lay-
out for a simple, yet effective, setup for production
of ID photographs. The elements required for the
setup include:

1. A 35 mm or 126-cartridge-loading
 camera.
2. A sturdy tripod or camera stand.
3. One or two electronic flash units.
4. A suitable background.

With sufficient light, the camera lens can be
stopped down to about $f/8$ to get good depth of field.
While the normal, fixed lens on an inexpensive 35
mm or 126-cartridge camera is usually adequate to
provide sharp pictures, a longer focal-length lens on
an interchangeable-lens camera will give better per-
spective when the head fills the full negative area.
When the camera is closer to the subject than 8 to
10 feet, there is some tendency for the facial features
closest to the lens to look bulgy in the photograph.
Fill the full frame of a 35 mm or 126-size negative
by using an 85 or 90 mm lens on an interchangeable-
lens camera.

Specific Crimes. The following suggestions for
photographing the more common types of crime are

*Mug shots usually include identifying data on a
board either hung around the subject's neck or
supported on a stand adjusted to chest height.*

Crime Photography

A simple setup using two incandescent lamps gives good lighting for identification photographs. The lamps should be 45 degrees to the left and right of the subject, one at eye level, the other about 18 inches higher. A vertical scale behind a subject indicates his or her height.

by no means comprehensive. Each crime will have individual features that should be photographed. Keep in mind the nature of the offense and try to show clearly those features which aid in establishing the elements of the offense.

Burglary and Vandalism. From a photographic viewpoint, burglary and vandalism can be treated alike. The following are examples of subject matter to photograph in a typical burglary or vandalism:

1. General views of the exterior of the building.
2. Point of break or entry. These should be photographed in such a manner that the marks of force will be shown clearly —usually a long view followed by a close-up to show detail.
3. Point of exit.
4. Conditions of rooms.
5. Articles left at the scene—often burglar's tools.
6. Trace evidence, such as burnt matches and cigarette butts.
7. Tool marks and impressions of shoes or tires.
8. Fingerprints and footprints as well as articles on which these prints may be found.
9. Area from which valuable articles were removed, such as from a wall safe, desk, etc.

Homicide. Homicide has so many forms that it is best treated by categories. However, from a photographic viewpoint, many factors are common to all. The photographs should set the scene, provide information concerning the manner of death, and indicate whether the crime was connected to a burglary or deliberate homicide. The crime scene should be photographed from every direction with plenty of close-ups to aid the investigator in reconstructing the crime.

Manner of death. To help explain how a crime took place, show from several angles not only the whole scene but all possible elements of the scene.

In an indoor scene, these pictures might include:

1. The room or area in which the body was found.

Crime Photography

2. The adjoining rooms, exterior of the house or surrounding area, visibility at various points, footprints, or impressions of tire prints.

3. Evidence of struggle, such as an overturned chair, a broken window, or bloodstains, and of objects being thrown.

4. Signs of activity prior to the occurrence, such as the telephone receiver off the hook or wires cut; playing cards orderly stacked or scattered; television and lights turned on; food in cooking stages; coffee cups; drinking glasses or liquor bottles; time-watch or clock stopped. In general, articles apparently in use immediately prior to commission of crime or that appear to have been disturbed from their customary position should be photographed.

5. Unusual signs, such as a door ajar, a window open, or a light on in the daytime.

6. Trace evidence, such as marks of conflict on a suspect's person or clothing; trails of bloodstains, footprints on paper or in blood; handkerchiefs or garments bearing laundry marks and other potential clue material.

In an outdoor scene, look for such items as shoe or tire impressions, discarded cigarettes, burnt matches, broken branches or shrubbery, signs of objects being dragged; then photograph them immediately before they can be disturbed.

Circumstances of death. To locate the body in the scene and its position in relation to other articles in the room, take at least two photographs of the body at right angles to each other. Point the camera down from the normal position of an observer standing. Other pictures might include close-ups of wounds, the location of the instrument of death, and other special aspects or conditions of the body. Additional photographs of the body may be taken later at the morgue under the direction of the autopsy surgeon.

Hangings. In death due to asphyxia as a result of hanging, doubt sometimes exists as to whether the occurrence is murder, suicide, or an accident. Photograph the original position of the body to help in determining the manner of death. Overall view of the body and rope should be taken at torso and foot level. Show the height of the body above ground; a murderer usually tries to raise the body completely, while the suicide frequently never gets his feet off the ground and is sometimes found in a sitting or half-prone position. Photographs should be made to show the relative position of any object, such as a chair or stool, that appears to have been kicked from under the feet of the deceased.

Subjects for close-up shots are the knot, its size, type, and location on the neck; depth and location of the grooves in the neck; black-and-white marks around the edge of the groove (here, color film is especially helpful); signs of violence about the neck, suggesting prior strangulation; protrusions of the tongue; binding of hands and feet, and so forth.

Drownings. In drowning cases, the body is usually the sole object of interest. But did the deceased actually die of drowning or was he thrown into the water after death from some other cause? The photographic operation should be directed towards those facts which will help to resolve this question. Color film is exceptionally useful here since many of the significant clues may be matters of discoloration. Photograph the whole body, both from the position of a standing observer and from the ground level. The latter view will show any distention of the body. Close-ups should include any foam about the mouth; the position of the mouth, whether opened or closed; wounds, peculiar markings, bruises, or unusual discolorations; articles, such as seaweed, grasped in the hand; and any rope or wire bindings. Many of these views can be made at the morgue before autopsy.

Accidental Electrocution or Shock. In addition to the usual photos, special attention should be given to those aspects of the scene which show how the electrical contact was made. Examples are the accessibility of lighting fixtures; wires lying in a pool of water; electrical hazards, such as frayed insulation or exposed wires.

Explosions. An explosion may be accidental or intentional—if the latter, it is the job of the investigator to determine if it was directed toward person or property. The photographer should follow the investigator's instructions because the key evidence may be as subtle as a small piece of string. Usually

such offenses are committed indoors. The following items are potential objects to be photographed:

Nature of explosive device. The detonator of a homemade bomb may leave items strewn about the scene, such as parts of the container; fragments of a box; pieces of string, or paper, or cloth; metal parts such as pieces of pipe, tape, wire, batteries; and parts of clock mechanisms.

Undetonated portions of explosives. These may be found at a considerable distance from the point of explosion.

Traces of liquid explosives. Stains or splashes on clothing, draperies, or walls; particles of paraffin or wax.

Point of origin. The exact spot at which the bomb exploded is important. Also, the window or other opening through which the bomb may have been thrown should be photographed.

Condition of utilities equipment. If it appears that the source of power for the detonation was derived from a doorbell, telephone, or gas equipment, photographs should be made of such items, as well as household appliances and similar pieces of equipment. Also photograph such items if found in places where they would not normally be placed. Faulty gas lines, open gas valves, and ruptured pipes or fittings should also be photographed.

Evidence from suspect. Indications of the use of explosives may be found on the person of a suspect or in his lodgings or vehicle. Thus, photographs should be made of acid burns, discolorations, or injuries on a suspect's person and of explosive components, binding materials, insulation materials, and so forth.

Sex Offenses. The crime of rape is typical of this class of offense. The purpose of the photographic record is to record information on signs of any struggle at the scene where the attack occurred, either indoors or outdoors, or indications of the victim's efforts to resist attack, such as bruises, black-and-blue marks, torn clothing, or any other evidence that might link the presence of either or both parties at the scene where the attack took place.

The scene of the crime. The locale itself may be important to show that outcries of the victim could not be heard or to illustrate the fact that the nature of the place would make it an unlikely meeting ground for ordinary social purposes. Thus, photographs to show the remoteness of the scene from

general traffic or from the nearest dwelling may be useful. Aerial photographs often show such areas best. A close-up view of the scene should be made to show the area where the crime took place. Additional shots should be made of special features, such as foot and tire impressions; broken branches; buttons; torn clothing or other personal property; used matches and booklets of matches; toe of the shoe marks; distribution of rocks, foliage, and other natural features; and the displacement of other objects from their normal position.

Photographs of the suspect. It is important to photograph all evidence discovered by the physician and investigator that will link the suspect to the scene of the crime.

Photographs of the victim. Evidence of resistance to the criminal act is particularly important. Therefore, photograph bruise marks and discolorations on the body in general (color film is excellent for this); the conditions of specifically affected parts; and the area where foreign hairs, fibers, and biological stains are found. Traces associating the victim with the crime scene are also important in some cases in order to confirm the victim's account of the occurrence. In photographing the body of a victim, permission should be obtained previously, preferably in writing, from the victim. If the victim is a minor, permission in writing from the parent or guardian is imperative. It is recommended that the victim's physician be present when such photographs are made, or that they be made in a medical facility by an experienced medical or clinical photographer.

Crimes Involving Firearms. Firearms as a weapon, having the advantage of distance, can make the work of the photographer very difficult. To aid the court in understanding the manner and cause of death or injury, the photographer will usually be directed by a firearms expert or trained investigator. Therefore, the photographs should be made to conform with this person's views on how the evidence should be shown.

Often it will aid the firearms expert in testifying if the trajectory of a bullet can be shown, and one technique for vividly showing the path of a bullet is to stretch a white cord from the body of the victim to the apparent point of the discharge of the weapon. The scene should be photographed both with and without the cord, so that an overlay can be made if

1

2

3

4

5

6

7

8

9

Photographs of a crime scene should show in meticulous detail all elements that might prove pertinent to the investigation. This sequence of a simulated murder scene is not exhaustive, but it shows what might be done to record a typical scene.

(1–6) General locale and closer views of front and rear entrances to the building and apartment. (7) From front hall, scene as it appears through open doorway. (8–12) Details of scene from inside apartment, including purse on floor and victim's body. (13) Kitchen and rear entrance; photographer is standing over the body. (14) Position of body viewed through kitchen doorway. (15) Sink where victim had apparently been working. (16) Close-up of victim's face for identification. (17) Photo of wound with victim's face for identification. (18) Close-up photo of wound. (19) Photo showing absence of exit wound as seen when body is turned by medical examiner. (20, 21) Overall photos of the room made with wide-angle lens.

Crime Photography

10

11

12

13

14

15

16

17

18

19

20

21

it is desirable to show in the picture the path of the bullet.

Indoor scenes. Marks made by bullets on impact with a wall or other solid object should be photographed from the assumed point of fire, as well as close up.

Outdoor scenes. If the crime took place outdoors, the possibility of long trajectories or ricochet of bullets exists. Since the position of the person discharging the weapon is often unknown and difficult to determine, photographs taken from the body position along the estimated direction of fire become very important.

Motion Pictures

Whether recorded on conventional film or on videotape, motion pictures—with or without sound —are an important aspect of crime photography.

Modern super 8 cameras and color films can be used as easily, and under the same conditions, as hand-held still cameras. Quarter- and half-inch videotape equipment is a bit more limited in scope and handling. Either medium can be used effectively by an experienced photographer after only a brief orientation to equipment operation. Because the end result is the same, the term *motion pictures* applies to both methods of recording.

One major use of motion pictures is in surveillance—keeping a subject or a location under observation. The visual record may be continuous, or it may be taken frame-by-frame at regular intervals, a technique called time-lapse recording. Surveillance photography is discussed in a separate article. A number of other uses of motion pictures in crime photography are covered here.

Riots and Demonstrations. For peaceful demonstrations, police intelligence and advance publicity usually provide enough time to make plans for handling the situation and for providing adequate photographic coverage. Vantage points and equipment can be selected and made ready in advance of the demonstration. Photography of such demonstrations will provide police intelligence with identifiable photographs of the participants, their mannerisms, their behavior, and of any signs or placards they may be carrying. Normally, still photographs will provide sufficient information because such demonstrations are usually carried out in an orderly

fashion and the participants are willing to have their photographs taken.

Photographic coverage of riots is difficult to plan because riots are not usually announced in advance, and they do not follow any set pattern. By the time the police photographer is called, the situation is comparable to a three-alarm fire—it is already "burning out of control." Unquestionably, a three-alarm fire presents certain problems, but because some general planning for such occasions has been done, and because the fire fighters have received training and experience, they have a plan of attack.

Police photographers should also do some advance planning for photography of riots and demonstrations. Such planning consists of evaluating the possible situations, deciding on tactics and placement of equipment, having available the equipment and materials that will be needed, and training under simulated conditions.

Still pictures taken during a riot have their value in identification, but motion pictures have the advantage of being able to record accurately the total actions of participants. A still photograph, for instance, may show an officer with his or her arm raised in an apparently threatening attitude, or show him or her bending over a prostrate victim. One might infer from such still photographs that the officer was about to strike a person resisting arrest, or that he or she had knocked a rioter to the ground; these photographs could supply the basis of evidence of police brutality. Such photographs could also be taken by press photographers. However, a motion-picture camera in the hands of a police photographer can record the entire, uninterrupted sequence of events. The film might show an entirely different reason for the uplifted hand or for the person's being on the ground. Also, television news films have sometimes been edited in such a way as to give a distorted impression. By providing their own motion-picture coverage, law-enforcement agencies can be sure that the "total picture" is available and in context.

Unlike a peaceful demonstration, a riot requires special protection for the photographer and equipment. Many times the photographer is a prime target for missiles and projectiles because rioters are unwilling to be identified through pictures. They are committing crimes and realize that photographs may be used as evidence.

Mobility and operation under low-light conditions are prime considerations in photography of riots. Lightweight, easily carried equipment, fast lenses, and a "super fast" film are essential for photography of riots.

One of the best methods of obtaining good photographic coverage and, at the same time, providing adequate protection for the photographer, is to use an armored vehicle. The vehicle can be equipped with high-intensity spotlights and a window or porthole through which motion pictures can be taken.

Additionally, plans should include placement of a photographer on a roof or in a second- or third-floor window near the center of the riot area. This is the ideal place to use an electric-drive camera and a zoom-lens combination.

Riots are not usually confined to a small area that can be covered by a single camera, but typically involve a large area or occur simultaneously in several locations. Because of the large area, or areas, involved, it is necessary to have several people photographing the riot. During a riot, law-enforcement agencies are usually taxed beyond their manpower capacity. If the agency is aware of the value of photographing such events, arrangements can perhaps be made in advance to borrow additional manpower. If such approval is obtained, the other police officers who will be available to assist in the photographic mission should receive advance photographic training. And, of course, additional equipment must be available for their use.

Usually, many arrests are made at the riot scene and prisoners are transported en masse in buses, trucks, or any other available vehicles, while the arresting officer is required to remain on the scene. A still photograph should be made of the prisoner and the arresting officer, before the prisoner is transported. This can be used later for identification purposes, to relate the prisoner to the arresting officer, and to record the prisoner's physical condition at the time of his arrest.

Interrogations and Confessions. In criminal trials, the defense counsel often makes the charge that a written or oral confession was obtained by coercion. The jury must rely ordinarily on the statements of the police officers and other witnesses in determining whether the confession was given voluntarily. The most effective method of aiding the jurors in this decision is a sound motion picture or video recording of the interrogation. With a concealed microphone and camera, a record can be made of the defendant while he or she is speaking or writing the words of the confession. Of course, in many instances, there will be no need to conceal the equipment. The police officers should be included to show their number, identity, and behavior. To show the absence of any threat of force or false promises, the group should be photographed also while engaged in the conversation leading up to and following the confession itself.

Reenactment of Crime. A sound motion picture of the defendant voluntarily reenacting the crime at the scene can be used to illustrate the testimony of the defendant or other witnesses.

Since reenactment of this nature is a form of confession, the element of voluntariness is important; hence, evidence of the willingness of the defendant to cooperate voluntarily in the reenactment of the crime should be provided in the manner described for confessions. To show the relation existing between the defendant and the police officers, include footage taken immediately before and after the reenactment. If the defendant is shown to be acting under free will, without compulsion from the officers, it will be difficult to deny the validity of this evidence at a later date.

Resisting Arrest. Resisting arrest is a serious problem. The arresting officer must not only protect himself or herself but subdue the person resisting arrest. Bones have been broken, and police have been accused of brutality and have been sued for large sums.

Several police departments have found a solution by supplying one of the two persons reporting at the scene with a movie camera equipped with a portable-battery-powered light for night use and loaded with one of the high-speed films recommended for surveillance photography. The magazine-type camera is especially useful because it can be reloaded very quickly.

This procedure has proven quite successful. Where generally publicized, it has had a tremendous sobering effect on those resisting arrest. Officers, knowing that they are being photographed, have been more cautious about their actions. It not only has saved the community money, but, by having a silent witness in their favor, has given police departments a feeling of confidence.

Intoxication. Motion pictures are an invaluable aid in providing evidence of intoxication. Even if chemical tests for intoxication have been made, a motion picture is more effective evidence for showing that the defendant was, in fact, unable to perform certain physical acts requiring coordination. This is especially applicable for intoxicated drivers.

A satisfactory setup for intoxicated-driver tests needs a room at least 30 feet long with sufficient illumination throughout the area. A camera should be used on a sturdy tripod to provide absolute steadiness of the camera and still permit freedom of vertical adjustment when the subject approaches the camera. A wide-angle lens is recommended.

The nature of the test should be determined by the physician who will testify in court. The subject's face should be included in all shots, and at least one close-up should be taken for identification purposes. To establish the time when the film was exposed, a large calendar and clock should appear in the background, or the time and date can be written on a blackboard in the background.

When sound motion pictures are required, it is necessary to use a single-system optical sound camera. This is actually a photograph of the voice that cannot be retouched, altered, or changed in any way. Magnetic recording is not permitted in court because it can be erased and re-recorded.

• *See also:* AVAILABLE-LIGHT PHOTOGRAPHY; BAD-WEATHER PHOTOGRAPHY; CAMERA MOVEMENTS; CLOSE-UP PHOTOGRAPHY; DOCUMENT EXAMINATION BY PHOTOGRAPHY; EVIDENCE PHOTOGRAPHY; EXISTING-LIGHT PHOTOGRAPHY; FINGERPRINT PHOTOGRAPHY; FIRE AND ARSON PHOTOGRAPHY; INFRARED PHOTOGRAPHY; INSURANCE PHOTOGRAPHY; LEGAL ASPECTS OF PHOTOGRAPHY; PERSPECTIVE; SCIENTIFIC PHOTOGRAPHY; SURVEILLANCE PHOTOGRAPHY; TESTIFYING IN COURT; TRAFFIC ACCIDENT PHOTOGRAPHY; ULTRAVIOLET AND FLUORESCENCE PHOTOGRAPHY; VIEW CAMERA.

Further Reading: Siljander, Raymond P. *Applied Police and Fire Photography.* Springfield, IL: Charles C. Thomas Publishers, 1976;——— *Applied Surveillance Photography.* Springfield, IL: Charles C. Thomas Publishers, 1975.

Custom Labs

A custom photolab offers processing, darkroom, and related services on an individual basis. In contrast to this, a commercial processing (photofinishing) lab deals in large-volume, mass-production work, with all materials of the same type handled in one average way, and all work turned out to a single standard of quality. Variations in process and printing, and special service for individual orders are seldom available. The customers of a commercial lab are chains of dropoff/pickup depots, and large-volume businesses and industries.

A custom lab deals primarily with individual photographers and studios and tries to give the kind of attention to each order that photographers themselves would give if they were doing their own processing. Work is handled order by order, or in small batches; black-and-white films are processed by inspection; prints are made with personal attention. Although a custom lab may use highly sophisticated equipment and procedures, there is an experienced technician rather than an automatic device controlling each process and service. This means that personalized judgments can be made and that modified or special procedures can be used at any point according to the needs of the order and the wishes of the photographer. In addition, a custom lab offers a variety of specialized services.

Reasons for Using a Custom Lab

Many different kinds of photographers use custom labs for a variety of reasons.

Time, Profit, and Facilities. Professionals with full schedules may not have time to do their own processing and printing. In addition, shooting time is far more profitable than darkroom time. When a typical job takes a day to shoot and a day to process and print, photographers doing their own darkroom work could handle two or three jobs a week while photographers using a custom lab could handle five. If the average fee is, say, $1000 per job, the difference is impressive, especially as the lab costs would be relatively minor and usually would be charged to the client in addition to the shooting fee.

A traveling photographer seldom has either the time or the facilities to process and print a job. A custom lab will receive or pick up orders by mail, messenger, express, or any other means; will follow special instructions, if any, in processing, printing, and finishing the order; will send or deliver the job to the client; and will keep an individual file of photographers' negatives, proofs, duplicate prints, and other materials.

Availability of Experts. Studio photographers may find that their money is best invested in a full-time studio assistant and a person-of-all-work (retoucher, print spotter, makeup artist, bookkeeper, and so forth). By using a custom lab, they are able in effect to hire a variety of experienced experts only for the hours they spend on a particular order. Studio photographers do not have to carry the overhead of a staff darkroom assistant, or try to find someone who is of equal value in the studio and the darkroom.

Specialized Processes and Materials. A photographer who wants to produce work by a wide range of techniques and processes may not be able to stock all the materials and chemicals required, or to afford specialized equipment that would be used infrequently. A custom lab can and does have these materials and facilities because the cost and usage can be divided among many customers over a long period of time. Also, the lab can afford to employ one or more people who devote their time to becoming expert in special processes.

Quality Services. Photographers may need copying, reproduction, duplicating, or printing services of a higher quality than they have the experience or ability to produce. The strength of a custom lab is the breadth of experience and abilities its staff possesses.

It is possible to find many more examples, but they all add up to the same point: Although some photographers use a custom lab simply for convenience, most do so because the lab provides better quality more economically and with greater efficiency than they could achieve themselves.

Custom Lab Services

The following list gives the services provided by a typical custom lab in a medium-size or large city. Many things are charged for at standard rates, but those that demand a great deal of specialized personal attention involve additional charges, or are billed on a time basis.

Black-and-white film processing—standard inspection development.
Black-and-white film processing—special developers; push processing.
Color film processing—standard.
Color film processing—special.
Contact proof prints and proof sheets—black-and-white and color.
Enlarged proof prints and proof sheets—black-and-white and color.
Negative/slide frame numbering.
Negative filing.
Black-and-white prints—contact and enlargement.
Exhibition prints.
Black-and-white prints from color negatives.
Intensification and reduction of black-and-white negatives.
Retouching; spotting; airbrushing.
Color prints from negatives.
Color prints from transparencies.
Dye-transfer prints.
Duplicate slides and transparencies.
Color internegatives.
Color conversions (black-and-white negatives from color originals).
Copy negatives from continuous-tone, halftone, and line originals.
Black-and-white slides from color and black-and-white originals.
Still-picture enlargements from movie frames.
Mounting—dry mounting; Masonite backing; Foamcore backing; framing.
Crating; shipping; delivery.

A variety of other specialized services may also be offered, depending on the expertise of the staff and the needs of the local photographic community. The distinctive feature of a custom lab is that each order receives individual attention and service.

• *See also:* COMMERCIAL PROCESSING.

Cyanide

Cyanide is a salt of hydrocyanic acid. Various cyanides dissolve silver or reduce silver compounds; since the beginning of photography they have been used to reduce image density and to clean silver plates such as daguerreotypes. However, *cyanides are deadly poisons*. Although they are still sometimes used in photomechanical reproduction to etch or reduce the size of halftone dots, most photographic reducers today use far less poisonous substances, such as potassium ferricyanide (for example, Farmer's reducer). A modern, non-poisonous method of cleaning daguerreotypes employs thiourea.

• *See also:* DAGUERREOTYPE; POTASSIUM CYANIDE; REDUCTION; SODIUM CYANIDE; THIOCARBAMIDE.

Cyanotype

The cyanotype is a negative-positive printing-out process. It was invented in 1842 by Sir John Herschel, based upon his discovery that certain iron salts are light-sensitive. The name was chosen because of the intense blue background (Greek *cyanos:* dark blue) against which a white (or paper-base color) image appears. It was also known as the ferro-prussiate process because the color is the compound Prussian blue. The modern common name is the *blueprint process;* the article under that heading contains additional formulas and procedures to those given here.

Cyanotypes may be printed from ordinary negatives as well as from drawings or reproductions on translucent or transparent materials. The original acts as a negative: Dark elements will appear light, and light elements dark in the cyanotype. The solutions for sensitizing paper or cloth are simple to prepare and use. No development is required in the basic process; the image prints out, and is made permanent by washing in water. Contact printing is required, with exposure to sunlight or a strong ultraviolet lamp. Therefore, enlarged negatives or other originals of the desired final size must be pre-

pared for printing. Films made for the direct duplication of continuous-tone negatives are most convenient for making enlarged negatives.

Modifications of the cyanotype and related processes can provide other results: black rather than blue background; hand-drawing with the color bleached away; slides or transparencies; positive-to-positive or negative-to-negative printing (Pellet process); and brown-black images (Poitevin process).

Making a Cyanotype

Print Materials and Handling. Any good quality paper that can be wet and dried without damage may be used. Thin papers are easily wrinkled or torn while damp and may dry with ripples; rough-surface papers are difficult to size well, but may be used if their texture contributes a desired effect. Colored papers can provide an image that harmonizes or contrasts expressively with the background color. Cloth for printing should be cotton or linen; synthetic materials may give uncertain results.

Paper should be sized before sensitizing. Solutions may be liberally swabbed on the paper with a sponge or flowed on with a wide, thick brush; or the paper may be floated on a tray of solution. Cloth may be immersed in sensitizing and developing solutions, but it must not have folds or wrinkles; it should be stretched tightly across a frame or flat support during printing. Paper should be floated on developing and other processing solutions to minimize unnecessary handling.

To float paper on a tray of solution, grasp it by diagonally opposite corners so that it hangs down in a U-shape. Lower the center of the U onto the surface of the solution; then lower the corners making sure that no air pockets are formed between the paper and the solution. To pick the paper up, simply grasp it by one corner, or two adjacent corners, and lift upward. Let it drain for a moment before further handling.

Cyanotype materials may be sized in ordinary light. They should be sensitized (and developed in related processes) in subdued artificial light—ordinary darkroom safelight is also suitable—and must be dried and stored in the dark before use. Once sensitized, materials should be used as soon as possible after they are dry; the useful sensitivity declines rapidly after about a day, and seldom extends be-

yond three or four days. Only small quantities of sensitizing solutions should be prepared at a time; they do not keep well.

Sizing. Size fills in the pores of paper fibers and gives a non-glossy coating to the surface. This keeps the sensitizing solution from soaking deeply into the paper, so that the image is formed at the surface, which improves the rendition of detail and tonal gradations. Cloth should not be sized because the size will dissolve out during repeated washings, taking part of the image with it. Bold, poster-like images are more suitable for printing on cloth than those with fine detail. It is worthwhile to size a number of sheets at the same time. They may be stored flat when dry for any length of time, and sensitized only when needed.

The most common size is starch or albumen (egg white). Modern spray laundry starches seem to give acceptable results and are easy to apply. Mark the side of the paper that is not to be treated. Pin the paper to a slanted surface or lay it flat. Spray it with three coats of starch to provide complete and even coverage. Spray lightly each time, avoiding puddles or runs of liquid, and allow each coat to dry thoroughly before applying the next.

Better penetration and sealing are achieved with a cooked starch size. Use a white laundry starch with no additives such as bluing. Crush about 1½ tablespoons of starch in a container and slowly stir in just enough cold water to dissolve the starch, making a thin paste. Then stir constantly as you add three cups of boiling water. Place the mixture over heat and boil gently about four minutes. Let it cool to a warm temperature before applying; if the starch jells, heat it again gently. Flow or sponge the size onto the paper, or float the paper on the surface of a tray of size. Let it soak for one to two minutes; then hang the paper to dry in a dust-free place. A second coating will make certain the entire surface is sealed.

Albumen size provides a smoother, shinier (but not glossy) surface than starch. Beat the whites of three or four large eggs and let stand a few hours until the froth completely disappears. Dilute four parts egg white with one part cool, deionized or distilled water. Flow the size onto the paper, or float the paper on the size for about one minute. Hang it up to dry.

Sensitizing. Sensitize the sized surface of paper with a mixture of the following solutions:

Stock solution A

Ferric ammonium
 citrate (green) 125 g
Water, 15 C (59F) to make 500 ml

Stock solution B

Potassium ferricyanide 75 g
Water, 15 C (59F) to make 500 ml

Notes: 1. The response of the iron compounds may be affected by traces of other metals. For the best results use distilled or deionized water, and non-metallic containers and stirrers when mixing any of the solutions. Store solutions in closed, dark-brown bottles, or in the dark.

2. Ferric ammonium citrate is available as both green and red-brown crystal scales; the green scales provide superior results. An equal amount of ferric potassium citrate may be used instead.

3. For increased printing speed, substitute an equal amount of ferric ammonium oxalate or ferric potassium oxalate for the citrate. However, ferro-oxalate paper does not keep well and must be used immediately.

4. For increased contrast, add 1 gram (15 grains) of potassium dichromate (bichromate) to each solution.

Combine equal quantities of the stock solutions A and B just before use. Sensitize paper or cloth for three minutes; swab, flow, or float paper, immerse cloth in the mixture. Hang to dry in the dark.

Printing. Make a contact-print exposure to sunlight or a strong ultraviolet lamp. Use a frame that permits you to open part of the back and lift a corner of the print for inspection without moving the paper and negative out of register. Expose until the shadow areas have a bronze tint. Wash the print for ten minutes in running water or at least three changes of fresh water. Then bathe the print for about two minutes in a tray of water slightly acidified with hydrochloric acid—four or five drops of acid into a litre (32 oz) of water. This makes certain that the whites of the image will not stain or discolor. Blot or squeegee the print carefully and air-dry it.

To print on cotton or linen cloth, follow the same procedures. Before the cloth is completely dry, iron it at a moderate temperature to help set the image.

Black Conversion

Treat the processed cyanotype in the following solution:

Bleach

Sodium carbonate 5 g
Water, 15 C (59F) to make 500 ml

The blue coloring will disappear, leaving only faint pink traces. Redevelop the print in a tannic acid solution.

Developer

Tannic acid 45 g
Water, 15 C (59F) to make 500 ml

Float the print on the developer. The portions that previously were blue will reappear in purplish-black. Wash ten minutes and dry.

Drawings

Draw over the dry cyanotype image with indelible pencil, crayon, waterproof ink, or some other non-soluble medium. Bleach away the blue image in the following solution.

Bleach

Oxalic acid 25 g
Water, 15 C (59 F) to make 500 ml

Wash thoroughly in several changes of water; dry.

Slides or Transparencies

For your base material use photographic film. Without exposing the film to light, fix it in a solution of hypo to remove all the silver halides, and thoroughly wash and dry it. Then sensitize it with the following solutions:

Stock solution A

Ferric ammonium
 citrate (green) 340 g
Potassium dichromate 1 g
Water, 15 C (60 F) to make 500 ml

Stock solution B

Potassium ferricyanide 85 g
Potassium dichromate 1 g
Water, 15 C (60 F) to make 500 ml

Combine equal parts of A and B under subdued light or safelight. Flow or swab the sensitizer onto the transparency material. Dry in the dark; expose within four days. Follow the printing and washing procedures for the cyanotype. Use standard slide mounts for projection.

Pellet Process

Introduced in 1878, this process produces a blue image on a ground of whatever color the paper may be. This is a positive-to-positive process; things that are dark or opaque in the original will be dark blue in the final image. Therefore, the paper base must be a light color to give a positive effect. Prepare the following solutions:

Stock solution A

Ferric ammonium
 citrate (green) 250 g
Water, 15 C (60 F) to make 500 ml

Stock solution B

Ferric chloride 250 g
Water, 15 C (60 F) to make 500 ml

Stock solution C

Gum arabic 10 g
Water, 15 C (60 F) to make 500 ml

Shake the gum arabic vigorously with the water in a closed container and let it stand until completely dissolved; this may take a day or two.

Combine 8 parts A, 5 parts B, and 20 parts C. Brush or float the paper thoroughly with this solution. When dry, expose by contact to sunlight.

This paper does not print out; a faint yellow image forms which must be developed to full blue strength. To time the exposure, place some test strips of Pellet paper under an image of similar density and expose them alongside the print. Remove one test strip at intervals and develop it to determine the progress of exposure.

Pellet developer

Potassium ferrocyanide*. 10 g
Water, 15 C (59 F) to make 500 ml

Note: Use potassium ferrocyanide, not ferricyanide.

Develop by floating the print on the solution. Only about 30 seconds is required; longer develop-

ment may cause spreading of the image lines. Wash the print as with a cyanotype, but rinse it thoroughly after treatment in the final acidified water bath. Blot and dry.

Poitevin Process

This is a positive-to-positive process that produces purplish-black lines on a light background; it was introduced in 1861. Treat sized paper with the following solution:

Poitevin sensitizer

Gum arabic . 60 g
Ferric chloride 60 g
Ferric sulfate 50 g
Potassium chloride 50 g
Water, 15 C (60 F) to make 500 ml

If this solution is to be kept for some time, add 10 g (0.35 oz) of tartaric acid as a preservative.

Sensitize and dry the paper as in the previous processes. Expose to sunlight, using test strips to time the exposure as described in the Pellet process. Develop for about three minutes by floating on the following solution:

Poitevin developer

Potassium alum 7.5 g
Tannic acid 90.0 g
Water, 15 C (60 F) to make . . . 500.0 ml

Wash thoroughly; blot well to prevent image lines from spreading during drying.
• *See also:* BLUEPRINT PROCESS; HERSCHEL EFFECT.

This architect's drawing, shown by a blue image on a light ground, was produced by the positive-to-positive Pellet process. Original drawing by Steven Bloom.

Daguerre, Louis Jacques Mandé

(1787–1851)
French artist, creator of the Diorama Theater and, with Joseph Nicéphore Niépce, largely credited with being the inventor of photography

Daguerre and Niépce had been working independently on methods of producing a permanent image in the camera obscura (*See:* CAMERAS.) and were brought together by the French optician Charles Chevalier in 1826. They became partners in 1829 for the purpose of perfecting Niépce's method of recording images in the camera by using treated metal plates. Sometime after the death of Niépce in 1833, Daguerre discovered that a partially exposed image on a silver iodide plate could be developed to a direct positive image by fuming it with the vapors of mercury.

The discovery was reported to the French Academy of Sciences by its secretary, Francois Arago, on January 7, 1839. A full public disclosure of the process was made on August 19, 1839. A printed handbook explaining the process was published later in the same year.

The French Government awarded Daguerre a cash payment and a lifetime pension for the rights

Louis Jacques Mandé Daguerre, inventor of the first practical method of photography. This daguerreotype portrait was taken in 1844 by Jean-Baptiste Sabatier-Blot. From the collection of the International Museum of Photography at George Eastman House.

to the daguerreotype, which were then given free to the world as a mark of the scientific genius and the generosity of the French people. However, Daguerre had patented the use of his invention for making portraits in England, Wales, and the British colonies. This action seems to have stemmed from a rebuff by the Royal Society of London when Daguerre had earlier offered to exhibit his invention, but not to explain its details. The rules of the Society required full disclosure so that all results could be

independently verified by open scientific investigation. As a result, the daguerreotype was not widely used in the British Isles, but it swept the rest of the world. Millions of daguerreotypes were produced until the process was generally replaced, in the 1850s, by the far more versatile negative-positive process.

To Niépce goes the honor of being the first, in 1826, to permanently record an image in the camera obscura. To Daguerre goes the honor of having invented the first practical method of photography. From their work, and that of William Henry Fox Talbot, who invented the negative-positive process, the medium has grown to its present level of technical and artistic sophistication.

• *See also:* CAMERAS; DAGUERREOTYPE; NIÉPCE, JOSEPH NICÉPHORE; TALBOT, WILLIAM HENRY FOX.

Daguerreotype

A daguerreotype is a photograph consisting of a whitish silver-mercury image on a polished metal plate. As originally practiced, the process had five steps:

1. A sheet of copper or brass was plated on one side with a layer of silver, and buffed to a high polish.
2. The plate was sensitized by placing it in a lighttight box containing iodine crystals, the vapor of which reacted with the polished silver surface to form a layer of yellowish silver iodide.
3. The plate was exposed in a camera by bright daylight; exposures with the slow lenses of Daguerre's time ran as long as 20 minutes. Since the image is produced on the surface of the plate, it is reversed left for right; some operators fitted their cameras with reversing mirrors to pro-

duce a correctly oriented image, but most daguerreotypes were accepted in the reversed form.

4. The plate was developed in a box containing a dish of mercury heated to about 75 C (167 F). During this step, the mercury vapor attached itself to the exposed portions of the plate, and formed a whitish image composed of a mercury-silver amalgam. When the plate was held so that the unexposed mirrorlike silver reflected a dark color, the image appeared positive.
5. The image was fixed in a sodium thiosulfate (hypo) solution, washed, and dried.

Daguerreotypists soon discovered that the speed of the plate could be increased by alternately sensitizing it over iodine and bromine vapors, and that image tone and strength could be improved by use of a gold chloride solution after fixing.

The silver plate was subject to tarnishing and would quickly be etched by fingerprints on the sur-

Hand-colored daguerreotype of a child, in a leather case. Unknown photographer and date; probably American, circa 1840–1850. From the collection of the International Museum of Photography at George Eastman House.

Daguerre, Louis Jacques Mandé

Daguerreotype portrait of an unknown woman, with engraved border. American, circa 1840–1850. From the Southworth and Hawes Collection at the International Museum of Photography at George Eastman House.

face. The image itself was quite fragile—"as delicate as the pattern on a butterfly's wing" was one description. To protect it, a metal mat with a cutout for the image was placed over the face of the plate. This was covered with a piece of glass, and all were held together by a thin metal decorative edge frame that could be bent into position with the fingers. Then the entire package was inserted into a small leatherette case with a velvet lining and a padded, hinged cover.

Restoring Daguerreotypes

In spite of the protective coverings and cases, many daguerreotypes eventually tarnished and became dirty over the years. At one time, it was the practice to clean the plate in a solution of potassium cyanide, a deadly poison. Today, a non-poisonous method is available. With the growth of photographic collecting, the value of daguerreotypes has increased significantly both in economic and in historic terms. For this reason, it is well worthwhile to restore daguerreotypes, particularly those that have little or no physical damage, such as deep scratches and etched areas.

Remove the packet from the case and carefully separate the plate from the glass and the frames. Wash the glass separately; clean the frames with a gentle-acting metal polish if necessary, and wash and dry them. Brush out the inside of the case thoroughly.

Be extremely careful in handling the daguerreotype plate; the image is fragile. It may be safer to grip it by one corner with a pair of surgical tongs or needle-nose pliers than with the fingers.

Wash the plate in distilled water to remove surface dirt and dust (do not brush or wipe it at any time). Drain the water off the plate, then place it face up in a shallow tray containing the solution specified below. Rock the tray to move the solution over the face of the plate until tarnish and discoloration are dissolved away.

Distilled water	500 ml
Thiourea*	70 g
Phosphoric acid (85%)	80 ml
Kodak Photo-Flo or equivalent wetting agent	2 ml
Distilled water to make	1 litre

Remove the plate from the thiourea solution and rinse it in running water; a tray of flowing water is gentler than a direct stream from a faucet. Place the plate in a mild solution of soap or detergent and water and agitate for about one minute. Rinse again in flowing water, then in distilled water. Immerse the plate briefly in 95 percent grain alcohol to drive off the water; drain the alcohol, and dry the plate by evaporation over an alcohol lamp.

• *See also:* DAGUERRE, LOUIS JACQUES MANDÉ; FILING AND STORING NEGATIVES AND PRINTS; RESTORING PHOTOGRAPHS.

*Thiourea (thiocarbamide) is a powerful foggant of photographic materials. Do not use it in the vicinity of unexposed films or papers. Wipe all darkroom surfaces thoroughly with a damp cloth or sponge to remove all traces of the powder. After measuring out the required amount, wash hands and implements before working with other materials.

Outdoor locations can make expressive settings for dance photographs. Without complicated studio setups, the photographer has made use of the natural setting and backlighting to give his dancer something of the quality of a woodland spirit. Photo by Neil Montanus.

Dallmeyer, John Henry

(1830–1883)
English optician of German ancestry

John Henry Dallmeyer worked in London for the Ross family, and produced a number of portrait lenses based on the work of Petzval in Germany. He patented the Rapid Rectilinear lens in 1866, a lens similar to the Aplanat of Steinheil. The peculiarity of these designs lies in the fact that they are made not of the usual flint and crown glasses, but of two types of flint glass, allowing of achromatizing (two-color correction) with much shallower curves than the usual combination.

Dallmeyer, Thomas Rudolph

(1859–1906)
English optician, son of John Henry Dallmeyer

Thomas Rudolph Dallmeyer's design of one of the earliest telephoto lenses earned him the Progress Medal of the Royal Photographic Society in 1896. He was President of the Royal Photographic Society from 1900 to 1903.

Dance Photography

Making photographs of the dance is an interesting phase of photography with a lot of creative potential. This is true whether you photograph a graceful ballerina, a go-go girl, or a child taking her first lessons. This article suggests ways to make some intriguing and exciting dance photographs.

Equipment
For available-light shooting at rehearsals, on stage, and at home, a single-lens reflex camera with a fast 50 mm lens ($f/1.4$ to $f/2$, if possible) is ideal. Sometimes a wide-angle or a telephoto lens is help-

ful; these lenses should also be fast enough to permit some available-light shooting. A camera with a motorized film advance is handy for action-sequence shots.

When light is more plentiful, such as in the studio and outdoors, a very fast lens is not required, so it is easy to use a 2¼″ × 2¼″ square-format camera. The size of film for this camera is good for big enlargements, and the camera's large ground glass permits ease of composing.

Films
Dance photography is most exciting on color film. For shooting under low-light conditions, a fast film is a must. A real aid to available-light photography is the special push-processing service available for Kodak Ektachrome films (135 and 120 sizes *only*). This service doubles the speed of the faster Ektachrome films (process E-6).*

When you want prints and need a high-speed film, Kodacolor 400 film is an excellent choice.

Pictures Outdoors
The easiest place to photograph a dancer is outdoors, where you are not limited by such things as walls and the number of lights you have to work with. Outdoors you do not need to be concerned with complex lighting setups, and can determine exposure as you would for a normal subject in daylight. Therefore, you can concentrate on selecting a beautiful pose in a beautiful setting. Choose a point of view that gives a pleasing background, such as foliage or a blue sky, and ask the dancer to perform. Practice snapping the shutter at the peak of the movements when the dancer is in the most graceful and artistic positions. You may want to ask the dancer to run or leap. If you have a camera with a

*To get this service, buy a Kodak special processing envelope, ESP-1, from your photo retailer. The cost of the envelope is in addition to the normal cost of processing by Kodak. After you have exposed the film at the higher speed, put it in the ESP-1 envelope and return it to your photo retailer for processing by Kodak, or send it directly in a Kodak mailer. The service, at the time of writing, is available for Ektachrome 160 and Ektachrome 200 films.

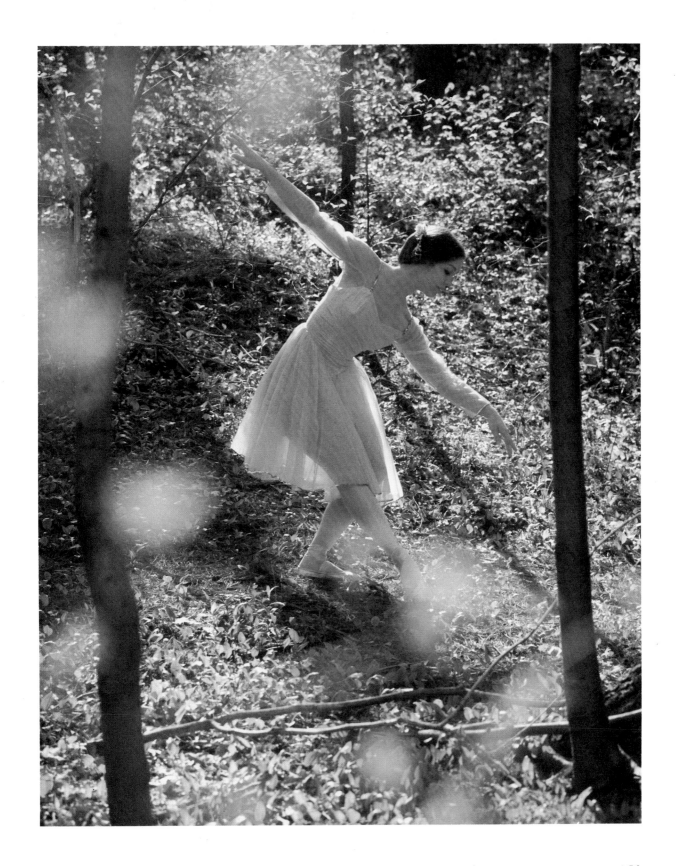

Dance Photography

Candid moments during classes or rehearsals in a studio make appealing photographs. The photographer should remain as inconspicuous as possible during such sessions, so as not to make his subjects self-conscious.

motorized film advance and fast shutter speeds, you can shoot a rapid sequence of pictures. This gives you the opportunity to have a good picture series, and also helps to catch the best position.

In the Dance Studio

One of the best times to capture candid moments is during a rehearsal at the dance studio. Be sure to get permission to take pictures from the dance instructor. You must get releases from the school and each student if you want to sell or publish the pictures. Remain as inconspicuous as possible as you shoot so that you do not disturb the class. You will probably use your normal lens and perhaps a medium telephoto lens. If there is enough light, shoot without flash. If there is not, use a small electronic flash unit and bounce the light off the ceiling. Fortunately, most dance studios have white (or nearly white) ceilings, so the color of the ceiling is

not reflected onto the subject. If the ceiling is colored or is too high for bounce flash, put the flash unit on a stand, and place it high and to one side. This helps simulate natural overhead lighting.

Pictures at Home

Having a dancer in your own home gives you the opportunity to take your time posing and working together. This is a good time for a "dress-up" dance costume such as one might wear for a recital.

Taking pictures by natural light produces the most natural and pleasing results. Pose the subject near a window, but not in direct sunlight. At night, if the available light in the room is too dim or too contrasty, use bounce flash. Watch the background; keep it simple and uncluttered.

Use an exposure meter to determine exposure for available-light pictures, both in the dance studio and at home.

Dance Photography

In the Theater

Professional dance troupes seldom permit performance photographs for a variety of legal and union reasons. But with local groups, the night of the big performance is a major picture-taking occasion. Ask permission in advance to go backstage and make shots before and during the performance. (If you can't get permission to shoot during the performance, dress rehearsal is second best.) The wings are the best places to be for taking angle shots that capture the stage lighting that gives an intimate and dramatic quality to your pictures.

Another important picture is one of the performance from the audience viewpoint. For the best

Professional dance groups may permit selected photographers to work during performances or dress rehearsals. Permission must always be obtained in advance. This photo was taken during a performance of Offenbach's Orpheus in the Underworld; the ballerina is Denise Jackson. Photo by Herbert Migdoll; courtesy of the Joffrey Ballet Company.

An important viewpoint for dance photographs is that of the audience. For the best angle, position yourself in the center of the balcony or mezzanine, rather than in the orchestra, which is too low, or in a box, which will probably be too far to the side. A telephoto lens will be necessary for good image size. This photograph was taken during a performance at the Bolshoi Theatre in Moscow. Photo by Victor Minca for Editorial Photocolor Archives.

view, shoot from the balcony. You will usually need a telephoto lens to get a good image size from this distance.

Determining the exposure for stage productions is a bit tricky because of the ever-changing lighting. This is especially true for full-scale stage productions. The following are some solutions to situations you may encounter when photographing stage productions.

Situation: To get the best exposure, you should make a meter reading of the dancer's face. But from the wings, an overall reading with a reflected-light meter may be unduly influenced by direct light from the stage lights and will indicate too little exposure. From the audience viewpoint, with no direct lights to contend with, large expanses of dark background may cause the meter to indicate too much exposure for the dancers.

What to do: If you have a spot meter (either separate from the camera or incorporated behind the camera lens), it is easy to read small areas from some distance away. Otherwise, attend the dress re-

To stop action in mid-air requires considerable familiarity with the choreography. If possible, attend several rehearsals; this will enable you to determine where and when the action will occur, so you can prefocus on that spot and know exactly when to snap the shutter. This is a scene from the ballet Rodeo. *Photo by Herbert Migdoll; courtesy of the Joffrey Ballet Company.*

Dance Photography

The studio setup is ideal for the photographer, who has complete control over his conditions—background, lighting, speed of action, pose. A splatter-painted backdrop was especially prepared for this photo session. Photo by Neil Montanus.

hearsal and get permission to make some close-up meter readings. With the cooperation of the lighting technician, you can make readings either before or after the rehearsal.

Situation: The subjects will be moving around on the stage, so focusing will be difficult. With large lens openings, depth of field will be shallow, and will be even less with a telephoto lens.

What to do: Attend a rehearsal or two to become familiar with the action. This will make it easier to anticipate where the movement will be on stage and to prefocus on that area. Then when the action moves into the area, snap the shutter.

Situation: When arc spotlights are used, you will get the best color with daylight-type color film. When only the stage lights are on, the best color will be obtained with a film intended for use with artificial light.

What to do: If possible, try to use two cameras. Load one with each type of film. Otherwise, artificial-light film with the arc lights will produce bluish, cold-looking pictures, and daylight film with the stage lights will produce warm, yellow-red pictures. If you must make a choice, use artificial-light film. Most of your pictures will probably be made under the stage lights, and most people are willing to accept some coldness in spotlighted pictures. Conversion filters are not a practical solution because they absorb too much light.

Studio-Type Situation

In a studio-type setup, you have complete control over all conditions. You will be able to place the dancer in an area with a plain background—perhaps a seamless paper background (available from large photo-supply stores). You can carefully choose the

(Left) Plain white paper makes an excellent studio background. Colored gels over the studio lights may be used in a variety of combinations for interesting effects. (Right) For single-image action photographs, electronic flash will help record the best and most graceful moments. Familiarity with the dancers' movements is essential. Photos by Neil Montanus.

position and lighting to create the mood you want. Talk with your model, and plan what poses and costumes both of you feel will make the most successful pictures.

The background is an important element in setting the overall tone or mood of your pictures. You can use a type of vignette in front of the camera lens to add color to the area surrounding your subject.

Types of Pictures

There are different techniques for photographing these four types of dance pictures in a studio-type setup:

1. At rest.
2. Action—single image.
3. Action—multiple sharp images.
4. Action—multiple sharp and blurred images combined.

At Rest. This is about the simplest way to photograph a dancer in the studio. If you use a little imagination in your choice of lighting and background, and perhaps add a prop or two, you can produce some fine shots. A talented and graceful model who can suggest various poses and hold them without moving is a great help.

You can light the subject with incandescent lights rather than with flash. Since the subject is not moving, you will not need the action-stopping ability of electronic flash, and with incandescent lighting you can see the effect you shoot. Such lighting

Dance Photography

aids as barn doors and snoots help keep the light from striking areas such as the background or foreground when you want these areas to go dark in your picture. You can also use pieces of cardboard taped to light stands or some other tall objects that are handy in order to block the light from areas where you do not want it.

Action—Single Image. For taking action shots of dancers, you will want the action-stopping ability of electronic flash. To help you catch the action at the precise moment that will produce the best and most graceful photographs, ask the subject to go through the dance several times while you simply watch. When you are familiar with the dance, you can anticipate the movement and snap the shutter at just the right times. This takes some practice and a fast reaction time. No matter how talented the dancer, if you catch the movement at the wrong moment you can make an awkward-looking picture.

Action—Multiple Sharp Images. These are pictures that are exciting and different. While they look hard to make, they are really not difficult. All

Multiple sharp action photographs such as this are less difficult to make than they may appear. Room and background must be very dark. With the camera shutter held open, an electronic flash is fired for each change in the subject's position. When the desired number of positions have been photographed, the shutter is closed. Photo by Neil Montanus.

Dance Photography

657

Dance Photography

(Left) A multiple sharp image on a vertical plane projects the frozen movement of an oriental statue. (Below) This combined multiple sharp and blurred image is made more effective by the use of carefully balanced flash and spotlights. Some exposure tests may be necessary to obtain exactly the desired results. Photos by Neil Montanus.

you need is a dark room, a black (or very dark) background, and an electronic flash unit that you can trigger independently from the camera shutter.

First decide on the action that is to take place and the number of images you want to show that action best. Next, turn off all the room lights. When your subject is in the first position, open the camera shutter and fire the first flash. When the flash unit has recycled and the model has taken the position for the second image, fire the flash again. Simply repeat this until you have photographed all the positions that you want. Then close the shutter.

Your lens opening will be the same as for a normal electronic flash shot. If necessary, use a cardboard baffle to keep the light from the flash from striking the background or foreground. If there is *any* existing light in the room, hold something, such as a dark cardboard, in front of the lens between flashes. Incidentally, if you do not have an electronic flash, you can use a normal flash unit that is separate

Dance Photography

(Left) For combined multiple sharp and blurred images, spotlights are used to provide exposure for the blurred images. The sharp image is recorded by electronic flash. (Right) The effect of motion is provided by a multiple exposure of a still subject. Photos by Neil Montanus.

Getting just the right balance between the flash and the spotlights requires some exposure tests. First, determine the lens opening for the electronic flash using the normal guide number. Then adjust the spotlight-to-subject distance to get the right lighting balance in this way: Adjust the spotlight distance so that an exposure meter reading of the subject indicates a shutter time of one second at the lens opening required for the electronic flash. For example, using the normal guide number for the electronic flash, assume that the lens opening should be $f/5.6$. Then adjust the spotlight distance so that a meter reading of the subject indicates a lens opening of $f/5.6$ at one second. After you see your test exposures, you will know if you must move the spots closer or farther away, or if they are satisfactory where they are. Be sure to keep careful records of your tests so that you will be able to repeat the results when you want to.

from the camera. Simply have an assistant fire the flash on your signal by shorting it with something such as a paper clip.

Action—Multiple Sharp and Blurred Images Combined. This technique is one of the finest for showing motion in a still photograph. Basically, you use the same technique described for multiple sharp images, but add a spotlight or two. (You can use colored gels over the spotlights, and over the electronic flash, too.) The electronic flash freezes the action, and the spotlights provide the exposure for the blurred images.

1. Turn on the spots.
2. As the dancer begins to perform, open the camera shutter.
3. Fire the flash for as many positions as you choose.
4. Close the shutter and turn off the spots.

The subject must move continuously and very slowly for multiple blurred-image photographs. Movements should have the continuity and appearance of a very slow-motion movie. Photo by Neil Montanus.

Dance Photography

The dancer must move *very slowly* for this type of photograph so that the movements appear as you would expect to see them in a very-slow-motion movie. The movements should also be *continuous.* Otherwise, the blurred effect will be jumpy and uneven. If the electronic flash takes a relatively long time to recycle, you may want to ask an assistant to hold an extra electronic flash unit or two that can be recycling while one is in use.

• *See also:* ACTION PHOTOGRAPHY; ELECTRONIC FLASH; LIGHTING.

Dark-Field Illumination

Dark-field illumination is a method of lighting a subject so that the surrounding area (the field, or background) is completely dark. It is a specific technique used in photomacrography and photomicrography, achieved by placing the light source at an angle so that only certain rays striking the subject are refracted (in transillumination) or reflected (in frontal illumination) to the lens. It may also be achieved in a microscope by using a special substage condenser, or by blocking off the center of the illuminating beam so that only the outer ring of illumination is focused onto a transilluminated specimen.

• *See also:* BRIGHT-FIELD ILLUMINATION; PHOTOMACROGRAPHY; PHOTOMICROGRAPHY.

Darkroom, Amateur

How elaborate a darkroom you make will depend primarily on your needs, finances, and space. To develop an occasional roll of black-and-white film, almost any makeshift arrangement will do. But if you want to make prints and enlargements as well, you may want a well-equipped room that is conve-

At left is a photomicrograph of the siliceous cell wall of a diatom—a type of one-celled algae—taken with dark-field illumination on Kodak Ektachrome 200 film. Magnification is 100×. Photo courtesy Ronald L. Heidke.

niently arranged and properly heated, lighted, and ventilated.

Darkroom Planning

The room must be lighttight. To check for stray light, stay in the darkroom for 5 minutes with all the lights turned off. After 5 minutes, if you still cannot see a sheet of white paper placed against a dark background, the room passes inspection. If there are light leaks, you will be able to see them because your eyes will have become adapted to the dark. (Of course, you do the testing during daylight hours.) Eliminate small light leaks with black tape. For large ones, such as the crack around a door, use dark heavy cloth or weather stripping.

Arrange safelights so that they provide as much light as possible, but keep them at a safe distance— at least 4 feet—from the working area. Use a safelight equipped with a 15-watt bulb and the filter recommended on the paper instruction sheet. An OC filter is recommended for most black-and-white papers. You can make the following simple safelight test for fogging:

1. Set the enlarging easel to give ½-inch white borders for the paper size you will use in the test.
2. Place a normal-contrast negative typical of your work in the enlarger. Be sure the clear borders of the negative are completely masked.
3. Size and focus the image on the easel.
4. With all safelights on, make a good-quality print on grade 2 paper, or on the paper you normally use. Develop for the recommended time in one of the developers recommended for the paper. Mark this print "No. 1."
5. Turn the safelights off, and make print No. 2 in the same way as print No. 1.
6. Turn the safelights off, and expose print No. 3 in the same way as print No. 2. Do not develop print No. 3.
7. With the safelights still off, place a piece of cardboard over the developing tray and put print No. 3 on it, emulsion-side up. Safelight illumination is generally brightest in this location. Cover one-fourth of the print with an opaque card

and turn on all the safelights. In the same way that you would make an exposure test strip, expose print No. 3 to the safelight for 1, 2, and 4 minutes, in steps. This gives four steps with safelight exposures of 0, 1, 3, and 7 minutes superimposed on the image exposure. Develop this print for the same length of time as prints No. 1 and 2, with safelights turned off.

8. Fix, wash, and dry all the prints in the normal manner.

When comparing the prints, prints No. 1 and 2 should be identical. If print No. 1 shows lower contrast or fogged highlights when compared with No. 2, there is a serious safelight problem. Be sure that the safelight filters (especially the one over the developing tray), bulb wattage, and distance and number of safelights are consistent with the recommendations on the paper instruction sheet.

If all three prints are identical, the safelight conditions are good. If print No. 3 shows slight fogging of highlights in any of the safelight-exposure areas, it is a warning to limit the time of exposure to safelight illumination to a time that will produce no fogging.

Note that fogging from safelight illumination will show up in areas that have already received some exposure before it will show up in the white borders. For this reason, safelight fog may go unnoticed unless the safelights are tested correctly.

In planning a darkroom, the main objective is to arrange your equipment and materials for efficiency and convenience. One of the most important requirements is to provide for a flow of work that can be done in the least amount of time with minimum effort. Another consideration is cost. Here are some desirable features for darkroom design and some suggestions to consider in setting up a darkroom.

Temporary Amateur Darkroom

For developing black-and-white films and making prints, you can get started with only a minimum of equipment, plus an easily darkened kitchen, bathroom, or any other room that has an electrical outlet. For night work, you can use practically any room as a darkroom. Pull the shades or cover the windows with some dark material to exclude light

from streetlamps, car headlights, or nearby lighted windows. A sink and a supply of water are desirable but do not have to be in the same room. The kitchen is probably the most convenient place to set up a temporary darkroom, since it is supplied with running water and electrical outlets, and the sink and counters provide adequate working space.

When space is not available for setting up a permanent darkroom and you must work in a room regularly used for other purposes, darkroom convenience sometimes has to be sacrificed. However, always try to arrange your equipment to allow for a smooth, convenient flow of work from the enlarger through the developer and stop bath to fixing and washing. You should have a large tray filled with water for washing your prints. An automatic tray syphon is a handy device for converting an ordinary tray into an efficient print washer. You should also have a container of water to rinse the solutions from your hands. This helps prevent contamination of the developer with other solutions. Use a clean towel to dry your hands thoroughly each time before handling film, negatives, and photographic paper. Group the equipment so that you can perform all operations with a minimum of steps, but allow sufficient working space. One suggested arrangement for a kitchen darkroom is shown in the accompanying illustration.

It is helpful to have a table or another separate work area on which you can perform all the dry operations, such as printing and loading film tanks. This prevents water and solutions from splashing on equipment and dry materials. Set up all wet processing operations in or near the sink.

If there is no lamp socket over the processing area, use an extension cord to suspend the safelight over the processing trays. Keep the safelight at least 4 feet from the trays. A good safelight to use in this manner is the Kodak 2-way safelamp, available from photo dealers. This V-shaped safelight directs the light in two directions at once. You can screw it into the lamp socket of an extension cord or into a ceiling socket.

The best way to develop film, especially in a temporary darkroom, is to use a film-developing tank, such as a Kodacraft roll-film tank. Since these tanks are lighttight, any light that might leak into your darkroom would affect the film only during the time you are loading it into your tank. This minimizes the danger of light fogging the film, a frequent source of trouble. Check for stray light in the darkroom by following the procedure described earlier in this article. After you have placed the cover on the film tank, you can turn on the white lights during development and the remainder of the processing steps.

A temporary kitchen darkroom might look like the set-up shown here.

Darkroom, Amateur

With a temporary darkroom, it is important to consider ways of reducing the time and energy required to prepare the room for use and to clean it up afterwards. For instance, keeping all of the darkroom equipment in one or two boxes reduces both the time spent collecting equipment and the chance of misplacing something.

While the kitchen usually makes the best temporary darkroom, other rooms will serve, too. One possibility is a bathroom. However, although it has running water and electricity, there is usually no work surface to support trays and apparatus. You can make a work surface by placing a piece of plywood on the bathtub, but processing trays will be uncomfortably low. Sometimes it is possible to set up a card table to hold your trays and printing equipment. Protect the tabletop from spilled solutions by covering it with a piece of plastic such as a plastic tablecloth.

You can also use a small closet as a temporary darkroom. A closet is usually easy to make dark, even in the daytime. This is its only advantage, however, since it will have no running water and possibly no electrical outlets. Moreover, the closet probably will be filled with its normal contents. If the closet has shelves, perhaps one of them is located at a convenient height. If not, you may be able to install a removable shelf or bring in a small table. In any case, use plastic sheeting under the trays to catch any spilled solutions.

Permanent Amateur Darkroom in a Small Closet

A permanent setup makes darkroom work much more convenient and saves a lot of time. If you have only a small closet available for use as a darkroom, make sure you utilize the space most efficiently.

Although a closet will not have running water, that is not too important if there is a sink nearby where you can wash negatives and prints. However, the closet must have electricity available. If there is no light socket in the closet, it is usually easy and inexpensive to have one or two outlets installed. It is desirable to have one socket in the ceiling for the white light, and a double electrical outlet on the wall above the bench for plugging in the safelight and the enlarger or printer. Have a licensed electrician install or inspect the wiring to make sure that it conforms to the electrical wiring code.

The accompanying diagram shows the arrangement of shelves for transforming a 3′ × 4′ closet into a darkroom suitable for developing film and making contact prints and enlargements up to 10″ × 12″. The 12-inch shelf is 36 inches from the floor and holds the developing, stop-bath, and fixing trays. The 16-inch shelf is the same height and supports the printer or enlarger.

A cabinet in the corner (upper right corner of diagram) on the wall above the processing shelf provides convenient and safe storage for your paper supply. A shelf about 9 inches wide and 2 feet above the processing shelf extends along the wall next to the cabinet and provides shelf space for a timer and other small items. This shelf should extend no farther than about 15 inches from the end of the processing shelf below so that it does not block the safelight illumination above the developing tray. Mount a safelight on the wall or ceiling no closer than 4 feet from the processing shelf. You can store bottles of processing solutions on the floor under the tray shelf.

The arrangement of shelves as illustrated is recommended when transforming a 3′ × 4′ closet into a permanent amateur darkroom.

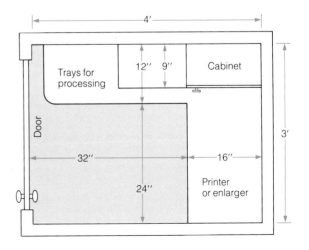

A Recommended Amateur Darkroom

Although you can produce good work in a closet darkroom, it is preferable to have a larger darkroom equipped with running water. With more room, you can make bigger prints and have space for additional equipment. For example, in the darkroom described, you can conveniently process color film and make color prints.

Location. Where you decide to locate your darkroom will depend primarily on the space available. You should, however, also consider convenience, temperature, and humidity.

Although a room on the first or second floor is suitable for a darkroom, a dry basement is usually the ideal location. If your basement is damp, you can make it dry by using a dehumidifier, available from appliance and department stores. The ideal relative humidity for darkroom work is between 45 and 50 percent; the ideal temperature is between 18 and 24 C (65 and 75 F). It is usually easier to maintain this temperature in a basement than in any other part of the house. Furthermore, hot- and cold-water connections and electrical connections are generally available in a basement. Another advantage is the ease of making a basement lighttight. Most basements have only a few small windows that you can easily cover with a piece of fiberboard or dark cloth. One more advantage of the basement darkroom is that spilled solutions are likely to cause little damage. However, all spilled solutions should be wiped up immediately.

A damp basement without a dehumidifier is not a good location for a permanent darkroom. Dampness causes mildew and rust on supplies and equipment. It also causes deterioration of films and papers, which results in weak, mottled pictures. However, if you must use a damp location, store chemicals, films, and printing papers where it is cool and dry, and bring them to the darkroom only when you need them.

An attic is another location that is usually not satisfactory for use as a darkroom. Unless it is well insulated, an attic is likely to be too hot in the summer and too cold in the winter. Also, it is usually difficult and expensive to install plumbing in an attic.

Size. The layout for a recommended darkroom, shown in the accompanying illustration is designed to provide the utmost convenience in the flow of work. The space used for such a darkroom should preferably be neither smaller than 6′ × 7′ nor larger than 10′ × 12′. The plan shown will fit within these limits.

You can close off the darkroom space from the rest of the area with partitions of wallboard. Although this is desirable, it may not be necessary in a small basement if your furnace burns oil or gas. However, if you have a hand-fired coal furnace, you should close off your darkroom to keep it free of dust from the coal and ashes. Also, partitions will prevent light from entering the darkroom if someone opens the door to the basement. As a precaution, put an appropriate sign on the darkroom door to show that the room is in use.

Capability. You can use the darkroom illustrated for both black-and-white and color work. It is designed so that you can process roll film or sheet film, make contact prints, and make enlargements up to 11″ × 14″ or 16″ × 20″, depending on the size of the room. You can also readily adapt the room for other types of work, such as copying. The darkroom layout is arranged so that you can work efficiently with a minimum of wasted motion. It is also designed so that two or more people can divide the various operations and work together without interference. You can provide an area for drying negatives by stringing spring-type clothespins or film clips on a galvanized wire suspended between two walls in your darkroom. Use the clothespins or film clips to hold your films by the edges while they dry. To keep construction costs at a minimum, you can omit conveniences such as tray racks and frames covered with nylon screening for drying prints (shown on the shelves under the contact printer).

Arrangement. The darkroom units illustrated include a dry bench and a wet unit, each 26 inches wide and 6 feet long. You can either have them built in a woodworking shop or assemble them from ready-made kitchen cabinets.

Use the dry bench for enlarging and printing, and for handling films, negatives, and photographic paper. Since storage space for supplies and accessories is very important for work in this area, drawers and shelves are provided. Also, it is convenient to have a lighttight drawer, or dark drawer, near the printing equipment. This will provide quick access to printing paper when making prints, and will eliminate the necessity of opening and closing the pack-

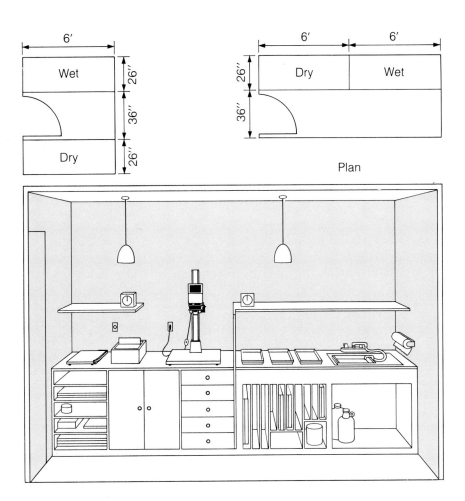

6′

Wet

26″

36″

26″

Dry

6′ 6′

26″

Dry Wet

36″

Plan

A recommended permanent dark-room like the one illustrated should be equipped with running water and should provide adequate space for equipment.

age of paper every time you need a sheet of printing paper. When you have finished printing, return the unused printing paper to its original package.

To make a dark drawer lighttight, install a sliding lid that fits into a groove around its top perimeter. Paint the inside of the drawer and the lid flat black. Attach a small block of wood on the top of the lid and another one on the underside of the countertop. The blocks of wood will push the lid closed when you close the drawer.

You can use the space on top of the wet, or sink, unit for mixing chemicals and for all processing operations. Storage space for processing trays and chemical solutions is beneath this bench. Shelves mounted 2 feet above each unit provide storage space for bottles of stock solution, timers, thermometers, and other small equipment. Wooden pegs mounted on the splash guard provide a place to keep

A lighttight draw for storage of light-sensitive materials must have a sliding lid, and its inside, including the lid, must be painted flat black.

graduates. A towel holder mounted near the sink provides a towel for drying your hands.

Locate the dry and wet units either on opposite sides of the darkroom with ample space between them or side-by-side with a splash guard separating them. With either arrangement, equipment and materials will be protected against water and solutions splashed from the wet work area.

A safelight is suspended over each unit at a distance of no less than 4 feet from the working surface. To provide safelight illumination for the dry bench, you can use a Kodak darkroom lamp or a Kodak 2-way safelamp; for the processing area, a larger safelight is useful. Double electrical outlets, properly grounded, are mounted over the units for plugging in the printer, enlarger, and other equipment.

A hot-and-cold mixing faucet is mounted over the sink. The nozzle should be at least 15 inches above the sink bottom, to provide space for filling gallon bottles.

Because water and solutions will be spilled on the wet unit, it should have a waterproof surface. An excellent material for this is sheet plastic, widely used for kitchen counters and tabletops. Sheet plastic has an extremely hard surface that is resistant to most stains and corrosion. It is available in a variety of attractive colors and is easy to keep clean. You can purchase this material in sheets and cement it to the top of the unit, or you can purchase it as a laminate on plywood, a form that is easier to install. You can also obtain a professional custom-made plastic counter top; most cities have firms that specialize in such products.

Another material that you can use on top of the unit is linoleum. You can extend the linoleum up the back wall to the shelf to protect the wall from splashes and eliminate the sharp, dust-catching corner at the rear. Treat the linoleum with a hard wax, rubbing the wax thoroughly into the surface to prevent penetration of spilled solutions. You can install vinyl floor materials in sheet form for the counter top of the unit in much the same manner as you would install linoleum. Vinyl is somewhat more expensive than linoleum, but it is more resistant to spilled solutions. Corrugated rubber matting also makes an excellent covering since it is resistant to chemical solutions and is easily cleaned. You can also use rubber sheeting. If you do not install a waterproof covering, the joints in the bench top must be tight enough to prevent solutions from dripping onto the shelf below. Also, to protect the wood, coat the bench top with a chemical-resistant paint or lacquer.

Equipment Placement and Work Flow. If you study your work pattern in the darkroom, you will readily see the reasons for the recommended arrangement of the bench units and equipment. To make enlargements, for example, take a package of photographic paper from the paper-storage shelf, open it, and place the paper in the dark drawer. After placing a negative in the enlarger and composing the image on the enlarging easel, place a sheet of printing paper in the easel and expose it. (For contact prints, place your printer on the bench next to the enlarger.) After the paper is exposed, pass it on to the developer and the rest of the processing solutions. Then wash your prints in the sink or in a tray equipped for washing.

When you have completed your work, you can place all equipment—including the printer, easel, and trimming board—on a shelf below the bench. This leaves the bench top clear for all other activities.

One last point to remember: Darkroom cleanliness is very important for making pictures of high quality. Rinse the processing equipment you have used with water, and wipe the work surfaces clean with a damp viscose sponge. Reserve a sponge for this purpose; wash it throroughly after each use to prevent a buildup of chemical contamination.

• *See also:* DARKROOM, PROFESSIONAL; BLACK-AND-WHITE PRINTING; COLOR PRINTING FROM NEGATIVES; COLOR PRINTING FROM TRANSPARENCIES; CONTACT PRINTING; ENLARGERS AND ENLARGING; PRINTING, PHOTOGRAPHIC; SAFELIGHTS; TANKS; TEMPERATURE CONTROL.

Further Reading: Eastman Kodak Co. *Basic Developing, Printing, Enlarging.* Rochester, NY: Eastman Kodak Co., 1977; Fineman, Mark. *The Home Darkroom,* 2nd. ed. Garden City, NY: Amphoto, 1976; Happe, I. Bernard. *Your Film and the Lab.* New York, NY: Hastings House, 1975; Hattersley, Ralph. *Beginner's Guide to Darkroom Techniques.* Garden City, NY: Doubleday Co., 1976; Kirkpatrick, Kirk. *Basic Darkroom.* Los Angeles, CA: Petersen Publishing Company, 1975.

Darkroom, Professional

On the professional level, the concept of a darkroom involves far more than just a lightproof room where films are loaded and processed and prints are made. Because of the great variety of work that may be done, and the volume of work, a professional installation is really a photolab. In addition to the darkroom, there must be areas for storage, chemical mixing, drying, print finishing, and related activities. Such support areas can be fully lighted for ease of working.

Although the needs of professional photographers are extremely diverse, processing rooms and support areas have many features in common, regardless of what kind of photography is done. In order to create the kind of facility that will meet *your* requirements, you must do some systematic planning. Before you can consider the details of laboratory layout and construction details, you must look at exactly what your needs are—short-term needs and future, long-term needs.

Preliminary Planning

Begin the planning by asking yourself a series of questions:

1. What kinds of operations will I be doing in the photolab?
 Black-and-white film processing?
 Black-and-white printing?
 Color-film processing?
 Color printing?
 Print finishing?
 Lith film work?
 Special processes?
 Motion-picture processing?
 Microfilming?
 Copying?
2. What volume of work do I anticipate in the new facility?
3. How many people will work in the photolab?
4. How much room do I have or will I need?
5. Do I have adequate solution-treatment and disposal methods available?
6. Is efficient work flow, or the best use of space most important?
7. Is location important to my business?
8. What kind of building is suitable?
9. Will I need mechanized equipment, or can I do operations manually?
10. Are adequate facilities available for rental, or must I create my own?
11. Are adequate utilities—water, electricity, heat—readily available?
12. What finances do I have or can I obtain in terms of what I will probably need?
13. If the market for my services changes and grows, can the lab be adapted easily?
14. Will a new facility provide a return in increased profit, better service, or increased production?

Consultation

In carrying out your planning and building of a photolab, you may be able to figure out everything yourself or with a little technical assistance. But if you are going to be involved in extensive remodeling or construction, if you are going to create a facility where several people will be working, you will probably need to consult some or all of the following professionals.

Architect. In addition to design services and cost estimating, an architect can, and usually must, determine zoning and building codes, pollution abatement requirements, fire protection, and other required standards. An architect can let bids, retain a contractor, and supervise construction.

Building Contractor. The contractor will carry out construction, installation, and finishing details, and will supervise all workers and subcontractors. If you have the experience, and can afford the time, you could be your own general contractor, hiring and supervising workers. However, a professional can do it better, and this involves dealing with just one person, rather than five, or a dozen, or more, to see that everything is the way you want it.

Industrial Engineer. If the installation is large, with automatic processors and similar equipment, the advice of a specialist is essential.

City Planning Engineer. In many communities, a city engineer oversees building codes, zoning restrictions, and waste management. If you are not

To determine the most efficient layouts for the workrooms, make scale templates of each piece of equipment and all fixtures, and arrange them on grid paper. For paper ruled in 1/4-inch squares, make the templates to a scale of 1/4-inch to 1 foot.

Layout

When you have decided what your needs are, make a preliminary layout from which you, an architect, or a contractor can make detailed plans and draw up specifications for construction.

To start the layout, make a checklist similar to the accompanying one. Check each area that applies to your work, and make a separate list of the equip-

employing an architect, you must contact the engineer to approve your plans. His or her office will inspect your construction at intervals to make sure all codes and restrictions are being observed.

Real-Estate Agent. If you need to lease or purchase a location, a real-estate professional is a good starting point.

Lawyer. You will need legal assistance to discuss contracts for real-estate acquisition, building, or finance. A lawyer will also advise you about your obligations under business laws, and tax and insurance laws.

Banker. If you need funds, a banker can advise you on loans and methods for financing a business.

Photographic Manufacturer's Representative or Photographic Dealer. Every manufacturer or dealer in equipment and supplies is interested in your success. They can assist you in selecting and evaluating equipment and setting up the required processes.

Professional or Trade Association. There are many benefits to membership in trade associations and professional organizations. Some groups may provide direct help in planning, as a membership service. Even if the group has no such service, you can derive a great deal of information and ideas through discussion at meetings and seminars.

Once you have evaluated your needs and received preliminary advice, you can consider the details of your photolab.

LAYOUT CHECKLIST

Room	No. Req'd.	Approximate Minimum Size Length × Width	Sq. Ft.
Reception			
Offices			
Dressing			
Mail-order receiving			
Prop storage			
Sensitized-goods storage			
Chemical storage			
Rest rooms			
Building services			
Lunchroom			
Studio or camera			
Process camera gallery			
Finishing			
Copying			
Chemical mixing			
Quality control or viewing			
Process camera darkroom			
Film-loading darkroom			
Black-and-white film darkroom			
Color film darkroom			
Black-and-white printing darkroom			
Color printing darkroom			

ment and fixtures that will be present in each room. Using templates and grid paper, follow the procedure described in the following text to find the space needed for each room. Enter these areas, in square feet, on the checklist. This will show the total space needed.

To find the amount of space needed for each room, cut scale templates of all the equipment and fixtures that you intend to use. Make the templates to a scale of ¼-inch to 1 foot, and lay them out on a sheet of paper ruled in ¼-inch-squares. Each square represents 1 square foot of floor space. For metric layout, use a scale of 1 centimetre equal to 1 metre and use centimetre grid paper. Employ this method to indicate the area needed for the required equipment or to indicate how well the equipment will fit in a limited floor space.

Remember to allow sufficient room for free movement of operators around the sinks, benches, and equipment. In the case of machinery, allow space for safe operation as well as for access to clean, repair, or service the unit.

The following figures can be used as a guide to the amount of working space needed by one or more operators. However, when dimensions are calculated, remember that some operations may require extra space for handling the material. For example, more room is needed at a sink where big enlargements are processed.

1. If one operator works in a room, allow about 76–91 centimetres (30–36 inches) of space between benches or between bench and sink for free movement.
2. If two operators work together, allow about 91–107 centimetres (36–42 inches) of space for free movement.
3. If more than two people work together, allow at least 122 centimetres (48 inches) of space where they must pass one another, or use a common gangway.
4. A corridor that carries general traffic or that is the main route to a fire exit should be at least 1.5 metres (60 inches) wide.

In making your preliminary layout, allow space for a chemical-mixing room, storage rooms, an office, rest rooms, and an air-conditioning plant. If

possible, locate rest rooms away from the main working area.

When you have determined the dimensions of each room by the foregoing method, combine the layouts of each area. Lay the templates on a large sheet of grid paper on which you have outlined the total space available. Remember to leave space for corridors and for free access to workrooms.

Work Flow

To avoid the waste of time and energy caused by backtracking and cross flow, place operations in the

Diagram the sequence of lab operations to establish requirements for efficient work flow. Such a diagram will help determine location of workrooms and placement of equipment.

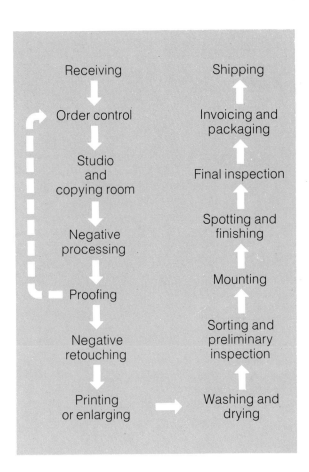

production cycle so that they follow each other in the order in which they are performed.

In a photofinishing plant, for example, where the order-service time may be no longer than one day, hindrances to production and the orderly flow of work are of great concern. Therefore, work must be kept moving at all times. In a small studio or an in-plant photographic department, fitting the equipment into the smallest possible space or making each piece of equipment do as many jobs as possible may overrule work-flow requirements.

Sequence of Operations. Ideally, the sequence of steps in photographic production should follow the pattern indicated by the work-flow chart. However, the pattern may have to be modified to suit the shape of a particular work area, to balance work load, or to accommodate individual operating requirements.

Equipment

During the design process you must assess your photographic needs and select the equipment that will be permanently installed—sinks, cupboards, heating and air-conditioning units, and the like. Consider your current work load and anticipated future expansion, and compare this with the advertised capacity of the equipment you are considering.

Do not underestimate the need for supporting equipment when you evaluate an equipment purchase. Consider, for instance, buying an enlarger. In addition to the enlarger, you will need additional lenses (and perhaps matching condensers), filter sets, a voltage stabilizer, a timer, an on-easel photometer, a static eliminator, and an easel. The enlarger is of little use if many or all of these accessories are not purchased with the enlarger itself. The same is true for other basic equipment. To make a realistic assessment of equipment needs, you should consult with a photographic dealer who can help you list the equipment and can recommend alternatives for added capacity, versatility, or convenience.

Darkrooms

Processing Rooms. A film-processing room for black-and-white work is usually about 1.8 × 2.4 metres (approximately 6′ × 8′). The space required for color-film processing varies according to the design of the processing unit, the number of steps in the process, and the arrangement of the tanks. One central wash tank can provide space-saving in processing color films, provided that the tank is one of the quick-emptying or quick-dump types. On the other hand, a single wash tank limits production because only one rack of film can be processed at a time. If you have large quantities of color film to process, install a wash tank at each step of the process that requires a rinse. In some processes, a pass-through permits a part of the process to be carried out in white light.

To avoid the possibility of fogging fast film, make the same test for complete darkness as described later in this article for film-loading rooms. Also, install a locking device on the white-light switch to prevent the light being switched on when valuable films are being processed.

Equip the film-processing sink with duckboards and a means to adjust the temperature of processing solutions. In small-scale black-and-white work, an immersion heater and a cooling coil through which cold water can be passed will serve the purpose. If processing is frequent, stand the tanks in a bath of tempered water to maintain the necessary temperature conditions.

Nitrogen-Burst Agitation. To process large quantities of color materials, a gaseous-burst agitation system is essential. Install this with a set of tanks in an ordinary processing sink, or buy a processing unit with nitrogen-burst fittings already in place. The elements of a gaseous-burst agitation system include a tank of nitrogen at an initial pressure of 2000 pounds per square inch, a pressure regulator or control valve, an intermittent-gaseous-burst valve, and gas distributors to fit the tanks in use. You can use compressed air in solutions other than developer; however, make sure that the compressor delivers oil-free air. Some solutions require the use of compressed air to regenerate the solutions.

Mechanized Processing of Black-and-White Sheet and Roll Films. Where large amounts of sheet films must be processed, or where the negatives are required for printing in the minimum of time, consider installation of an automatic film processor such as a Kodak Versamat film processor. These machines save space and time by delivering negatives that are dry and ready for printing in approximately 6 minutes.

Black-and-White Printing Room. Darkrooms for black-and-white printing vary in size from those

This is one-half of a 16-station instructional darkroom that might be used by a newspaper photographers' pool or a camera club. The center sink is divided, and the divider has multiple taps, all temperature-controlled by a single mixing valve.

that accommodate one operator who prints only occasionally to those large enough to permit a number of people to print and process throughout the day. For the individual, a room 1.8 × 2.4 metres (approximately 6' × 8') is comfortable and large enough to contain any equipment that he or she needs for ordinary printing work. In some press photography, camera clubs, and similar situations, a number of individual darkrooms of this kind may be preferable to one large printing room. Quantity production of prints is best done in a larger room where several people can work together. Large darkrooms with multiple printing stations save darkroom construction costs, provide for better supervision, and permit group instruction.

Provide processing sinks and washing tanks that are as large as space permits, if you habitually make prints in large quantities or in the larger sizes. Sinks that are too small restrict production and involve extra handling of prints to achieve efficient processing. Do not install an oversize sink just for an occasional large print. Use half-round trays or use only two trays (for developer and fixer) or stack trays.

Safelighting for Black-and-White Printing. A printing darkroom should be as well lighted as safety of the material in use permits. (*See:* SAFELIGHTS.) However, do not allow the direct rays from a safe-light to fall on the enlarging easel. The direct light may obscure the projected image and make both dodging and exposure assessment more difficult.

If you install several printing rooms, make sure that the lighting conditions are the same in each room. That is, the number and positions of the safelights, as well as the reflectivity of the walls and ceiling, should be the same. With this uniformity, printers can transfer from one printing room to another with a minimum of inconvenience. When a darkroom is to be used for two different purposes requiring different safelights, it is a great time saver to have two sets of safelights on two different circuits. Conversion of the safelights is as simple, then, as flipping two switches.

Many printers habitually examine their prints under a white light placed over the fixing bath. This practice may be objectionable in a shared darkroom. Some operators fashion a long, cylindrical shade around the light and position it within a few inches of the surface of the fixer tray. Used with care, such a light will not disturb other printers.

Color-Printing Darkrooms. A room approximately 2.4 × 3.1 metres (about 8' × 10') is sufficient for exposure and processing of small quantities of color prints. If you use a 20 × 25-centimetre (8" × 10") enlarger, you must allow some extra space to accommodate this bulky piece of equipment.

Remember also that big enlargers require more headroom than smaller ones—3.1 metres (approximately 10 feet) is usually sufficient—although making provision for lowering the easel to the floor may reduce this requirement somewhat.

On a production basis, three Kodak rapid color processors, model 11 (prints to 28 × 36 centimetres or 11″ × 14″), model 16K (prints to 40 × 50 centimetres or 16″ × 20″), and model 30A (prints to 75 × 100 centimetres or 30″ × 40″), provide a convenient way to process small quantities of prints. These machines can handle the output of a one-man operation. Only a single processor is necessary for occasional work, of course.

In a photolab where several people are color printing, individual printing darkrooms are necessary. A centrally located basket processor can handle the output of exposed prints from a number of operators. You can install either a manually operated or an automatic basket processor. These machines are available in sizes to suit your operation.

The darkroom should be large enough to accommodate the dark end of the process, a small bench, and a lighttight box to hold a loaded basket. To avoid too frequent opening of the darkroom door, install a lighttight pass-through in the wall to receive boxes of exposed prints.

Install a light lock, formed by two doors, between the two rooms, or install a door-operated switch that turns the white light off automatically when the darkroom door is opened.

Large Prints and Photomurals. You can make a limited number of black-and-white prints—up to 76 × 102 centimetres or 30″ × 40″—in a medium-size printing room. Use half-round trays as a convenient way to process a few prints of this size. Using this method, roll and reroll the paper through the solutions until the process is complete.

For large color prints, process the enlargements on Kodak Ektacolor 37 RC paper on drum-type processors especially made for the purpose. The Kodak rapid color processor, model 30A, handles 76.2 × 102-centimetre (30″ × 40″) color prints and provides a 6½–7½-minute process for Kodak Ektacolor 37 RC paper. The alternative to a drum processor is a large tank-type processor. For more detailed information, see the articles DRUM AND TUBE PROCESSING; LARGE COLOR PRINTS AND TRANSPARENCIES; and MURALS.

Film-Loading Room. The size of this room should be about 1.2 × 1.5 metres (4′ × 5′), and it should be situated close to, or adjoining, the camera room. Absolute darkness, cleanliness, and freedom from materials that generate static charges in film are the main requirements for a loading room.

A space that appears quite dark to unadapted eyes may still be unsafe for handling film. The best way to check for light leakage is to close the door and remain in the darkened room for about 10 minutes. When your eyes are adapted to the dark, you will readily see any leakage of light into the room. Ventilation openings and cracks above and below the door are the main sources of light leakage. Use strips of polyurethane foam or similar material to caulk the door; mask air ducts and fan openings with louvered boxes over the openings.

Cleanliness is very important in a film-loading room; a dust-free atmosphere in this area saves you an immense amount of time-consuming spotting of both negatives and prints. To reduce static charges, avoid plastic bench tops—polished wood is more suitable—and do not wear clothing made from synthetic yarn when you are handling film. Maintain the relative humidity above 45 percent. If dust is a problem or if your work is critical, consider installing a laminar-flow workbench or air-filter unit. If you decide to use such a unit, allow an extra space for the filter unit at one end of the bench.

Painting Darkrooms. It is advisable to consider safelight illumination when the darkroom is painted. Paint the ceilings white for use with indirect safelights. Darkroom walls should be painted a light color, preferably a color similar to that transmitted by the safelight filters to be used. A light tan or buff is suitable for a black-and-white printing room, for example. Paint the wall area immediately behind each enlarger a matte black to avoid possible reflection of white light from the enlarger onto the paper. A matte black paint is also useful around light locks to prevent unwanted light from entering darkrooms. A single 10-centimetre (4″) white line at eye level parallel to the floor is a useful guide for safety. There are some situations where the all-black darkroom is desirable to prevent fog or latensification.

Darkroom Entrances Small darkrooms—such as those used for film processing, film loading, and small-scale printing work—usually have a single lighttight door. Provide doors of this kind with a

small lock or bolt that can be forced easily in an emergency.

The Light Lock. This type of entrance generally serves larger film-processing rooms and color-printing rooms, where safety and free access are required. A light lock consists of a small hall with two doors, one of which opens into the darkroom and the other to the outside. These doors are either opposite or adjacent to each other. Interlocking devices, either electrical or mechanical, prevent accidental opening of both doors at the same time. However, the interlocking system must incorporate a safety release so that it will be possible to open both doors in an emergency, or when bulky objects must be moved in or out of the darkroom. In processing rooms where several people work, there should be an emergency exit in the form of a door easily opened from the inside. This door also permits movement of large pieces of equipment or supplies.

To relieve changes in air pressure caused by opening and closing the doors, and to provide some ventilation, install a lightproof vent in either a door or a wall of the light lock. Illuminate the dark interior of the light lock with a suitable safelight.

Minimum dimensions for a light lock depend on the size of the doors. The smallest useful door size is 2 metres (80″) high and 60–75 centimetres (24–30″) wide. Leave enough space between the doors to permit a person going through to open or close either door from within while the other door remains closed. If space is at a premium, use sliding rather than hinged doors.

A center sink with a pass-through to the finishing area is useful for many larger darkroom applications.

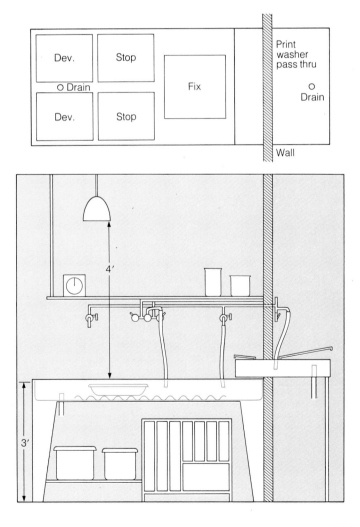

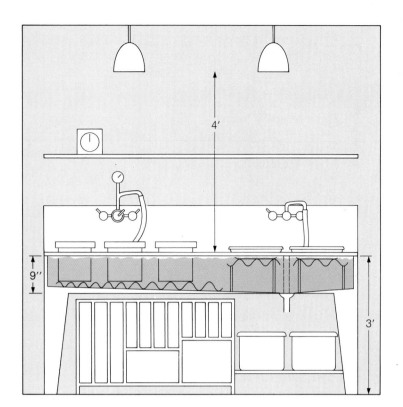

The basic darkroom should be equipped with a multi-purpose sink and duckboards of various heights to provide a place for film-processing tanks or print-processing trays.

This enlarging station has ample cupboard and drawer space. The enlarger easel can be lowered to provide additional enlargement capability. At either side of the enlarger is a space large enough for a stabilization processor.

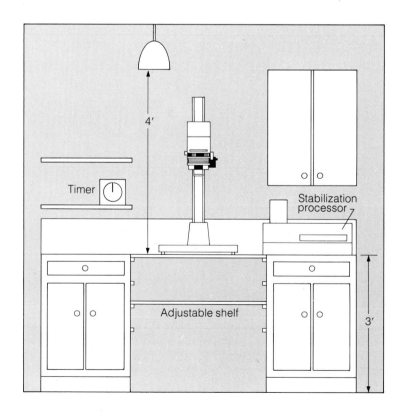

Timer

Stabilization processor

Adjustable shelf

Darkroom, Professional

The light trap or light lock, which affords light-safe entrance to the darkroom, is a unique feature of photo-labs. A number of designs provide a choice for ease of access, space utilization, or light safety. The diagram with a projected ray from the outer entrance shows the requirements for constructing a maze-type light trap to block light reflections from outside.

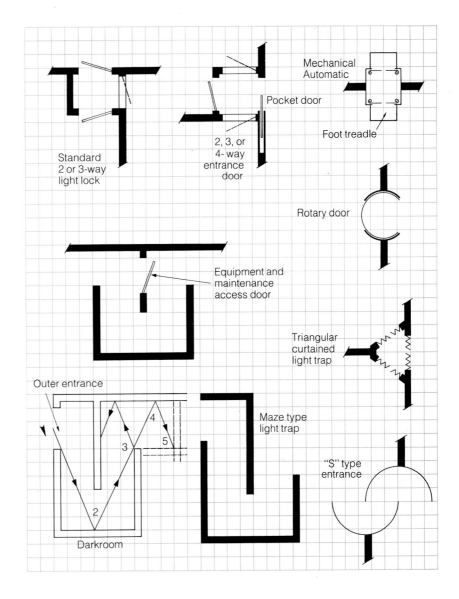

Standard 2 or 3-way light lock

2, 3, or 4-way entrance door

Mechanical Automatic

Pocket door

Foot treadle

Rotary door

Equipment and maintenance access door

Triangular curtained light trap

Maze type light trap

"S" type entrance

Outer entrance

Darkroom

The Light Trap. This type of darkroom entrance is suitable mainly for black-and-white printing rooms, because total darkness is difficult to achieve with such a doorway. However, it does permit easy passage from room to room, and it also allows free air circulation. An efficient light trap requires at least twice as much space as a light lock.

The accompanying drawings illustrate varied designs for light traps. The safety of a light trap depends on reducing reflection of white light to a minimum. Paint the interior walls of the light trap with matte black paint. Avoid placing this kind of darkroom entrance opposite a window or a light-colored wall. To further reduce reflection, subdue the illumination in the immediate vicinity of the entrance to the light trap. To help guide people through the darkened entrance, paint white arrows at eye level throughout the interior walls and install a safelight.

It is usually impossible to pass bulky articles through a light trap; in order to overcome this difficulty, place a lighttight door in the center baffle. As an alternative, situate an emergency exit in another part of the darkroom. Use this door to move goods

and large pieces of equipment in and out of the room.

To permit easy access, make the light-trap entrance at least 60 centimetres (2 feet) wide. To reduce the amount of light entering from the outside, keep the entrance height to less than 2 metres (80 inches) high.

Curtains. If space is limited, neither a light lock nor a light trap may fit. In such cases, curtains probably provide the best means to black-out darkroom entrances. However, this alternative is most suitable for black-and-white printing rooms or for rooms where a high degree of safety is not necessary. If the illumination outside the darkroom is strong, two pairs of curtains deeply overlapped and placed about 45 centimetres (18 inches) apart will make a fairly good light lock. Curtains should be opaque, of course, and made from a strong fabric that will withstand considerable abuse. Install the curtains as close to the floor as possible, and weight the bottom edges with heavy chain to keep them in place.

Support Areas

There are a number of reasons why chemical storage and mixing, print and film drying, and finishing operations should be carried on outside the darkroom and be kept separate from one another.

These procedures can be performed in full light; there is no sense in having to shut down darkroom operations in order to carry them out. Dry chemicals powder into the air, and liquid chemicals and solutions splash and spill during mixing. They could contaminate storage areas and darkroom surfaces where sensitized materials are handled. The frequent moist, humid conditions in a darkroom can affect dry chemicals, will slow film and print drying, and could damage materials during finishing.

Although separated from the darkroom, support areas should be logically located for work efficiency. Place drying facilities close to processing rooms to reduce the distance wet materials must be carried. Chemical storage and mixing areas should be next to one another, with the mixing area close to the darkroom to ease the problem of transporting quantities of solutions. If the quantities of solutions used are large, special chemical plumbing systems to carry the solutions from a bulk storage area to the point of usage should be considered. Finishing areas should be as far from processing and mixing areas

as conveniently possible, to avoid contamination of the final product. The facilities, as well as the techniques for these support operations, are covered in separate articles; see the list at the end of this article.

Ventilation and Air Conditioning

The health, comfort, and efficiency of personnel, as well as the proper conditions for processing, handling, and storage of photographic materials, depend on a suitable atmospheric environment.

Processing operations in photography are usually accompanied by chemical odors and fumes, by high humidity from processing solutions or wash water, and by heat emitted by lamps, electric motors, dryers, mounting presses, or high-temperature processing solutions. Therefore, it is necessary to introduce a plentiful supply of clean, fresh air (within the optimum ranges of temperature and relative humidity) into all processing rooms.

Air Supply and Movement. The volume of incoming air should be sufficient to change the air in a processing room in about eight minutes. The flow of air should be diffused or distributed so that objectionable drafts are not created. Apart from causing personal discomfort, drafts can disturb the uniformity of surface temperature on drying drums and other heated equipment.

Provide suitably placed exhaust outlets to remove humid or heated air and chemical vapors. The air flow should be arranged so that hot air or vapors do not traverse the room, but, instead, are immediately exhausted.

Some operations in photographic work require local ventilation by an extraction hood. These operations include print drying by continuous-processing machines, film drying in heated cabinets, chemical mixing, sulfide toning of prints, spraying prints with lacquer, and certain steps in color processes. In all cases, follow the safety recommendations given in the instruction sheets packaged with the processing chemicals.

The ventilation hood should be placed as close as possible to the source of the contaminant; this will provide efficient extraction. For a processing tank, use a hood with a narrow opening placed at the back of, and level with, the top edge of the tank.

Temperature and Humidity. Temperatures between 18 and 24 C (65 and 75 F), coupled with a relative humidity between 45 and 50 percent, are

compatible with photographic work generally. At the same time, these ranges provide comfortable working conditions for most people.

In small-scale black-and-white work, some deviation from these standards is acceptable. Many difficulties stem from lack of uniformity in both temperature and relative humidity. In all color processing and in continuous processing of both black-and-white papers and films, accurate control of temperature and relative humidity is essential.

A proper level of relative humidity is necessary in all photographic work. Excessive humidity is personally uncomfortable, and it has adverse effects on photographic materials. Insufficient humidity causes respiratory discomfort in people, static buildup on films and equipment, and curl and brittleness in photographic paper. With low relative humidity, water evaporates rapidly from solutions in open trays, and static charges build up readily in the film. Such charges attract dust to the surfaces of the material and also cause discharge markings that often render a good negative unusable.

Water Quality, Conditions, and Systems

An abundant supply of relatively pure water is essential to photographic processing. Generally, municipal or public water supplies are sufficiently pure for photographic use. Such water almost always contains added chlorine and often added fluoride. In addition, it may contain traces of detergents, weed-killers, and insecticides. Fortunately, these substances are not usually present in sufficient quantities to have an adverse effect on photographic materials or solutions. Excessively hard water can be troublesome in chemical mixing. Very soft water swells and softens the gelatin on film and paper during washing.

The hardness of water is measured in parts per million of calcium carbonate ($CaCO_3$). The following gives the quantity of this substance contained in water described as soft or hard:

Soft Less than 40 ppm
Moderately hard 40 to 120 ppm
Hard 120 to 200 ppm
Very hard Over 200 ppm

The practical limits of water hardness for photographic use are 40 parts per million to 150 parts per million of $CaCO_3$. The local water authority or water company can usually provide information about a particular water supply. Since there are seasonal and possibly other periodic changes in the condition of a water supply, the long-term monitoring by the water company is more reliable than the analysis of a single sample of the water.

However, when considering any water source, and especially if you intend to use an undrinkable water supply or water from a well, have a sample analyzed. If it is below the level of impurities given in the accompanying table, it is suitable for photographic use.

PRACTICAL LIMITS FOR THE COMMON IMPURITIES IN WATER FOR PHOTOGRAPHIC PROCESSING

Impurity	Maximum or Range of Content (ppm*)
Color and suspended matter	None
Dissolved solids	250.0
Silica	20.0
pH	7.0 to 8.5
Hardness, as calcium carbonate	40.0 (preferable) to 150.0
Copper, iron manganese (each)	0.1
Chlorine, as free hypochlorous acid	2.0
Chloride (for black-and-white reversal)	25.0
Chloride (for color processing)	100.0
Bicarbonate	150.0
Sulfate	200.0
Sulfide	0.1

*Parts per million.

Conservation of Water. In more and more areas, good water is in short supply. Water supplies must be conserved in every way possible. Although there are a number of ways to save water in processing, you can take the following steps when you install or equip new photographic facilities:

1. Install efficient washers; the water in a washer should change completely every 5 minutes.

2. Do not use washers that are too large for the size of prints or batches of prints to be washed.

3. Insulate all long hot-water lines. This helps to save water by making hot water available immediately when the tap is turned on. At the same time, it saves money on the fuel used to heat the water.

4. Use stabilization processing where possible. The Kodak Ektamatic processor uses no water in print processing. The Kodak Royalprint processor is very water efficient.

5. Provide adequate space for trays or tanks of Kodak hypo clearing agent; this preparation can save two-thirds or more of the water normally used to wash negatives and prints.

6. Use water from wells or other untreated sources with proper treatment and filtration.

7. Reduce unnecessary water depth in washing tanks or trays. A greater rate of flow is necessary in this case to achieve satisfactory washing in the minimum time.

8. Use a Kodak automatic tray siphon or a similar tray bailer if you wash sheet materials in a tray, because water running into a tray from a tap or hose pipe does not usually make an efficient washer.

9. Use water conservation devices for automatic processors. When a machine is standing by, conservation fittings automatically reduce the flow of water through the machine to that necessary to maintain solution temperatures only.

10. Wash prints, where possible, in three stages by arranging three washers in series—each one at a lower level than its predecessor. In this way, fresh water from the upper tank flows into the two lower tanks. Move prints at regular intervals from the lowest tank—where the bulk of hypo is removed—to the intermediate tank and then to the upper tank, where washing is completed by the incoming fresh water. Use a ringing clock to time the intervals; you will eliminate guesswork and avoid too long a washing time and the consequent waste of water.

11. Use seawater, where it is available and fresh water is very scarce, to wash films and prints. Salt water is very efficient in removing hypo from photographic material. However, residual sodium chloride causes fading of the silver image, especially when combined with residual hypo. Therefore, if seawater is used for washing, give a final wash of five minutes—or four complete changes—in fresh water.

Other important aspects of using water in the darkroom are discussed in the articles MIXING PHOTOGRAPHIC SOLUTIONS; TEMPERATURE CONTROL; and WASHING.

Plumbing. Improperly designed plumbing can easily disrupt the routine in an otherwise efficient processing room. With careful materials selection and proper installation, you can avoid the troubles that result from an inadequate water supply, corrosion, or obstruction of the drainpipes.

Plumbing installations are most economical and efficient when all sinks and drains utilize a common drain along outer walls of the darkroom area. This offers the additional advantage of making internal partitioning simpler and more flexible. Avoid long runs of uninsulated, exposed piping in order to minimize temperature fluctuations of the water supply.

Pipes supplying water to a sink should be high enough to provide a clearance of at least 40 centimetres (16 inches) between the sink bottom and the faucets. This allows room for a 4-litre (1-gallon) jug or a standard 13-litre (3½-gallon) tank to sit in the sink beneath the faucets. The sink should have at least two faucets—a swing spout with hot and cold water and a cold water faucet with a hose attachment for rinsing trays and other equipment.

Water Distribution. The size of the main supply, or intake, pipe depends on the total amount of water needed in the installation. For small establishments employing hand-processing, a 1-inch-diameter pipe with ½-inch branches is satisfactory. In larger installations, particularly those which use

mechanized processing machines, a supply pipe of larger diameter will probably be necessary. If you estimate the total water in gallons per minute that will be drawn at any one time, your plumbing contractor can determine the diameter of the pipe to be used.

Drainage Systems. The drainage line must be ample to accommodate the maximum flow of water from the sink. It should be at least 2 inches in diameter. The flow capacity through the drainage line depends not only on its size but also on the pitch of the pipe. The National Bureau of Standards and the National Plumbers Association recommend that the pitch be at least ¼-inch per foot. It is always good practice to flush the drain with rapidly flowing water after old processing solutions have been discarded through it. This minimizes corrosion and washes away any sludge or gelatin that may be present.

The nature of the chemicals carried into the drain requires that the line be constructed of acid-resistant and corrosion-resistant material. In addition, the pipes should be able to withstand rapid changes in the temperature of the water without cracking.

Generally, drains last indefinitely if chemical solutions, particularly acid solutions, do not stand in the traps and pipes for any length of time. After discarding processing solutions, flush the drains thoroughly with cold water. Drains are often clogged by pieces of cotton and other waste matter left in the sinks. Avoid loss of production, as well as costly water damage caused by an overflowing sink, by keeping sinks clean and free of debris.

Processing Sinks. Consider carefully the design, placement, and construction material of processing sinks. You may choose sinks of stainless steel, fiberglass, or other plastic material to suit your particular requirements. Many of these sink units have taps, mixing valves, water filters, and a vacuum breaker already fitted. Plumbing on the site is therefore confined to connecting the water and drainpipes. A further refinement is the completely self-contained, manual color-processing unit that has

A well-stocked professional darkroom contains a wide variety of chemicals, clearly labeled and meticulously maintained. The arrangement of equipment and materials should be planned for maximum efficiency to avoid wasting time and motion. Photo by Joseph Saltzer.

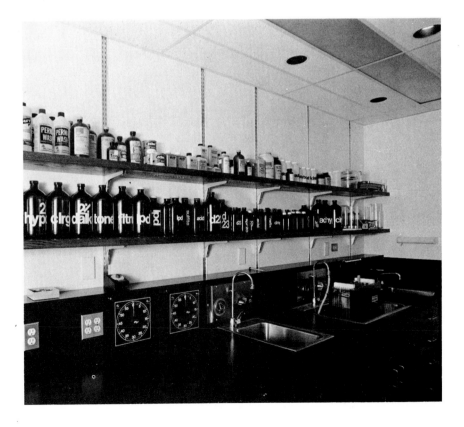

built-in, water-jacketed tanks and fittings for all services, including nitrogen-burst agitation.

Homemade Sinks. If you are unable to justify the cost of the proprietary article, you can make serviceable sinks by using a wooden form covered with several laminations of fiberglass cloth and a suitable polyester resin. The technique of coating the form is essentially the same as that used to cover the hulls of small boats.

Use polyester resin and a suitable catalyst for wooden surfaces; epoxy resin is more suitable for bonding to metal. Make sure that the wood is clean and free from grease or dust. To obtain a more effective bond, roughen the wood surface with a fairly coarse sandpaper. Color the resin if desired. Thin the final coat and apply with a spray to obtain a better finish. Follow these safety rules:

1. Mix and apply the resin in a well-ventilated place.
2. Do not smoke near the chemicals.
3. Wash your hands frequently.
4. Familiarize yourself with any precaution or any warning phrases appearing on the product labels and in accompanying instructions.

Duckboards of cypress or fiberglass roofing material resist chemical attack and do not absorb moisture. If the cypress slats are triangular-shaped or if corrugated material (shown here) is used, more water can come into contact with the bottoms of developing tanks, thus facilitating temperature control of solutions.

Placement of Sinks. Reduce the cost of plumbing by locating sinks where the same drains and water supplies can be used for other equipment in adjacent rooms. For example, the darkroom sink and a washing tank in the finishing room could have common plumbing if they are close to one another on opposite sides of a wall.

Duckboards. Use duckboards of moisture-resistant cypress in the sink. Made in sections, they can be removed readily for cleaning the sink. If the slats are triangular-shaped instead of flat, more water will come in contact with the bottoms of developing tanks, making it easier to control the temperature of the solutions. Corrugated fiberglass roofing material is also suitable for duckboards.

Tray Storage. Store trays by standing them vertically between separators in a removable tray rack. This permits easy access and cleaning of the storage area, and at the same time allows wet trays to drain. In addition to the racks, provide shelf space under the sink for chemicals and processing equipment.

Electrical Installation

The electric wiring and equipment in a photographic plant must conform to the regulations laid down by the National Board of Fire Underwriters. Also, all electrical work, whether a new installation or an alteration to an older one, is subject to both state and local approval. These regulations are necessary to safeguard the worker as well as the plant. In addition, you must follow these rules so that insurance policies remain valid in case of claim.

Electrical work is never a do-it-yourself project, unless you happen to be an electrician. A competent electrician should handle all technical matters relating to the installation because faulty electrical work is particularly dangerous in the wet and dark conditions of a processing room.

Electrical circuits designed for 30-ampere loads are adequate for darkroom needs unless you intend to install mechanized processing equipment.

Safety and Convenience. The following suggestions outline the safety and convenience features of the electrical installation:

1. Install reset-type circuit breakers instead of replaceable fuses. Locate breakers close to the area served by the circuit.

Light switches equipped with a guard or locking plate are unlikely to be snapped on inadvertently in the darkroom.

2. Separate the lighting circuits from those used for equipment. You will then continue to have darkroom lights in case of an equipment overload.

3. Install constant-voltage transformers to minimize the effect of voltage fluctuations on printer and enlarger lamps. Changes in the voltage of electric current cause corresponding changes in the color temperature of tungsten lamps; this in turn alters the color balance of color transparencies and prints. Therefore, maintenance of constant voltage in color work is essential.

4. Install at least five double outlets in a small darkroom. Locate them about 110 centimetres (45 inches) from the floor. If they are too low, you must pull equipment away from the wall to insert or remove a plug.

5. Do not locate electrical outlets in wet locations. An outlet too near a processing sink, for example, may be splashed with chemical solutions and water.

6. Use foot switches for convenience in enlarging; however, equip them with a cable long enough to enable the switch to be lifted out of harm's way if the floor is wet.

7. Ground all metal objects in a darkroom. Ask the electrician to take care of this in all places where it is necessary.

8. Use lamp sockets that include a switch for each of the Kodak darkroom lamps. You can then switch any lamp off independently of the others.

9. Control all processing-room circuits with a master switch located about 1.8 metres (6 feet) from the floor. However, make sure that refrigerators, freezers, and electric clocks are not affected by such an arrangement. Install the white-light switch just below the main switch; place the safelight switch below the other two, about 110 centimetres (45 inches) from the floor. Accidentally turning on white lights in a film-processing room can be an expensive and embarrassing experience, particularly when customers' materials are involved. To avoid such an accident, install a guard on the white-light switch.

10. Install ground-fault circuit interrupters in high hazard areas such as chemical mix rooms and darkrooms.

Safelights

Illumination that does not fog photographic materials under conditions of normal handling and use is "safe" light. It is usually created by placing a suitable filter over a low-intensity light source. Safelights should be installed to give even, overall illumination in print darkrooms, and to give local illumination that is easily switched on and off in film-handling darkrooms. In no case should a safelight source be closer than 1.2 metres (4 feet) from a work surface where sensitized materials are handled. Safelight switches should be well separated from white-light switches to avoid accidental exposures, and should be marked with luminous paint or dots of luminous tape so they can be found easily when all lights are out. Further information is contained in the article SAFELIGHTS.

• *See also:* AGITATION; DARKROOM, AMATEUR; DEVELOPERS AND DEVELOPING; DISPOSAL OF PHOTOGRAPHIC SOLUTIONS; DRUM AND TUBE

Show off the family hobby, life-style, or interest with photographs that personalize the den or family room. Here, two large photos for skiing enthusiasts have been printed to size, mounted on a stiff backing, and set into a bookcase storage wall. An abstract photograph of skis hanging alongside the window provides a variation on the decorative theme.

PROCESSING; DRYING FILMS AND PRINTS; EN-LARGERS AND ENLARGING; GASEOUS BURST AGI-TATION: LARGE COLOR PRINTS AND TRANSPAR-ENCIES; MIXING PHOTOGRAPHIC SOLUTIONS; MURALS; PRINT FINISHING; PRINTING, PHOTO-GRAPHIC; PROCESSORS; SAFELIGHTS; STABILIZA-TION PROCESS; STORAGE OF SENSITIZED MATERI-ALS AND PROCESSING SOLUTIONS; TANKS; TEMPERATURE CONTROL; WASHING; WATER CONSERVATION.

Further Reading: Carroll, John S. *Photographic Lab Handbook.* Garden City, NY: Amphoto, 1974; Eastman Kodak Co. *Construction Materials for Photographic Processing Equipment,* pub. No. K-12. Rochester, NY: Eastman Kodak Co., 1973; Hertzberg, Robert. *Photo Darkroom Guide,* 5th ed. Garden City, NY: Amphoto, 1976.

Decamired

A decamired (pronounced dekka-my-red) is a unit of color temperature equal to 10 mireds (10 microreciprocal degrees). A mired value is equal to 1,000,000 divided by the color temperature of a source in degrees Kelvin. The decamired value is equal to 100,000 divided by the color temperature, or to the mired value divided by 10.

Decamired filters are light balancing filters calibrated in decamired shift values.

• *See also:* COLOR TEMPERATURE; MIRED.

Deckel, Friedrich

(1871–1948)
German engineer

In 1902, Deckel invented the Compound shutter, which used an air cylinder to regulate the slow speeds (1 sec. to 1/10 sec.) and a spring tension device for the faster speeds (1/25 sec. to 1/200 sec.).

It was a great improvement over earlier shutters, but the pneumatic retard device was not reliable; dirt or oil would obstruct its action. In 1912, Deckel designed the Compur shutter, which retained the spring-tension arrangement for the higher speeds, but substituted a gear train and escapement for the slow speeds. The firm of Friedrich Deckel Precision Mechanics was absorbed into the Zeiss-Ikon combine under the name Compur-Werke GmbH & Co. In 1970, production of Compur shutters was taken over by Prontor-Werke Alfred Gauthier GmbH.

Decorating with Photographs

Decorating a room gives it personality. A room can be vibrant with color, warm, and casual, or it can be cool, quiet, and formal. A room's personality depends on the colors and accessories you choose for it, and they should reflect your personality and interests. Whether you are an advanced photographer or a casual picture-taker, you can use your photographs to give your rooms personality—your own personality.

Perhaps your pictures have not been getting much exposure—in your home, that is. You may make enlargements, enter them in camera-club competitions, and then store the prints in the closet. And what about your family snapshots? Do they get shoved into a shoe box right after their first showing? If you just have not thought about using your own pictures to decorate your home, some of the ideas presented here should set your imagination in motion to enhance your home's decor.

Decorating with Large Pictures

The first thing that may come to mind when you decide to decorate with large pictures (larger than 8″ × 10″) is hanging the pictures.

Putting Pictures on the Wall. You will discover many different and interesting ways to display

Decorating with Photographs

A neutral setting can be personalized with photographic art. Two large prints of the area's most famous tourist attractions do just that in this Washington, D.C., hotel room. A guest room in your home or an office waiting room may also benefit from such treatment; it will interest visitors and show off your community pride.

pictures on a wall. Display one large picture, or combine several pictures in an interesting grouping. You can get many ideas for grouping pictures from the photographs of home interiors that you see in magazines.

Pictures usually look most pleasing if they are centered when hung over a piece of furniture such as a sofa or a chair. With a long piece of furniture such as a buffet, stereo, or sideboard, you may want to hang the picture off center and balance it with a planter or a flower arrangement placed on the other end of the furniture. Most pictures look best when hung at the eye level of an average-height person. There are special situations in which a print

Decorating with Photographs

looks pleasing when hung slightly below eye level; however, single pictures hung above eye level give the impression that they are not part of the room.

Mounting can enhance the visual effect of a picture. Some pictures look attractive when mounted on a white mat and put into a frame; other pictures look their best if they are flush-mounted and displayed without a frame. The best advice to keep in mind is to choose a mount that suits your personal taste, keeps the emphasis on the picture, and blends with the finished display.

Mounting boards are available in a variety of colors at art supply stores (avoid bright mounts that may steal attention). It is easy to mount large prints

An easy and inexpensive do-it-yourself project will dress up any area or room. Just adhere mounted photographs of any subject you like to the painted wooden surface of a cube table, then surround with molding trim to form a frame.

Decorating with Photographs

with dry mounting tissue and an ordinary iron. Be sure to follow the directions that come with the tissue. If you prefer mounting with cement, be sure you use one that will not stain your prints, such as Kodak rapid mounting cement. Rubber cement or pastes that contain water or penetrating solvents may stain prints.

If you have your pictures framed, the mounting is usually included in the framing. Many ready-made frames come with mats, and you just slip the picture into place under the mat.

Color Schemes. Especially when the photographs are large, they will look better if the colors in the photograph harmonize with the color scheme of the room in which they are hung.

Neutral-toned black-and-white enlargements go with almost any colors in a room. However, even prints made from black-and-white negatives often

A dramatic portrait receives full attention in this simple, uncluttered foyer where family and visitors can appreciate the photograph. Photographic portraits may be made in any size, mood, color, or tonal quality to suit selected placement and decor.

Decorating with Photographs

A photographic mural can entertain, educate, or amuse the people who spend time in a waiting room or a place of business. Here, a photo mural of a huge mailbox is an ideal subject for the reception area of a direct-mail advertising agency.

look better if they are toned a color that will harmonize with the surroundings. Brown toners are appropriate for many types of subjects, and are suitable for most warm room color schemes, especially those with earth colors. Selenium toners used on portrait-type papers provide tones that range from neutral browns to reddish browns. Sulfide toners used with neutral image-tone papers provide a range of chocolate-brown hues. Brown-gold toners used with warm image-tone papers provide more neutral-brown to yellow-brown image color. Cream- and warm-tinted paper bases work harmoniously with the brown toners. Fall scenes, portraits, sunny summer scenes, desert scenes, and copies of old photographs are all suitable subjects for brown toning.

Blue toners, either of the proprietary type or those mixed with gold chloride from formulas, provide gray-blue image tones that look well in rooms with cool color schemes. Papers with warm image tones and a white paper base are more suitable for blue toning. Landscapes with large sky areas, sea scapes, snow scenes, and night scenes are usually appropriate subjects for blue toning. For formulas and procedures, see the article on TONING.

A print with almost any hue can be made on color paper, such as the Kodak Ektacolor RC pa-pers, from a black-and-white negative by the appropriate use of filters. The following list gives an idea of the range of colors that can be obtained.

Kodak Wratten filters	*Print color*
Yellow: No. 8, No. 15	Blue
Yellow-green: No. 11, No. 13	Violet
Green: No. 58, No. 61	Magenta-rose
Bluish-green: No. 44, No. 65	Red
Blue: No. 47, No. 47B	Yellow
Violet: No. 34A	Yellow-green
Magenta: No. 33	Green
Red: No. 25, No. 29	Cyan-blue-green

In-between hues can be obtained by making part of the exposure with one filter and part with another. For example, an orange hue can be obtained with part of the exposure through a No. 44 filter and part through a No. 47 filter. A slight additional exposure through a No. 25 filter will change the orange to a brown hue.

With color prints, it is usually a case of selecting prints with colors that harmonize with the room. However, if portraits are to be made for a particular setting, the photographer can be asked to provide

Food and photography are natural companions, as shown in this bright Italian restaurant, where these enlarged close-ups of pasta are definite eye-catchers. Photographs of food and food-related subjects would make ideal decorative elements in any kitchen or eating area. They can easily be scaled to the amount of display space available.

backgrounds that will be suitable, and clothing and accessories can be chosen that will fit the color scheme.

Some subjects are appropriate for false-color rendering in printing. The use of high-value color compensating filters during exposure will provide false colors. The colors to use are indicated in the filter list on page 689. For example, the addition of about 50 CC magenta filtration to the regular filter pack will make a woods scene quite green.

Life of Photographs. If the photographs used to decorate walls are to be of more than temporary

Decorating with Photographs

value, some thought should be given to their lasting qualities. Given reasonable care, properly finished black-and-white prints made on conventional papers, whether toned or not, can last a lifetime.

Prints made on resin-coated papers may not last as long. If not displayed under illumination that contains considerable ultraviolet radiation, such as direct sunlight or fluorescent lighting, and if not subject to drastic temperature and humidity variations, such prints will last for years.

The images in color prints, which are formed of dyes, do not last as long as the images in black-and-white prints. Avoidance of strong illumination (direct sun) or illumination containing large amounts of ultraviolet radiation will lengthen the life of color prints. Where such prints have a high value, extra prints stored in dark, cool places with moderate to low relative humidity will provide backup prints for display. Color negatives sealed in appropriate protective devices and kept in a freezer will last a long time, and provide for the making of new prints when the original prints have faded from long-time display. For the archival keeping of color images, black-and-white separation positives and/or negatives can be made that can be considered permanent with proper storage.

Flush-Mounting on Cardboard. For a simple, modern look, flush-mount your print on ⅛- or ¼-inch-thick cardboard. Use good-quality board, available at art supply stores, not corrugated cardboard. Cut the print a little larger than the mount, and then use a sharp knife, razor blade, or paper cutter to trim off the excess print after mounting. Finish the edges of the mount with a black felt marking pen.

Mounting on Plastic Foam. You can make a very lightweight three-dimensional mount with a piece of 1-inch-thick polystyrene plastic foam. Craft shops will cut the plastic foam to the size you want, or you can cut it yourself with a saw or a serrated knife. Mount your print on a thin piece of mounting board and then glue the board to the plastic foam. Finally, cover the edges of the plastic foam with strips of 1-inch-wide wood veneer. The veneer comes in an 8-foot roll, and it is very thin, so you can cut it with scissors. This veneer is available in a variety of wood finishes, and it is sold at such places as lumber dealers. Use a white glue, such as Elmer's glue, to attach both the wood-veneer edging and the mounted print to the piece of plastic foam. The result will look as though the print has been mounted on a large piece of wood.

A single impressive professional color photograph can become the center of interest in any setting. Hung low enough to be appreciated from a seated position, this photo of a Grecian vase dominates a pale-hued, Art Deco dining room.

Finishing Mounts with Edgings. The ribbon or yard-goods department of any large department store has an almost unlimited selection of edgings that you can use to finish the edges of a mount. Mount your print on a mounting board and leave about ½ inch of the board exposed around the edge of the print. Glue the edging to the exposed edge of the board and put the board under a weight until the glue dries. Edging can become an instant frame in any color combination you desire.

Pictures on Place Mats. Place mats come in a great variety of shapes, colors, and textures, and some of them make excellent backgrounds for pictures. For example, you can attach an enlargement to a plastic place mat in a matter of seconds with double-faced tape. To finish the mount, cover the edges of the print with thin rickrack or ribbon edging in a matching color. You may want to make several of these for the kitchen or dining room, and change them to suit the season.

Mounting Prints on Wood. Mounting prints on wood is an unusual way to display them, and wood makes a sturdy, rich-looking mount. There is a great variety of wood finishes and shapes that are suitable for mounting pictures. For example, a picture mounted on distressed wood fits in well with an Early American decor. If you have a chance to hunt for driftwood along a beach, you may find weather-beaten boards that often make good mounts.

If you prefer finished wood, but do not want to do the finishing job yourself, look for an inexpensive cutting board in the housewares section of a department store. Cutting boards come in many shapes—from round to rectangular—and usually have an attractive wood grain.

Framed informal family portraits and souvenir photos add personality and warmth to this comfortable executive office. Two large prints of the company's primary products fit neatly into the niche above the visitors' couch. Because of their versatility, industrial photographs can be as realistic or artistic as desired; while most are generally suitable for office or business decoration, some may be used in areas of the home.

Decorating with Photographs

For an untraditional arrangement, a collection of photographs showing plants, portraits, or other favorite subjects may be hung directly on a floor-standing screen. Each framed photo is nailed to the panels; the screen can be moved from one location to another as desired.

If the wood you have selected has a smooth mounting surface, you can mount the print directly on the wood with double-faced tape or Kodak rapid mounting cement, or the equivalent. If the wood has indentations, like distressed wood, you can use a wet-mounting process and press the wet print into the indentations to make it look very similar to decoupage.

To wet-mount prints, use white glue or printer's colorless padding compound (available from most paper supply houses). Padding compound is less expensive to use; however, white glue is readily available from hardware and drug stores. Use the following procedure:

1. Soak the print in clean water until it is limp.

2. Sponge any excess water from the print and use a paint roller to apply an even coating of adhesive to the back of the print.
3. Use a damp sponge to press the print to the mount. Work from the center of the print toward the edges to remove any air bubbles.
4. Rinse the sponge and wipe off any traces of adhesive. If you are mounting a color print, swab the entire surface of the print with a sponge that has been soaked in stabilizer. You can use Kodak Ektaprint 3 stabilizer and replenisher, or the equivalent, available in a one-gallon size from photo retailers. The print will take about three hours to dry.

Mounts for Changing Prints. If you want to mount your prints in a manner that will allow you to change them as often as you wish, the following methods and materials can be used.

Bulletin Boards. One of the easiest ways to display prints that you might want to change often is to put them on a large bulletin board. Bulletin boards come in many sizes and you can buy them already framed. If you prefer something more original, try covering a piece of bulletin board with colorful burlap or yard goods that matches the draperies of your room. Use pins or thumbtacks to attach the prints to this type of mount.

Pegboards. A pegboard can be a versatile mount for displaying pictures because the pictures are easy to change and you can hang other objects on the pegboard at the same time for an interesting display. You can hang the prints with small pegboard hooks around the edges of the mounts. You can also hang small shelves on a pegboard on which to display plants or knickknacks, or any trophies you may have won for your pictures.

Cork. Insulating cork has become a popular decorating accessory, and it is often used in place of wood paneling. You can tack prints up anywhere on a cork wall and change the arrangement often without leaving a mark.

Building supply stores sell this cork in 12-inch squares with or without adhesive backing, or in 18″ × 36″ sheets without adhesive. You can cut it with a serrated knife or a fine saw and attach it to the wall with the adhesive usually used for putting down floor tile.

Frames. A picture frame should complement the photograph. Many types are available, including the following styles.

Traditional Frames. Frames, like mounts, help separate a picture from its surroundings. Select a frame that adds to the impact of the picture, and avoid frames that draw so much attention to themselves that they detract from the beauty of the print. Frames come in many sizes, styles, and prices. A frame can be as simple as four aluminum strips that finish off the edges of your mount—similar to the frames used in some modern-art museums—or it can be as ornate as Victorian furniture, with many carved designs. Large department stores and some small specialty shops usually have a good selection of frames, and many of these stores offer a framing service (for a fee).

If you are a do-it-yourself type, you might prefer to buy an unfinished frame and do your own finishing. You can also buy a framing kit or choose from a variety of wood framing materials available in 8-foot lengths from hardware and lumber dealers. This allows you to frame a print in any square or rectangular format. If you enjoy hunting for antiques, you may come across some antique picture frames that you can refinish yourself. Then add your color enlargements, and display the products of two hobbies at the same time.

Those who prefer the sleek lines of modern design may want to make shadow-box frames from 1-inch right-angle molding. Most lumber yards carry this molding, and it is quite inexpensive. Miter the corners of the frame and use heavy-duty staples on the back to hold the pieces together. Finish the wood and then glue your mount into the frame from the front. This type of frame is very light and really quite easy to make.

If you want to use glass in a frame, be sure to provide a slight separation between the picture and the glass. You can insert a mat or shim between the borders of the print and the glass to prevent the emulsion of the print from sticking to the glass under humid conditions.

Molding-Strip Frames. Photographers who enter salons usually have many pictures mounted on 16″ × 20″ mounting boards. A molding-strip frame provides a convenient way of displaying these prints and allows you to change the prints easily. This type of frame is made from two strips of flat molding, either wood or aluminum, with a groove along one edge. The grooves must be wide enough to hold a mounting board. Attach the strips to the wall either 16 or 20 inches apart—depending on whether you want to display more horizontal or vertical prints. You can slide your print into this frame from either end or bend the print slightly so that it will snap into the molding.

Glass-Sandwich Frames. With two sheets of glass and four mirror holders, you can create an almost invisible frame that will hold an unmounted or mounted print. The glass goes on each side of the picture (similar to mounting a slide in glass) and is held together and attached to the wall with mirror holders. A glass-sandwich frame is simple and inex-

pensive to make, and you will be able to change the print as often as you like with very little effort. If you mount color prints in this manner, put several small pieces of felt between the glass and the borders of the color print. (You can hide the felt behind the mirror holders.) The felt will create a slight separation be-tween the print and the glass and prevent them from sticking together under humid conditions.

Free-Standing Frames and Room Dividers. Another effective way to display a number of large prints that you would like to change often is with a free-standing frame that can also be used as a room

These cheerful photographs of stuffed animals were used to decorate a hospital pediatric ward, but would be delightful in a child's bedroom or playroom at home. Each photo was mounted on a stiff backing, then cut out around the figure to create a three-dimensional, lifelike effect.

divider. This frame is suspended between the floor and the ceiling much like a pole lamp. A frame of this type can become the focal point of your living room, and your guests will always be anxious to see what new prints you have on display.

The vertical poles and cross pieces on the top and bottom of the frame are square, 2 inches on each side. The flat pieces that hold the pictures are grooved on the rear edge so that the pictures can be slid into position easily. Because the frame is held between the floor and ceiling by pressure, you can easily convert it into a room divider by adding some additional strips of molding and displaying the prints back to back.

Decorating with Small Pictures

Because of their size, small pictures can be worked into your decorating scheme in many different and unusual ways. Consider any picture that measures 8″ × 10″ or less to be in this small-picture category.

Arranging Small Framed Pictures. Since most small pictures are processed by photofinishers, they come in standard sizes and it is easy to find frames for them. Desks, tabletops, buffets, and bookcases are ideal places to display small pictures in frames. When you have several small pictures to display,

you can hang them on the wall above a piece of furniture such as a desk. Frames of the same size can be hung in a straight row just above the desk top. Or, you may want to make a random arrangement with pictures of various sizes. If you want to experiment with several arrangements to find the one you like best, you can avoid making unnecessary nail holes in the wall by cutting pieces of paper the same sizes as your pictures. Masking tape will hold the paper shapes in place while you rearrange them to find the balance you want. Then you can hang the pictures in place of the paper cutouts.

To display a number of snapshot-size pictures, mount them on the same background and present them in one large frame. For example, you can cut out head-and-shoulder portraits from snapshots, use Kodak rapid mounting cement, or the equivalent, to mount them on colored art paper or black velvet, and then frame the mount.

Displaying Small Pictures on Unusual Mounts. An unusual mount can help you group small prints together and can make them draw as much attention as larger pictures. For example, you can mount small prints on a colorful window shade to create a wall hanging. Or, cover a piece of mounting board with burlap in one of the many colors available. You

The decorative use of photographs need not be limited to contemporary or informal settings, as this period dining room demonstrates. Subject matter, custom finish, and frames may be chosen in a wide variety of styles to complement any setting.

Decorating with Photographs

An uninteresting or "difficult" wall area may be turned into a spectacular display setting for photo groupings, such as this distinctive collection of family portraits and snapshots. The mix-and-match approach, using color and black-and-white photos in varying sizes, formats, and frame styles, makes it easy to change or add pictures as the collection grows.

can staple or cement the pictures to the burlap and use a ribbon edging in a contrasting color to finish off the edges of the prints.

For an unusual paperweight, make a cube from a milk carton and cover it with pictures. Put a rock in the cube to give it weight and attach the pictures with double-faced tape. Finish off the edges with yarn held in place with a few dabs of white glue. To help protect the prints from surface scratches and abrasions caused by handling, spray your paperweight with a clear spray, such as Krylon Crystal Clear No. 1303 or Marshall's Pro-Tek-To Spray. Practice spraying on an extra print. Hold the spray can about a foot from the surface and spray with an even, sweeping motion. Repeat the process if the first coat does not cover. If you apply too much spray at one time, the print surfaces will have an "orange-peel" appearance.

Many ordinary things can make unusual mounts for small prints, and most of them are both inexpensive and easy to assemble. For example, on a shopping trip to a discount store, you might discover a wooden hamburger press that would make an attractive mount for two small portraits. Just let your imagination run loose and see what unusual mounts you can create.

Pictures and Plants. Pictures and plants make a good combination for home decoration. You can tape four snapshots to a plain square planter or cut down a milk carton and make your own planter in the same manner as described for the paperweight previously. A picture planter makes a good centerpiece for a table, and it makes a good conversation piece, too.

Try making a mobile. If you enjoy taking close-up pictures of small decorative subjects such as flowers, these will be ideal for a mobile because the images are large even though the prints are small. But almost any kind of picture can be used for a mobile, and you can combine pictures of different sizes or cut the pictures into various shapes.

To make one type of mobile, simply trim your prints to various sizes, mount them back to back on light cardboard, and darken the edges with a black felt marking pen. You can use three pieces of a wire coat hanger to support the mobile, and suspend the pictures on clear spinning line (the kind fishermen use). Because the line is clear, the wires and pictures seem to be floating in air.

Chances are that your first mobile will launch many more ideas for mobiles and swinging pictures. To make another type of mobile, try using 3-inch

Informal portraits are mounted and framed with simple shadowbox molding in this colorful breakfast nook—perhaps one of the most popular areas of the home. They are hung low to be easily visible for people seated at the table.

polystyrene plastic foam blocks that you have covered with pictures. Hold the pictures in place with straight pins, and suspend the blocks by their corners with spinning line. Use a large needle to thread the line through the corners of the blocks.

For a mobile-like display of pictures in a vertical arrangement, mount prints on both sides of several pieces of mounting board. String these pictures together with clear spinning line and hang your creation from the ceiling. If you are really ambitious, you could use swinging pictures as a room divider. Attach strips of molding to the floor and ceiling. Screw

small hooks into the molding and string pictures on spinning line between the hooks.

From conventional frames to mobiles, there is no end to the ways you can decorate your home with pictures.

• *See also:* MOUNTING PRINTS; PRINT FINISHING; TONING.

Further Reading: Anderson, A. J. *The Artistic Side of Photography in Theory and Practice.* New York, NY: Arno, 1910; Eastman Kodak Co. *The Sixth Here's How.* Rochester, NY: Eastman Kodak Co., 1974; Sheppard, J. *Photography for Designers.* New York, NY: Hastings House, 1970; Varney, Vivian. *The Photographer as Designer.* Boston, MA: Davis Publishing Co., 1976.

Decorating with Photographs

Demeny, Georges

(1850–1917)
French scientist and inventor

Demeny was a pioneer in the motion-picture field, working with Professor Etienne Jules Marey from 1882 to 1894. He built the second Chronographe camera for Marey, using film in magazines. He also worked on methods of producing moving pictures from images arranged in sequence on glass discs. Demeny was probably the inventor of the "beater" movement for motion pictures, utilizing it in a camera in 1893 and in a projector in 1896. This equipment was designed for and distributed by Gaumont in France. The earliest equipment used a film 60 mm wide, but was later modified to use the 35 mm film width.

Densitometry

Densitometry (the practice of density measurement) is using a measuring instrument—a densitometer—to get the data that define the response characteristics of an exposed and developed photographic emulsion. These characteristics may include, among others, contrast, useful exposure range, gross fog, and response to various developers and development conditions.

On the practical, darkroom level, densitometry is not a complex scientific and mathematical process. It is the practical aspect of the more theoretical area called sensitometry (the practice of sensitivity measurement). It is a way of using photographic theory to improve your own photographs and save yourself some work.

Terms of Densitometry

Density. This term relates to the amount of developed silver (or dye) in any area of a black-and-white or color negative, transparency, or print. It is a measure of the light-stopping or light-absorbing power of that area.

Since light passes through a negative or a transparency, the density of these materials is related to *transmission,* and is measured with a *transmission*

densitometer. Light is reflected back from the surface of a print, so print density is related to *reflection,* and is measured with a *reflection densitometer.* The light shining or falling onto something is called *incident light.*

Transmittance. Transmittance is the amount of light that passes through a given emulsion area divided by the total amount of light that is incident on the area. Transmittance is usually designated T; when it is expressed as a percentage, it is called percent transmission (the above division must be multiplied by 100). A transmission of 85 percent means that 85 percent of the light that falls on a specific part of a negative or transparency passes through.

Reflectance. Reflectance (R) is the amount of light that is reflected by a given area of a print divided by the total amount of (incident) light that falls on it. It is the equivalent of transmittance in a negative or transparency. A percent reflection of 85 percent means that 15 percent of the light striking an area is absorbed; the rest is reflected.

Transmission and reflection vary from area to area, according to how much image-forming silver or dye is present.

Opacity. Opacity (O) is the inverse, or the reciprocal of the transmittance. It is the total amount of (incident) light that hits an area divided by the amount of light that passes through. Mathematically, $O = 1/T$. Opacity is not a percentage, so T must be expressed as a decimal to determine opacity. As a transmission example, if the transmission is 85 percent, the transmittance is .85, and $O = 1/0.85$, or 1.175.

Density. Transmission density $(D_{Tr}$ is directly related to opacity; it is the logarithm (to the base 10) of the opacity. $D_{Tr} = \log O$ (or, $D_{Tr} = \log 1/T$). In like manner, reflection density is the logarithm of the reciprocal of the reflectance. $D_{Ref} = \log 1/R$.

If the transmission is 85 percent, the transmittance is .85 and the opacity is 1/0.85 or 1.175. Since the log of 1.175 is .07, when the transmission is 85 percent, the density is 0.07.

There are two kinds of density; the difference is in how they are measured. *Specular density* is determined by measuring light that passes straight through an emulsion, disregarding any scattered or diffused light. *Diffuse density* is determined by measuring all light passing through an area, regardless

of path. Since that means more light is measured, the "light-stopping power" of an area will always be less in a diffuse density measurement than in a specular density measurement. (*See:* CALLIER EFFECT.) Most densitometers for individual darkroom use measure diffuse density.

Densitometers

A densitometer is an instrument for measuring the density of silver or dye present in an emulsion. The area measured is usually a spot of only a few square millimetres. In a visual densitometer, a comparison is made by eye—a reference brightness provided by a density wedge is adjusted until it matches that of the sample area. In an electronic densitometer, the measurement is made by a photocell which is adjusted to read zero when there is no emulsion in the instrument. When a sample is placed in the reading position, the densitometer indicates how much the intensity of the light has been diminished by the sample. With color emulsions, each area is read three times—through a red, a green, and a blue filter.

The accompanying diagrams show the schematic functioning of transmission and reflection densitometers of both the visual and the electronic type. Not all densitometers operate exactly in the ways shown, but the principles are the same. Some densitometers are designed to make both transmission and reflection density readings; many models can make both black-and-white and color density measurements.

Making a Reading. Densitometers read directly in density units, so there is no need to compute logarithms. To make a reading, first zero the densitometer with no sample in position. With a visual densitometer, set the filter or density control at zero and turn the zero-adjust control until the two areas seen in the eyepiece are the same brightness. With an electronic densitometer, lower the photocell onto the empty measuring area (a built-in switch will turn the reference light on) and adjust the zero

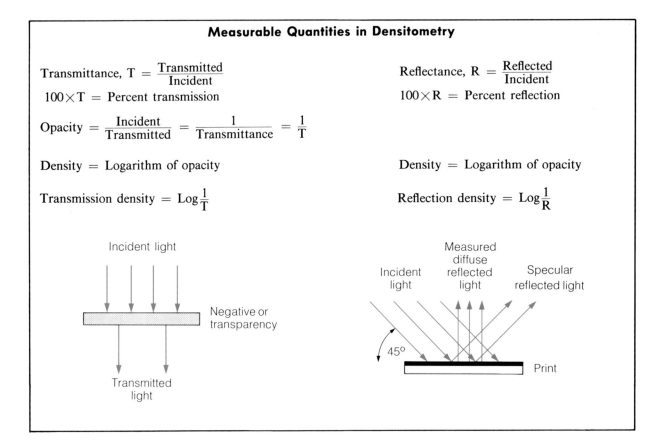

Measurable Quantities in Densitometry

Transmittance, $T = \dfrac{\text{Transmitted}}{\text{Incident}}$

$100 \times T = $ Percent transmission

Opacity $= \dfrac{\text{Incident}}{\text{Transmitted}} = \dfrac{1}{\text{Transmittance}} = \dfrac{1}{T}$

Density $=$ Logarithm of opacity

Transmission density $= \mathrm{Log}\dfrac{1}{T}$

Reflectance, $R = \dfrac{\text{Reflected}}{\text{Incident}}$

$100 \times R = $ Percent reflection

Density $=$ Logarithm of opacity

Reflection density $= \mathrm{Log}\dfrac{1}{R}$

Incident light

Negative or transparency

Transmitted light

Incident light

Measured diffuse reflected light

Specular reflected light

45°

Print

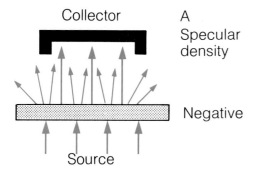

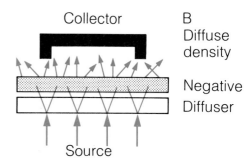

Specular and Diffuse Density

An emulsion scatters some of the light passing through it. When only the light that travels in parallel paths straight through the emulsion is collected (A), specular density is measured. When the light is diffused, there is no specular light (B), and the collector measures diffuse density. Most densitometers for darkroom use with negatives measure diffuse density.

Visual (Optical) Densitometers

Illumination from a light source (a) is reflected by mirrors (b) to a combining mirror (c). A hole in the combining mirror allows illumination reduced by the density of a negative (d) or print (e) to pass to an eyepiece (f) along with reference illumination, which can be varied by adjusting a graduated optical-density wedge (g). With the wedge at zero position and no negative or print in place, the center spot and surrounding ring in the eyepiece are the same maximum brightness (h). With the negative or print in position, the center spot is dark (i) because the density of the emulsion being measured reduces light that passes through the hole in the mirror. To make a reading, the wedge (g) is adjusted until the outer ring in the eyepiece is reduced to the same brightness as that of the center spot (j). The scale on the filter control (k) is marked in density units for direct reading; no computations are necessary. In color densitometry, red, blue, and green status (reference) filters are inserted between the combining mirror (c) and the eyepiece.

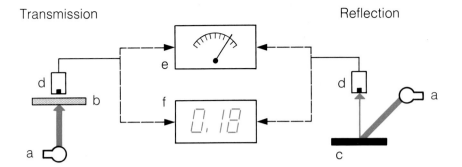

Transmission Reflection

Electronic Densitometers
Illumination from a light source (a) is reduced by the density of a negative (b) or print (c) and strikes a photosensitive cell (d). The output signal from this cell may either activate a moving-needle meter (e) to give a reading on a scale marked in density units, or give a direct digital readout (f).

control for a zero density reading. An electronic densitometer must also be calibrated at a high density value.

Next, insert an emulsion sample in the reading position, centering it directly over the measurement location. The bright light shining up through the film makes this easy in a transmission densitometer. Reflectance densitometers have a collar or ring to mark the location; the print slips under this locator and is adjusted as required. An electronic densitometer will give a reading as soon as the photocell is lowered into place; it may be a scale reading on a meter, or a numerical indication on a digital readout panel. With a visual densitometer, the reference area in the eyepiece will be brighter than the sample area. Turn the optical wedge or density control until the reference area darkens to match the sample area—they will seem to blend together when the proper adjustment is reached. Then read the equivalent density from the scale on the optical wedge control.

Some black-and-white film emulsions have a slight pink or lavender coloration from residual dye. This is perfectly normal and does not affect a negative's printing characteristics, but it sometimes makes visual densitometry more difficult because the reference light is not similarly colored. The color difference can be eliminated by placing a green filter of the type used for color density readings just under the eyepiece, so that both the light from the sample and the reference light pass through it. This filter position will not affect the density reading; both areas will blend together in a single intensity of green light when the proper reading adjustment has been reached.

Recording Density Readings

The density in any part of a negative depends on the exposure that that part of the negative received and the amount of development given the film. In any negative, the density differences are there because the different areas received different amounts of exposure. With any given degree of development, the density anywhere in the negative depends on the exposure at that point.

As explained in the section on black-and-white printing, sometimes it is useful to read density in only two key areas of a negative and work with the resulting numbers. However, for more complete information about an emulsion's response to exposure and development it is necessary to measure the densities of several areas. That produces a list of numbers that can be difficult to interpret. But if the numbers are used to make a graph, a great deal of information can be gained.

Such a graph can be produced by giving a piece of film a series of increasing exposures (like a test strip), developing it, reading the densities, and plotting the densities against the logarithm of the exposures. (Log of exposure is used because density is also a logarithmic measurement. Logarithms are used in both instances because they best represent the proportions of exposure-cause and density-effect involved, and because they make it possible to express the large numbers and relationships involved on the limited space of a practical graph.)

The accompanying diagram shows a typical graph. This is an H&D curve (for Hurter and Driffield, who devised it), or a D-log H (formerly D-log E) curve, or, most familiarly, a *characteristic curve.*

This curve actually describes the photographic characteristics of the film for the development given. Densities falling on the toe portion (A–B) of the curve are not directly proportionate to the log-exposures. Neither are the shoulder (C–D) densities. That is not a drawback. In a good negative, the toe densities are extremely important.

B–C is the straight-line portion of the curve; the density in the film increases proportionately with the log of the exposure. Extend the straight-line part of the curve so that it meets the log E scale at the bottom of the graph. The slope (the steepness of the upward slant) of the line (tangent of the angle between the line and the log E scale) is *gamma*. Generally, the longer you develop any film, the higher the gamma will be, until it finally reaches a limit. In other words: The higher the gamma, the greater the contrast of the negative *due to development*. The total—or printing—contrast is due to quite a few factors: subject contrast, development contrast, flare in the optical systems of camera and enlarger, etc. Gamma refers only to *development* contrast.

Contrast index is also a measure of development contrast of a film. It indicates the *average slope* of that portion of the characteristic curve commonly used in a particular picture-taking application, such as portrait, press, or amateur photography. To measure the contrast index for most general-purpose films, a point is selected on the toe of the curve that represents the minimum density used in most negative making. A straight line, whose length is equal to 2.0 log E or density units, is drawn between this point and another point on the curve where it intersects at a higher density. The slope of this straight line is the average gradient, or *contrast index*.

The characteristic curve, gamma, and contrast index are covered in detail in separate articles.

The practical consideration is this: In the straight-line portion of the characteristic curve, density increases an equal amount for each log exposure increase. That does not mean that density increases in the same amount that exposure does. If exposure increases by 0.3 each time, density may increase by only 0.05. But the increase is constant—each time the exposure makes a uniform step of increase, density makes its own uniform step of increase. In photographic terms, there is even tone separation in pictures that are composed of straight-line densities.

In the toe and shoulder regions of the curve, equal log exposure differences do not produce equal density differences. The tones in pictures are compressed in the shadows and highlights. The tone separation is never as great in the toe and shoulder regions as it is in the straight-line portion.

As a general rule, exposing so that the shadow densities fall on the upper part of the toe and all the

This is a typical H&D curve, or characteristic curve, which describes the photographic characteristics of a particular film for the development given. A–B represents the toe portion of the curve; C–D represents the shoulder portion. Densities falling on the toe and shoulder portions are not directly proportional to the log exposure.

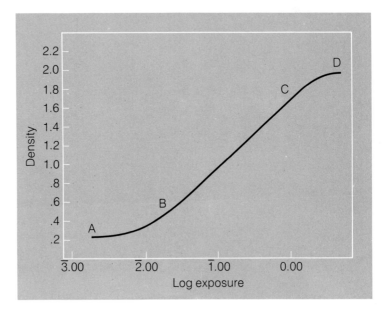

other densities come on the straight line, and developing so that density difference between highlight and shadow densities matches the paper range, produce good negatives, that is, negatives that are easy to print and that produce good-quality prints.

Diffuse vs. Specular Density

Densitometers in use in some laboratories and photographic installations read specular (or semi-specular) densities, for which there is no recognized standard of measurement at the present time. Specular densities* are always somewhat higher than diffuse densities, and the extent of difference between the two will vary to a considerable degree. Two factors contribute to this difference:

1. The geometric arrangement of the optical system in the densitometer with which the measurements are made.
2. The extent to which the sample scatters the light.

Diffuse density (as defined by ANSI PH2. 19–1959) is a measurement taken with a solid angle of collection of 180 degrees (see the accompanying il-

lustration). Specular density, however, is measured with a solid angle of collection approaching 0 degrees. In practice, specular densities are measured at a solid angle of 5 to 10 degrees.

A principal factor contributing to scattering by a silver density is grain size. For a given silver density of a coarse-grain emulsion, the difference between specular and diffuse density readings would be greater than for a similar comparison made with a fine-grain emulsion. Saying it another way, as granularity values decrease, the difference between specular (or semispecular) and diffuse densities generally progresses towards zero as illustrated in the accompanying diagram.

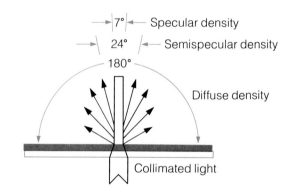

*Specular densities of black-and-white films are always somewhat higher than diffuse densities, but the difference between specular and diffuse densities of color films is negligible.

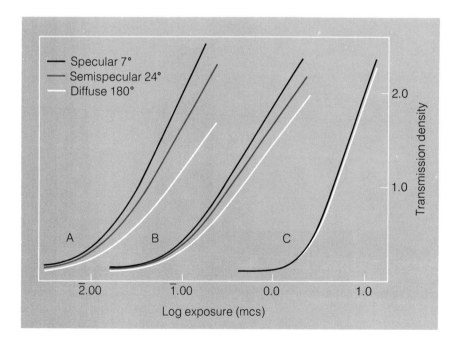

(Above) As shown in the diagram, diffuse density is a measurement taken with a solid angle of collection of 180 degrees. Specular density is measured with a solid angle of 5 to 10 degrees. (Left) The light-scattering characteristics of developed silver density and optical geometry of the densitometer are factors that affect recorded values of transmission density.

Densitometry

Densitometry in Black-and-White Printing

Judging Negative Exposures. To check the current quality of your negatives, select some that are representative of your work.

Take a density reading of the clear edge of the film. Next, read the density of the shadow area—the lightest part of the image in the negative that you want to print just lighter than black. Subtract the first reading from the second. If the difference is lower than 0.05, the negative is probably so underexposed that you will never get a really good print from it.

The first reading indicated the density of the film support *(base density)* and the small amount of fog that is always present due to development. Such a measurement is called a "base-plus-fog" density determination.

The difference in density between the deepest shadow in the negative and the base-plus-fog should not be less than 0.05, and preferably it should be a little greater, but not over 0.15. If your shadow densities are consistently lower, increase exposure by using a lower film speed. On the other hand, the difference between the shadow density and base-plus-fog should not be more than about 0.15. If it is consistently more than this, reduce exposure by using a higher film speed. You will notice an improvement in your prints and in the ease of printing your negatives. Do not consider changing development yet. Shadow-density measurements are used to check on proper exposure level; development primarily affects the contrast.

Density Range of Negatives. To measure the density range of a negative, you do not need to measure the base-plus-fog density. You are going to compare two densities in the negative, and the base-plus-fog density will be part of each; it will cancel itself in any calculations you make.

Read the density in the negative of the blackest highlight in which you expect some detail in your print. This will be a diffuse highlight area. Then read the shadow density, or the lightest part of the negative in which detail is required. This will be a density that you want to print just lighter than black. Subtract the shadow density from the highlight density; the difference between them is the density range of the negative. For example:

Diffuse highlight density	1.18
Detailed shadow density	(−)0.13
Density range	1.05

Some things you photograph may contain shiny objects—metal, glass, and so forth—that reflect light brilliantly. The highlights in your negative will not be these very bright reflections, which are called specular highlights. They contain no detail at all and should reproduce in the print as white. The highlight you measure should be the densest part of your negative in which you want to be able to see detail in the print. This is the type of area sometimes referred to as a "diffuse highlight."

The density range of a negative is not an abstract concept; it can be put to practical use.

Log-Exposure Range and Contrast-Grade Number of Photographic Papers. The log-exposure range of a paper is the difference in the amounts of exposure to light necessary to produce the full range of tones of which the paper is capable. Logarithmic units for exposure are used because they relate directly to the logarithmic density range of the particular negative.

If the log-exposure range of the paper approximately equals the density range of the negative, the resulting print, in many cases, will be satisfactory. The accompanying table shows the relationship between negative density range and the log-exposure ranges of Kodak papers. However, in pictorial or portrait printing, you may want to use a paper with a higher or lower contrast to achieve a particular effect.

As can be seen in the table on the following page, the density range of negatives matches the log-exposure range of the paper when contact printed or enlarged with a typical, incandescent-light diffusion enlarger. Because of the Callier effect, negative density ranges are lower than the paper log-exposure range when printed on condenser enlargers. The values given in the table apply to condenser enlargers with incandescent opal bulbs and polished condensers. Dirty enlarger lenses and incomplete masking of the negative image will lower print contrast.

These values apply when the negatives are measured on an off-easel densitometer, like those described earlier. There are densitometers that will measure the easel image—"on-easel densitometers."

NEGATIVE DENSITY RANGE AND LOG-EXPOSURE RANGE OF *KODAK* PAPERS

Contrast-Grade Number of Paper*	Typical Log-Exposure Range of Paper	Density Range of Negative Usually Suitable when Contact Printed or Printed with Diffusion Enlarger	Density Range of Negative Usually Suitable when Enlarged with Semi-Specular Condenser Enlarger
0	1.40–1.70	1.40–1.70†	——†
1	1.15–1.40	1.15–1.40	0.87–1.07
2	0.95–1.15	0.95–1.15	0.72–0.87
3	0.80–0.95	0.80–0.95	0.60–0.72
4	0.65–0.80	0.65–0.80	0.50–0.60
5	0.50–0.65	0.50–0.65	0.78–0.50

*These values typical of Kodak number-graded papers.
†There is no Kodak zero grade enlarging paper available.

With these, the typical log-exposure range of the paper should equal the density range of the negative with all incandescent-bulb enlargers.

How to Make a Characteristic Curve

You will need a step wedge such as a Kodak photographic step tablet No. 2 or No. 3. This is a negative gray scale consisting of 21 densities running from about 0.05 (base-plus-fog density) to about 3.05. Each step differs from the preceding step by a density difference of about 0.15, corresponding to an actual exposure difference of 1.414 (square root of 2). To calibrate the tablet, read all the densities of the steps and record them.

Actually, the steps on a Kodak photographic step tablet are so close to being 0.15 apart that calibration is not necessary. If you just assume that the steps run from 0.05 to 3.05, they will be easy to lay off on graph paper, and any small deviations from these values won't matter in making comparisons.

Now, make a contact print of this calibrated step tablet on the black-and-white film you normally use. Use a printing frame, but be sure to back up the film with black paper. Sheet film is the easiest to handle, but you can also work from roll film (including 35 mm) or film packs.

An enlarger is an excellent light source to use in making your exposures, since most contact printers are too "fast." You need an exposure long enough to control easily. If you have an exposure meter,

measure the light intensity on the baseboard. Change the magnification of the enlarger to obtain a reading of 3 to 5 footcandles with the lens at $f/4.5$. Then, after the lens has been set at $f/16$, the exposure time should be about 10 seconds.

Exposure here is *not* critical except that all the 21 steps of the original should show in the reproduction. Do not use an exposure that is too great; try to get a density of about 0.1 or a little less in the reproduction of the densest step of the original. You can do it easily after a couple of trials. Do not work for *exactly* 0.1 in the lightest step, just something close to that value. The idea is to include all the steps of the original in the reproduction *without* getting too much density in the lightest steps. You want some toe in your curves—that's where the deepest shadows in a scene fall in a normal negative.

Develop this test scale just exactly as you normally do your films and at whatever temperature you use regularly. If you usually use a tank, use it here. If you tray-develop, do so now.

Next, make a graph. Use regular graph paper, which is divided into little squares, not log paper, which has uneven divisions. Or, use Kodak curve plotting graph paper, which is specifically made for this purpose.

Follow your normal procedure until you make a few curves. You'll then know whether you need to change your routine or not.

Fix, wash, and dry your test scale in the normal way; then read the densities of the steps. Write them

Densitometry

DENSITY MEASUREMENTS

Step No.	Original Density	Density of Test
1	0.08	2.19
2	0.10	2.12
3	0.41	2.02
4	0.57	1.93
5	0.73	1.82
6	0.86	1.73
7	1.01	1.63, and so on.

down beside the densities of the original step tablet, but *backwards*. That is, start with the heaviest densities of your test scale, and write them opposite the lightest densities of the original as shown in the accompanying table.

Kodak Curve Plotting Graph Paper. This specially designed graph paper provides a quick and easy way of plotting step-tablet or gray-scale images made on black-and-white and color films. The semi-transparent paper stock enables two or more sheets to be superimposed for easy direct comparison. The vertical lines marked 1 through 21 along the bottom of the graph represent the 21 steps of the Kodak photographic step tablet No. 2 or No. 3. Plot the density of each step in the step-tablet image on the vertical line corresponding to the step number. With a Kodak photographic step tablet No. 1A (an 11-step tablet), use only the odd-numbered lines. Consider the starting point at the far right (step No. 1) as zero and proceed to the left. The smallest unit division is 0.02. Step No. 2 is 0.15, No. 3 is 0.30, etc. (The scale may at first seem to run backward, but it is set up this way to represent increasing exposure from left to right. That is because the least amount of exposure comes through the highest densities of the step tablet.)

The horizontal axis of this graph is called the abscissa. The vertical axis, upon which the density increases in 0.02 units, is the ordinate. The ten density values printed on the 0.20-density line represent the steps of a Kodak gray scale, a 10-step reflection gray scale that can be placed in scenes for sensitometric measurements. Plot the density of each step in the gray-scale image (from negatives containing the gray scale) along vertical lines drawn from these points.

Plotting the Characteristic Curve. If you use Kodak curve plotting graph paper, plot the densities in the test scale above the 21 points on the abscissa that represent the steps of the tablet. If you use regular graph paper, start the abscissa scale at the right with 0.0 and then plot the densities of the test scale above the actual densities of the original step wedge. In either case, the shape of the resulting curve will be the same.

For example, if step No. 1 has a density of 2.19, that means you make a dot at this density level on the vertical line over the figure "1" on the graph paper, or over the density of original step No. 1 (which is 0.08) on the abscissa of the regular graph paper. Step No. 2 plots at the 2.12 density level over figure "2" on the Kodak paper, or over 0.26 on the regular paper, and so on. When you've plotted all the steps, you should come out with something like the accompanying diagram, Graph A.

Begin determining the characteristic curve by plotting the densities of the test scale above the actual densities of the original step wedge.

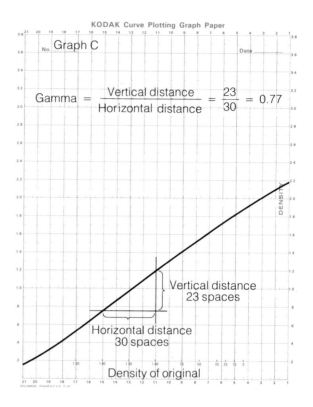

(Left) Draw a line through the average of the plotted points so a smooth curve like the one shown is formed. (Right) To determine gamma, count 30 small units (0.6 on the lower axis) to the right of any point on the straight-line portion of the characteristic curve. Then, along the vertical axis, count the small units up to the curve, and use these numbers in the formula given.

Now, draw a smooth curve through the *average* of these points. Do not try to connect each individual point to the next one, because they never line up perfectly. The first curve ought to look like the diagram, Graph B.

Gamma. To figure gamma, pick any point on the straight-line portion of the curve and count to the right 30 small units (0.6 on the lower axis). Now count the small units up to the curve (on the vertical axis). If there are 23 of them, then:

$$Gamma = \frac{vertical\ distance}{horizontal\ distance}$$

$$or\ \frac{23}{30} = .77\ (Graph\ C)$$

While you are experimenting with the step tablet, you can make your own time-gamma chart. Expose four test scales from the original. Expose them just alike. Then develop them like this:

Develop one of them for ¾ of the time that is recommended; another for the recommended time; another for 1¼ times the recommended time; and the last for 1¾ to 2 times the recommendation.

Now plot all four curves on one sheet of graph paper and measure the gamma produced by each developing time (see Graph D).

Take a fresh sheet of graph paper and plot time of development (on the horizontal axis) against gamma on the vertical axis. Draw a smooth curve through these points, as shown in Graph E.

If you want to use any particular gamma for any reason, find it on the "gamma" axis. Then draw a

Densitometry

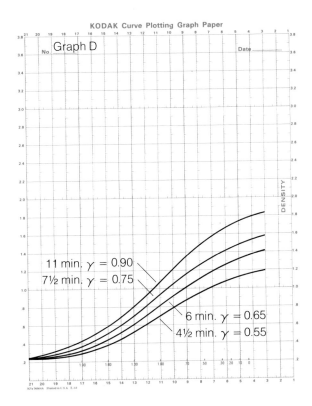

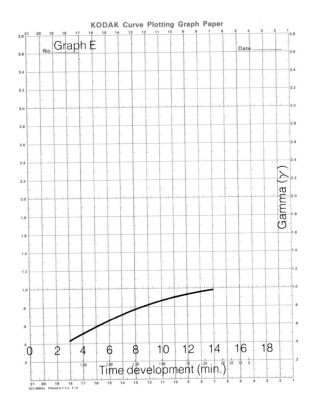

(Left) Using a particular film and developer, expose four test scales, plot all four corresponding curves, and determine the gamma for each developing time. (Right) Now, plot developing time against gamma, drawing a smooth curve through the plotted points, as shown.

horizontal line over to the curve. From that point on the curve, draw a perpendicular line down to the "time" axis. Develop for the time indicated, and provided you do everything as you did when you made the time-gamma curve, you will get pretty close to the gamma you want. You never will come out exactly right unless you do everything exactly the same way each time, but you ought to be within ±0.04 of the predicted value. If you are not, standardize your technique more.

Contrast Index. Gamma is the tangent of the angle that the straight-line part of the characteristic curve makes with the horizontal. Because the shape of the toe and the length of the straight-line part of the curve vary with different emulsions, gamma does not always yield consistent results in measuring development contrast. For this reason, the develop-

ment times recommended for Kodak continuous-tone films are now based on a value of contrast index.

Contrast index (CI) is the gradient of a straight line drawn between two points on the characteristic curve. These points represent the highest and the lowest useful densities in a normal negative. Again, the value of contrast index is the tangent of the angle that this straight line makes with the horizontal. Negatives developed to a given contrast index will have similar density ranges. If the negatives are correctly exposed, noticeable variations in contrast will be due to different subject brightness ranges. Such variations are well within the contrast range of printing papers, so that good quality prints can be made with a minimum of difficulty. For normal continuous-tone work, a CI of about 0.56 is suitable for

Densitometry

diffusion enlargers, a CI of about 0.42 for condenser enlargers. The method for determining contrast index is covered in the CONTRAST INDEX article.

Contrast-index curves for several Kodak developers are printed in the data sheets for continuous-tone films (see the accompanying example). These curves provide a means to change development contrast in a controlled manner. For example, if your negatives are consistently too flat when developed for the recommended time, select a higher contrast index figure, say 0.70, and then develop the test film for the time shown on the scale below the graph. On the other hand, if your negatives are consistently too high in contrast, select a contrast index value below 0.60, say 0.50, and develop for the shorter time indicated by the time scale. You may need to make more than one trial to arrive at the contrast that best suits your conditions. When this has been done, however, you can then use the most suitable contrast index to get the same density range with other films or other film-and-developer combinations.

In making adjustments to negative contrast by means of the contrast index curves, be sure that you develop the test films at a temperature of 20 C (68 F) or as indicated, and that you use the agitation pro-

cedure recommended for the method of development in use. Also, be sure that the developer is at proper working strength. Obviously, any departure from the standard conditions would make the tests valueless.

Densitometry in Color Printing

The basic principles of densitometry can help eliminate the guesswork and trial-and-error methods from color work.

Color films have three emulsions—one sensitive to red light, one sensitive to green light, and one sensitive to blue light. After processing, these three emulsions contain images consisting of dye alone. The image in the layer that was sensitive to red is composed of cyan dye; in the green-sensitive layer, magenta dye; and in the blue-sensitive layer, yellow dye.

A photographic silver deposit absorbs light of all colors about equally, so it makes very little difference what color light is used to measure its density. This is not so with color films. The cyan, magenta, and yellow dyes in the dye layers are selected because their maximum absorptions are in the red, green, and blue parts of the spectrum, respectively. A neutral gray area in a color film, then, will be neutral because just the right proportions of all three dyes are there.

To find out how much red, green, or blue light is being absorbed by the dyes in a neutral area of a color film, you must take tricolor density readings of that area, through red, green, and blue filters.

Although densitometry can help you control your black-and-white film development as you wish, this is not practical with color films. If colors are to be reproduced faithfully, all three emulsions must be developed to predetermined values. This can be accomplished only if development times and temperatures are standardized within rather narrow limits.

However, you can certainly use color densitometry in making color prints from negatives. The objective is to determine the approximate filter pack required for printing each negative, thereby arriving at a satisfactory final print with a minimum of trial and error.

The Gray-Card Image. To obtain a standard area to measure density, you should include a neutral area, such as the image of the gray side of a Kodak neutral test card, in color negatives that you

Plotted here are contrast index curves for the same type of film developed in different developers.

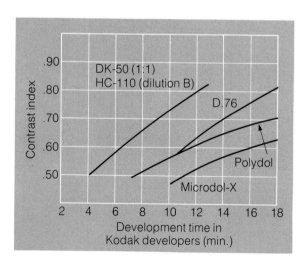

are going to print yourself. The Kodak neutral test card, provides a reference area of known reflectance for making exposure-meter readings in scenes, for inclusion in pictures (as an aid in controlling their reproduction), and for use in precision printing of color negatives. Manufacture of the test card is controlled within close limits in order to produce neutral surfaces of standardized reflectance values. To prevent specular or mirror-like reflections, both sides have a matte finish.

The required size of the image of the test card on the negative varies somewhat, depending on the method used to determine printing exposures. In general, the shorter dimension of the image should be about ¼ inch at a minimum.

Place the card at the center of interest, where it receives the full subject lighting. Do not, however, locate the card near colored objects that reflect colored light onto it because the control patch in the negative will then be misleading. Make another negative without the gray card. This negative can then be used to make print exposures based on measurements of the gray-card negative.

Occasionally, it may be possible to place the card along the edge of the scene area in such a position that it does not interfere with the actual picture and can be trimmed off the final prints. Particularly in artificial light, however, it may be difficult to obtain the full subject lighting along the edge of the scene. For this reason, it is generally easier to make an extra negative with the card at the center of interest.

A gray-card negative must, of course, be made on film of the same emulsion number, and if possible, the film should come from the same package. The film must also be processed with the other film exposed under the same lighting conditions.

The practical function of the gray card image is this: If you can get that image to reproduce the same in each print, it logically follows that the rendering of other colors should stay the same.

The Basic Filter Pack. As the first step, choose one of your negatives as a master. Pick a good negative of the same type as the negatives you are going to print. Preferably, it should contain not only the gray-card image, but other colors as well, including, by all means, a flesh tone.

Next, print that negative, selecting the filters by trial and error, until the print really satisfies you.

(The image of the gray card may not be exactly neutral when the subject colors are rendered in the most pleasing way.)

Third, record the filter pack used for that print. As an example, suppose that the pack was 50M + 70Y. That is the basic pack.

Fourth, read the red, green, and blue densities of the gray-card image in the master negative. Write them down in columns headed *Cyan, Magenta,* and *Yellow,* respectively. Assume values of 1.10C, 1.20M, and 1.30Y.

Finally, add the basic filter pack to the *Magenta* and *Yellow* columns as shown here.

The sum of these values represents the color of the light that must be used in order to obtain good color balance with that emulsion of paper. This is, therefore, the master set of values you work for when predicting filter packs for other negatives with that paper.

The procedure for finding the new filter pack when changing from one emulsion number to another is outlined in the instruction sheet packaged with the color paper.

	Cyan	Magenta	Yellow
Gray card densities in negative	1.10	1.20	1.30
Basic filter pack		(+) .50	(+) .70
Sum (master values)	1.10	1.70	2.00

Predicting the New Filter Pack. Just read the tricolor densities in the gray-card images of the other negatives to be printed, and subtract them from the master values (master negative densities plus printing filters). What you have left represents the filter pack required for printing each negative. If one of the new negative densities is greater than the master value, the difference will be negative. This indicates a negative darker than the master.

To predict an approximate pack for a negative having densities of 1.00, 1.10, and 1.50 when measured through red, green, and blue filters, subtract them from the master values:

	Cyan	Magenta	Yellow
Master values	1.10	1.70	2.00
New negative densities	(−) 1.00	(−) 1.10	(−) 1.50
Differences	0.10	0.60	0.50

It appears that the filter pack required to print this negative is 10C + 60M + 50Y, but there is one thing left to do.

Getting Rid of Neutral Densities. Equal densities in all three colors add up to gray (neutral density), which does nothing but increase the required exposure, and therefore should be eliminated. In the example, there are 10 units of neutral density (10C + 10M + 10Y). To eliminate this, simply subtract 0.10 from each of the columns:

	Cyan	Magenta	Yellow
Density differences	0.10	0.60	0.50
Less neutral density	(−) 0.10	(−) 0.10	(−) 0.10
Printing filter pack	0.00	0.50	0.40

The filter pack for the new negative is 50M + 40Y.

Note that the 0.10 neutral density cancelled out is the amount by which the new negative is *lighter* than the master negative. That is why you subtracted to eliminate neutral density. If the next negative is *darker* than the master, you must *add* 0.40 to all three columns:

	Cyan	Magenta	Yellow
Master values	1.10	1.70	2.00
Unknown negative densities	(−) 1.50	(−) 1.60	(−) 1.70
Differences	(−) 0.40	0.10	0.30
	(−) 0.40	0.10	0.30
	(+) 0.40	(+) 0.40	(+) 0.40
	0.00	0.50	0.70

The pack for this negative is 50M + 70Y.

You can calculate the exposure necessary for each negative from the amount of neutral density you canceled out in each case. Just use the accompanying table.

What would be the exposure times for the two "new" negatives used as examples? (In the first case, you subtracted 0.10 to cancel the neutral density; in the second, you added 0.40.) If you assume 20 seconds as the exposure for the master negative, the new printing times would be 16 and 50 seconds, respectively.

Value added or subtracted to cancel out neutral density:	Multiply master-negative* exposure time by:
+0.40	2.50
+0.30	2.00
+0.20	1.60
+0.10	1.25
0.00	1.00
−0.10	0.80
−0.20	0.65
−0.30	0.50
−0.40	0.40

Color Densitometry without a Gray-Card Image. While a gray-card image is excellent, the same system will work in reference to any common type of density in negatives to be printed, for example, a flesh tone. The only catch is that all flesh tones will then look alike in the final prints. This is usually not too disturbing, unless wide differences in flesh tones are to be expected. For instance, predicting the filter pack for a negative of a dark-skinned adult from a negative of a baby might lead to a rather startling effect. Just use common sense in picking reference densities. Remember that the densitometric system is based upon the reproduction of similar tones.

• *See also:* BASE DENSITY; BRIGHTNESS RANGE; CALLIER EFFECT; CHARACTERISTIC CURVE; COLOR PRINTING FROM NEGATIVES; CONTRAST; CONTRAST INDEX; DIFFUSION; D-LOG E CURVE (D-LOG H CURVE); GAMMA; GRAININESS AND GRANULARITY; GRAY CARD; LOGARITHM; NEGATIVES; SENSITOMETRY; SPEED SYSTEMS; TONE REPRODUCTION.

Further Reading: Eastman Kodak Co. *Halftone Methods for the Graphic Arts,* pub. No. Q-3. Rochester, NY: Eastman Kodak Co., 1974; Kowaliski, Paul. *Applied Photographic Theory.* New York, NY: John Wiley & Sons, 1972; Neblette, C. B. *Photography: Its Materials and Processes,* 5th ed. New York, NY: Van Nostrand Company, 1952; Spencer, D. A., L. A. Mannheim, and Viscount Hanworth. *Color Photography in Practice,* rev. ed. Garden City, NY: Amphoto 1976.

*It may also be necessary to allow for changes in paper sensitivity with illumination level (reciprocity effect). Such compensation is built into the color-printing computer of the KODAK Color DATAGUIDE, Kodak publication No. R-19.

Densitometry

Dental Photography

Photography can be an extremely valuable tool for dental students, practicing dentists, and dental educators. The various aspects of dental photography discussed here can assist such professionals, and can be of special value to staff photographers in departments of photography serving medical and dental institutions. Many of the photographic techniques to be mentioned—notably close-up photography and the use of electronic flash—are covered in detail in separate articles. A list of relevant entries appears at the end of this article.

Significant Uses for Dental Photographs

The following are several of the major functions that dental photographs serve. Knowing what the photograph is attempting to illustrate is basic to its best rendering.

To Illustrate a Finding, or Series of Observations. A photograph can be of valuable assistance when it accompanies a biopsy specimen to be examined and diagnosed by a pathologist. It greatly enhances the description of the area from which the tissue sample was taken—an essential feature for accurate histopathologic interpretation. A photograph also serves well to record tissue changes (reparative or degenerative) taking place over a period of time.

(Below left) This photograph of the area from which a biopsy specimen may be taken is considerably more graphic and comprehensive than a written discription would be. (Below) Photos record a series of observations in the development of a tongue cancer. (The patient had refused treatment on religious grounds.) (A) Early stage. (B) Later stage. (C) Advanced stage. All photos in this article by Claude A. Sherrill, D.D.S., M.S.

(A)

(B)

(C)

A "before and after" situation is documented here. (Left) A broken lateral incisor. (Below left) The restored tooth.

To Document "Before and After" Conditions. This can involve either the recording of the extent of a traumatic injury and its subsequent repair, or the documentation of aesthetic (cosmetic) considerations related to the proposed treatment. In the latter case, photographic pretreatment records might prove to be vital from a medico-legal standpoint should some misunderstanding give rise to future litigation.

To Provide Assistance in Teaching. Photography quite naturally lends itself to the demonstration of "how-to-do-it" procedures. From table clinics to formal teaching methodology, the intrinsic visual characteristic of photographs is utilized to advantage. Photographic images from prints and transparencies can be readily transferred to videotape and mixed with live television elements during the production of instructional materials.

Photography is used as a teaching aid. Illustrated here is a stainless-steel crown-contouring technique.

Dental Photography

These photos demonstrate a technique used to remove tissue for biopsy.

For Community Service Projects. Assembling and presenting original pictures at dental-health programs for schools, civic clubs, or youth groups offers a means to interest and inform at the same time. The use of familiar faces, scenes, and events adds vitality to the program and stimulates the interest of an audience. The handiwork of students (such as posters, displays, bulletin boards) relating to dental health may be photographed and used during a subsequent presentation to those same students with their fascination practically guaranteed.

To Obtain a Basic Series of Patient Photographs. Such a series can be used to assist in the description of the overall visual features of a case and to record these features. The limits of the series would be determined by the requirements of the specific case.

Guidelines for a Basic Series of Patient Photographs

The following criteria describe the basic series of eight views of a dental patient found in the accom-

panying photographs. These criteria can be used as guidelines for designing a series that best meets the needs of the case at hand, and can assist the photographer in evaluating the results. There will be, of course, other conditions in or about the oral cavity that will need to be recorded photographically. The techniques used in the basic series can be adapted to handle almost any variation.

It is assumed that color transparency film and electronic flash illumination will be used. The choice of equipment is discussed in a later section of this article. Each transparency must be neither excessively dark (indicating underexposure) nor excessively light (indicating overexposure).

Dental Photography

The Full-Face View (No. 1). Position electronic flash unit above lens. A full-face view:

1. Uses a vertical frame position and includes the area from the top of the patient's head to the hyoid process.
2. Includes both the left and right ears (approximately where obscured by hair).
3. Fills the frame with the patient's face. (The vertical axis of the head should be perpendicular to the base of the frame, and the sharpest focus placed in the eye area.)
4. Appears to have been photographed from neither above nor below the level of the eyes.
5. Contains no distracting shadows or objects in the background.

Basic Series of Patient Photographs

View 1: Full-face view.

View 2: Profile view.

Dental Photography

View 3: Anterior view, maximum interdigitation.

View 4: Anterior view, edge-to-edge.

View 5: Maxillary occlusal view.

View 6: Mandibular occlusal view.

View 7: Right lateral view.

View 8: Left lateral view.

The Profile View (No. 2). Position electronic flash on profile side of lens. In a profile view:

1. The frame is used vertically, and includes the area from the top of the patient's head to the hyoid process.
2. The frame includes the complete profile of the face and all of the ear on that side (approximated where obscured by hair).
3. The structures included between the top of the head, the profile, the hyoid process, and the ear fill the frame. Excess space in the frame is positioned on the profile side of the frame.
4. The Frankfurt Plane (lower border of orbit to external auditory meatus) is parallel to the base of the frame.
5. Sharpest focus is at the outer canthus of the eye.
6. The patient is seen from a point on the level of the eye, and does not appear to have turned his or her profile either away from or toward the camera.
7. There are no distracting shadows or objects in the background.

The Anterior View—Maximum Interdigitation (No. 3). Position electronic flash on either side of lens. Using retractors, and with teeth in maximum interdigitation, an anterior view of both dental arches should meet the following criteria:

1. The upper and lower teeth fill the frame in the horizontal direction.
2. The frame includes the buccal surfaces of all posterior teeth, photographed in such a manner that structures other than the teeth are visible to the least possible extent.
3. Sharpest focus is at the cuspid or first bicuspid position.
4. The arches are centered in the frame with incisal edges parallel to the base of the frame.

The Anterior View—Edge-to-Edge (No. 4). Position electronic flash on either side of lens. With retractors, and with teeth in an edge-to-edge rela-

tionship, an anterior view of both dental arches should show the following:

1. The upper and lower teeth fill the frame in the horizontal direction.
2. The frame includes the buccal surfaces of all posterior teeth, photographed in such a manner that structures other than the teeth are visible to the least possible extent.
3. Sharpest focus is at the cuspid or first bicuspid position.
4. The arches are centered in the frame with incisal edges parallel to the base of the frame.

The Maxillary Occlusal View (No. 5). Position electronic flash on either side of lens. Using mirrors and retractors, a maxillary occlusal view of the mouth should meet the following criteria:

1. The occlusals and incisals of all maxillary teeth are visible, and their surfaces fill the frame.
2. Structures other than the occlusals and incisals of the maxillary teeth are visible to the least possible extent.
3. The edges of the mirror are visible to the least possible extent.
4. No images of teeth other than the mirror images of the maxillary teeth are visible.
5. Sharpest focus is at bicuspid position.
6. The arch is positioned in the frame so that an imaginary line through the cuspids would be parallel to the top of the frame.

The Mandibular Occlusal View (No. 6). Position electronic flash on either side of lens. With mirrors and retractors, a mandibular occlusal view of the mouth shows the following:

1. The occlusals and incisals of all mandibular teeth are visible, and their surfaces fill the frame.
2. Structures other than the occlusals and incisals of the mandibular teeth are visible to the least possible extent.

3. The edges of the mirror are visible to the least possible extent, and no images other than the mirror images of the mandibular teeth are visible.
4. Sharpest focus is found at bicuspid position.
5. The arch is positioned in the frame so that an imaginary line through the cuspids would be parallel to the base of the frame.

The Right Lateral View (No. 7). Position electronic flash on same side as mirror. Using mirrors and retractors, and with right posterior teeth in working position, take a rigid lateral view of the mouth that meets the following specifications:

1. The frame includes the buccal surface of the most posterior tooth and as many teeth as the frame permits anteriorly.
2. The teeth fill the frame in the horizontal plane, and structures other than the teeth are visible to the least possible extent.
3. The edges of the mirror are visible to the least possible extent, and no images of teeth other than the mirror images are visible.
4. Sharpest focus is found at the bicuspid position.
5. The teeth are centered in the frame from top to bottom with the occlusal plane of the teeth parallel to the base of the frame.

The Left Lateral View (No. 8). Position electronic flash on same side as mirror. With mirrors and retractors, and with the left posterior teeth in working position, a left lateral view of the mouth should meet the following criteria:

1. The frame includes the buccal surface of the most posterior tooth and as many teeth as the frame permits anteriorly.
2. The teeth fill the frame in the horizontal plane, and structures other than the teeth are visible to the least possible extent.
3. The edges of the mirror are visible to the least possible extent.

4. No images of teeth other than the mirror images are visible.
5. Sharpest focus is found at the bicuspid position.
6. The teeth are centered in the frame from top to bottom, with the occlusal plane of the teeth parallel to the base of the frame.

Equipment for Dental Photography

As the pictures of the basic photo series show, a camera and lens combination suitable for dental photography must be capable of taking full-head views of a patient as well as more detailed close-ups. Because of the variety of working positions used and the physical closeness required for some pictures, the camera must be small enough to be hand-held with ease. The light source must also be small, because it most often must be located directly beside the lens in order to shine directly into the oral cavity. It cannot be an incandescent or other continuous source because of the discomfort and even injury that the heat it generates might cause. Flash sources are the solution—either flashcubes, or a compact, lightweight electronic flash unit.

It is possible to get some of the pictures in the basic series by using close-up adapters with 110- or 126-size-film cameras. But the greatest range of coverage is provided by a suitably equipped 35 mm camera; it is by far the preferred choice.

A Minimum Investment. For maximum simplicity and a minimum investment, some worthwhile results can be obtained with the Kodak pocket Instatech close-up camera* from the Scientific Photo Outfit. Color-coded framing accessories and lens combinations are available, which will permit field sizes ranging from 10″ × 12½″ (a full face or profile view) to 1⅓″ × 1¼″ (a view of both arches). Views No. 1 through No. 4 of the basic series may be obtained satisfactorily with this outfit. Views No. 5 through No. 8 are not readily obtainable with this equipment. The outstanding features of the pocket Instatech camera are its simplicity of operation and its comparatively low cost. Although the relatively

*These cameras, along with focal frames and lenses, are available as the Scientific Photo Outfit from Lester A. Dine, Inc., New Hyde Park, New York.

Shown here are Views 1 through 4 of the basic series as obtained with the Kodak pocket Instatech camera. With the 110 format, four views may be placed on one 2″ × 2″ glass slide mount.

small size of the image on the film with the 110-size slide may seem somewhat less than ideal, it may at times serve as an advantage. Several views can be mounted in the same 2″ × 2″ slide mount and projected simultaneously for comparisons.

A similarly constituted outfit features the Kodak Instatech-X* close-up camera and utilizes

*These cameras, along with focal frames and lenses, are available as the Scientific Photo Outfit from Lester A. Dine, Inc., New Hyde Park, New York.

the 126-size slide. Color-coded lenses and focusing arrangements are available, which permit taking views No. 1 through No. 4 successfully. This equipment, with its 126-size, permits a larger image size on the film, which improves the projected image quality with slides. Views No. 5 through No. 8, however, are not readily obtained with this outfit either.

If you require the extended range of capability and control necessary to obtain views No. 1 through

Dental Photography

No. 8 of the basic series, you will need to consider another method.

A 35 mm Camera System for Dental Photography. The 35 mm format provides images of more than adequate size and quality for dental photography, and employs equipment that is portable, easy to hand-hold, and both versatile and sophisticated. A single-lens reflex camera should be chosen, because it allows the photographer to see both the field of view of the lens and the plane of sharpest focus, with the greatest accuracy. Because dental pictures will be taken with flash, a built-in metering or exposure-control system is not required; however, that may be a desirable feature if the camera is also to be used for other kinds of photography.

Lens Focal Length. For clinical dental photography, a lens with a focal length of about 100 mm is preferred because it minimizes viewpoint distortion. In addition, it provides a working distance between the subject and camera lens that is adequate to allow views of the posterior part of the mouth and nasopharynx to be brought in focus, while still per-

mitting illumination of the subject with a directed light source (conventional electronic flash unit). The use of a lens with a focal length much shorter than 100 mm will introduce noticeable viewpoint distortion for views No. 1 and No. 2 of the basic series and will require a ring-light type of electronic flash unit for views of the posterior regions of the oral cavity, if in fact, the area can be brought into focus at all. In order to obtain head and neck views, the use of a lens of focal length much longer than 100 mm will require a subject-to-lens distance that is greater than most dental-treatment rooms can conveniently accommodate.

Lens Focusing Capability. To obtain the large image magnifications required in dental photography, it must be possible to focus the lens at distances much closer than normal. This can be accomplished by extending the lens farther from the film plane. Some modern 100 mm lenses have a built-in "macro focusing" capability—the lens barrel can be extended far enough to obtain approximately life-size (1:1) images. There are also models that focus con-

These photos demonstrate the degrees of viewpoint distortion that various focal lengths produce. (Left) 28 mm lens. (Center) 55 mm lens. (Right) 100 mm lens. The 100 mm lens renders the subject comparatively free of the unflattering effect of exaggerated foreshortening.

tinuously down to about half life-size (0.5:1) and are equipped with an extension ring that is placed between the lens and the camera body to provide additional focusing to the 1:1 range. Stopping to insert or remove the extension ring in order to change from one focusing range to the other is only a momentary inconvenience.

Greater flexibility can be obtained by using an accessory bellows in conjunction with a conventional or a short-mount 100 mm lens. (A short-mount lens has no built-in focusing mechanism; it is specifically designed to be used with a bellows.) This arrangement, as shown in the accompanying illustration, can extend the focusing capability so that larger than life-size images can be obtained when required.

The camera system illustrated is recommended for dental photography.

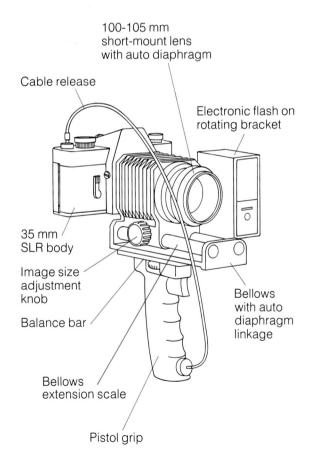

100-105 mm short-mount lens with auto diaphragm

Cable release

Electronic flash on rotating bracket

35 mm SLR body

Image size adjustment knob

Balance bar

Bellows with auto diaphragm linkage

Bellows extension scale

Pistol grip

Whatever lens is chosen, it should have an automatic diaphragm. This feature allows the photographer to preselect an aperture setting, but the lens remains at its widest aperture during viewing and focusing so that the brightest possible image is seen in the viewfinder. When the shutter release is pushed, the diaphragm automatically closes down to the aperture selected for the exposure. If a bellows is used, it should have a means of coupling the lens auto diaphragm to the associated shutter linkage in the camera.

NOTE: It is also possible to obtain large images by the use of other lens attachments such as supplementary lenses, extension tubes, and "tele-extenders." These devices are generally not suitable for dental photography because they produce images of lesser quality, or are unacceptably cumbersome, or require aperture and exposure settings that are impractical for close-ups of this sort.

Other Equipment. As the illustration of the camera system shows, a pistol grip with a trigger type of shutter release provides the most convenient means of holding the camera system. A cable couples the grip trigger to the camera shutter release. The grip is especially useful when the system incorporates a bellows. The balance bar, which mounts between the pistol grip and the camera or bellows, permits shifting the grip forward or backward to obtain the best balance. This is quite important, because with a flash unit, the entire system may weigh 1800 grams (4 pounds) or more.

Filters may be required to adjust for the color balance of the film in use, especially to obtain accurate gingival tissue tones. Screw-in or a series-type of plastic or glass filters provide the greatest convenience because they do not require the relatively large filter frames and frame holders commonly used with gelatin filters. However, it is a good idea to use inexpensive gelatin filters to make a series of exposure tests. These tests will indicate which particular filters are required, and unnecessary investment in the more expensive plastic or glass filters can be avoided. The other two components of the 35 mm dental camera system are a flash unit and a flash mounting bracket.

Electronic Flash. Two basic types of electronic flash illumination are available. The illumination provided by a circular ring-light unit, which fits

around the lens, is at its best for intraoral shots like Views No. 3 and No. 4 of the basic series. This type of flash is almost a necessity if a 50–55 mm focal length lens is used for intraoral photographs, because the working distance is so limited. For extraoral views of patients (and objects), the circumferential shadows cast by the ring flash are distracting, and textures lying in a plane perpendicular to the lens axis are less well-defined than when a directed light source is used for illuminating the subject. In addition, with the ring flash, a power unit and AC cord are required at all times.

A directed light source can be obtained when a conventional electronic flash unit is mounted to one side of the lens and inclined slightly toward the lens axis. Although there are instances when the lips and cheek retractors can prevent uniform illumination in the oral cavity (producing unwanted shadows usually on the same side of the mouth as that on which the flash has been positioned), a small conventional electronic flash unit offers the best all-around illumination for oral cavities—inside and out—and for most dental objects.

Electronic flash units offer a variety of features. The following factors should be considered.

Manual versus automatic sensing. For the subject-to-lens distances encountered in most dental photography, the automatic sensing systems of most units are neither functional nor required.

Sources of energy. There are flash units that can utilize various combinations of the following sources of energy: alternating current (via transformer), built-in rechargeable nickel-cadmium batteries, expendable regular or alkaline batteries, and rechargeable AA (penlight) nickel-cadmium cells.

A flash unit's facility for using an AC adapter is a worthwhile backup feature to have, along with a battery source. For extended shooting sessions, especially those not involving a patient, an AC adapter can save many a battery while providing prompt recycling for rapid completion of an uncomplicated assignment.

A unit that uses replaceable, rechargeable nickel-cadmium AA cells is probably the best choice. It is considerably cheaper than one with integral rechargeable cells. The replaceable, rechargeable cells are not unreasonably expensive, and when they have finally reached the limit of their rechargeability, they can be replaced without factory service.

Light output and guide numbers. Manufacturers publish specifications for their flash units that indicate the quantity of illumination provided by each model. This information may be expressed as a BCPS (beam candlepower seconds) value, as a watt-second rating, or as a table of guide numbers for films of various ASA numbers. Coordination between film sensitivity, minimum aperture of the lens, and light output of the electronic flash is of paramount importance.

With a combination of an ASA 25 film such as Kodachrome 25 film, and a minimum lens aperture of $f/32$, a flash unit should have a BCPS value of about 1400 and a guide number of about 40 for ASA 25 film.

A useful test with a bellows system is to set the bellows to maximum extension and the lens to minimum aperture and make a series of exposures—each time increasing the lens opening by ½ stop (such as $f/32$, $f/27$, $f/22$). Although not numerically marked, most modern lenses for 35 mm cameras have "click stop" settings at intermediate half-stop positions.

Ideally, you would like to obtain acceptable exposures with maximum bellows extension at about $f/27$. This maximizes the depth-of-field capability, reserving $f/32$ for subjects of slightly greater-than-usual luminance. This kind of test provides a meaningful basis for selecting an electronic flash that will function in harmony with the rest of the system.

If underexposures at $f/22$ result from the test, either a flash with greater light output or a more sensitive film, such as Kodachrome 64 film (ASA 64) is required. If overexposures should occur at $f/32$ with maximum bellows extension, either a flash unit with less light output can be used, or a Kodak Wratten neutral density filter No. 96 can be placed over the flash or lens. Each 0.1 increase in neutral density will reduce the exposure by the equivalent of ⅓-stop. The use of a less powerful light source is by far the most preferable choice.

Ultimately, a balance between film speed, light output, and minimum aperture must be achieved, which will require f-stop settings of $f/22$ or higher for exposures with the fully extended bellows.

Flash unit shapes and shoe locations. The flash unit's dimensions and general configuration must fit the constraints of the rotating brackets currently

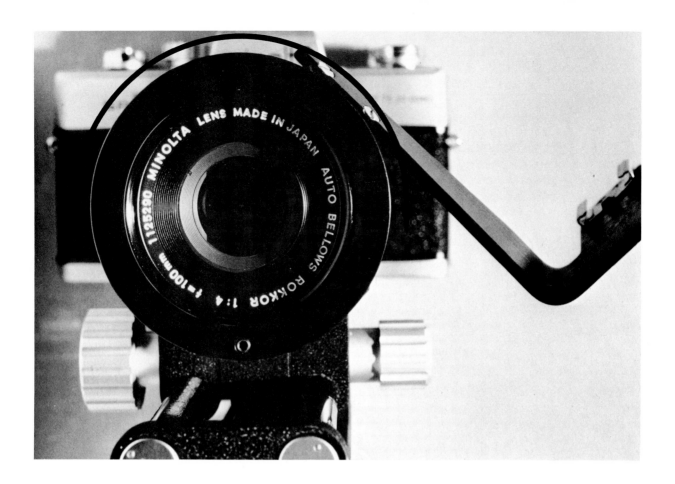

The bracket that joins the flash unit to the camera lens should permit 180-degree rotation of the flash unit around the lens axis.

available for attaching the flash to the lens. Those units presenting their broad sides to the subject are not usually adaptable in this respect. An acceptable relationship of flash unit to camera lens is shown in the diagram of the camera system.

The Flash Bracket. The flash unit should be attached to the lens of the system so as to accompany the lens as it travels back and forth with various adjustments of the bellows extension. To provide maximum directional lighting flexibility, this flash bracket must also permit rotation of the flash unit around the lens axis, as shown in the accompanying illustration. Most bracket designs require an adapter to couple them to existing equipment. A useful feature that has proved to be helpful in positioning the flash unit is a "click stop" at 45 and 90 degrees of rotation. A second valuable feature is an adjustable drag for varying the tension on the rotational device (which gradually loosens with use). Some rotational brackets are sold only in combination with a flash unit.

Dental Accessories—Retractors and Mirrors. For best aesthetics and illumination, adequate retraction of the lips and cheeks is essential when taking most intraoral photographs. For the basic series, a pair of transparent plastic cheek retractors will be needed along with one wire retractor. The plastic retractors are available in both adult and child sizes, or assorted sizes may be made by modifying the adult size with conventional denture acrylic

Dental Photography

cutting and polishing equipment. An adult-size retractor with ¼ inch removed from each of its lip-retracting extensions will make a convenient "medium" retractor. In a like manner, removing ½ inch from each extension produces a handy retractor for a small adult's or a child's mouth. The wire retractor is used with the buccal mirror.

High-quality, front-surface glass mirrors may be obtained in an assortment of shapes. A set of mirrors adequate for the vast majority of conditions presented consists of a large and small occlusal mirror, plus two types and sizes of buccal mirrors.

These mirrors are coated on both sides, are given reasonable care in handling, and are not easily scratched or broken. They are capable of extremely fine image reproduction. These mirrors and retractors can be cleaned and disinfected by scrubbing first with soap and water—then immersing in a solution of Cidex-activated dialdehyde. Where transfer of pathogenic microorganisms is determined to be of utmost concern, all-metal mirrors and retractors can be used with fair photographic results. These instruments may, of course, be autoclaved for complete sterilization.

Dental accessories needed for obtaining best results in the basic series of patient photographs include: (top left) pair of plastic retractors and one wire retractor; (top right) modifications of the plastic retractor to accommodate various mouth sizes; (bottom left) wire retractor, used to advantage with buccal mirror; (bottom right) arrangement of buccal mirror and wire retractor for View 8 of the basic series on page 727.

Dental Photography

Lingual and buccal

Palatal and buccal

Child's occlusal

Adult occlusal

A set of four mirrors will permit excellent intraoral views in the vast majority of cases.

Photographing Objects Associated with Dentistry

Copying Dental Radiographs. Transparencies (2″ × 2″ slides) may be obtained by using the same camera setup as for clinical photography, but substituting transmitted light for the electronic flash. Place the radiograph to be copied on an x-ray viewbox and carefully mask around the x-ray film with black opaque construction paper or tape, making sure that no light from the junction of the radiograph and mask reaches the camera lens. Adjust the image-size-adjustment knob so as to include the desired extent of the original radiograph. Since most

Arrangement of Elements for the Eight Views of the Basic Series

View 1

View 2

View 3

View 4

View 5

View 6

View 7

View 8

This dental radiograph, which was made with Kodachrome 25 film, a fluorescent light source, and no filtration, has a greenish cast.

An improved result is obtained by using FL-D filtration in addition to the same film and light source.

bellows extension assemblies do not provide linkage with the light-metering system, the stop-down method for exposure determination should be used. Consult the lens manufacturer's operating manual for details. Usually, this amounts to setting the ASA adjustment for the correct speed of the film to be used, and setting the aperture to its widest opening. Then, while the illuminated radiograph is viewed through the viewfinder, the shutter speed is adjusted to center the light meter's needle. For best results, the camera system should be stabilized with a tripod since the shutter speeds are likely to be very long, even with the lens aperture at its widest opening.

This, of course, would depend upon the light output of the viewbox, the density of the radiograph, and the sensitivity of the film emulsion being used.

If fluorescent tubes are used to provide the illumination, and color slide film (*e.g.,* Kodachrome 25 film) is the recording medium, some divergence from normal color balance may be expected. An overall greenish cast usually results when no filtration has been used. Some improvement may be obtained by adding an FL-D* filter over the lens. However, the FL-D plus an additional color-compen-

*Available from Tiffen Optical Co. Roslyn Heights, New York.

Dental Photography

sating filter will most likely be required for precise duplication of the original radiograph's color balance. This problem can be avoided completely by using black-and-white film in the camera.

For direct production of slides with the approximate tonal relationship of the original radiograph, Kodak rapid processing copy film SO-185 offers improved results. It is a black-and-white film and thereby avoids all problems with color balance. It is a reversal film, producing a positive image from a positive image. It is available in 36-exposure cartridges for about the same cost as conventional

(Left) This reproduction of a dental radiograph was made from a slide with Kodak rapid processing copy film SO-185. (Below) Shown here is an extra print used to convey vital information for journal reproduction. The printer should be made aware of key areas where specific tonal reproduction is essential.

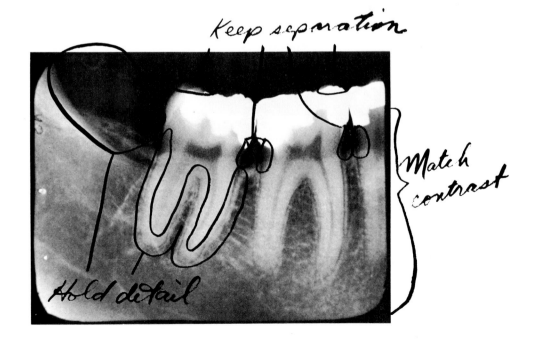

black-and-white film, and may be processed either with conventional dental x-ray chemicals or in most automatic processors using the Kodak RP X-Omat chemicals. When SO-185 film is used, a tripod or copystand for stability is essential. Exposure times will be very long—approximately 1 minute at $f/4$ for a radiograph of average density when a viewbox is used with a light output of 500 footcandles measured at its surface. Initial test exposures with generous bracketing in one f-stop increments are suggested. As with all reversal film, a longer exposure produces a less-dense transparency as a result, and vice versa.

If black-and-white prints for publication or insertion in patient folders are the ultimate goal, Kodak Panatomic-X film may be used to produce high-quality negatives. Here again, the radiograph is placed on the viewbox and masked appropriately. A light-meter reading using ASA 32 is taken through the lens. Bracketed exposures, including the one indicated by the through-the-lens meter, plus one additional exposure stopped down one stop, are suggested. A 30 percent decrease in the manufacturer's recommended development time for Kodak developer D-76 (diluted 1:1) is also suggested (e.g., 5½ minutes at 70 F).

If prints are being supplied to a journal for publication, a double-weight, glossy-surface photographic paper should be used. It is also a good idea to mark up a second print of the illustration so the printer knows exactly which areas of the picture are most important.

Dental Cast Photography. The clinical camera system performs this task with simplicity and dependable results. The luminance of dental casts varies with the color of the gypsum material and therefore calls for special consideration. In general, it may be helpful to note that the settings on the f-number scale prescribed for patient photography will correspond fairly well for gypsum materials other than white gypsum. A suggested exposure bracket for the other-than-white casts would be one shot with the recommended f-number setting plus a second shot with the aperture reduced by ½ stop (e.g., $f//16$ and $f/19$). For white gypsum casts, use an f-number setting one stop down and another 1½ stops down from that setting prescribed for clinical work. An assortment of white paper reflectors will be helpful in reducing shadow densities. A suitable nonreflective background can be prepared with a sheet of suede (velour) paper, available from most art supply stores. The far edge of the sheet is ele-

Assorted white paper reflectors are helpful in photographing dental casts. Nonreflective black backgrounds are readily available.

Dental Photography

The top two photographs demonstrate the effects of different flash positions on the rendering of a pair of dental casts. (Top left) Sidelighting; note how unified the two casts appear. (Top right) Top lighting; note shadows cast by incisal edges of maxillary teeth, which accentuate overlapping of upper teeth. The two lower photographs show the suggested placement of white paper reflectors to provide fill illumination. Electronic flash is positioned to the side of the lens, opposite the reflectors.

vated and fastened at a level high enough to preclude its being seen in the pictures, thus providing a contrasting and seam-free surround.

Anterior view of a pair of casts. If the effect of sidelighting is desired, position the electronic flash on one side of the lens and a white paper reflector on the opposite side of the casts (just outside the field of view). For the anterior view, the casts may be positioned on the base of the mandibular model or on the heels of both casts (preferred). When the electronic flash is positioned on top of the lens, a slightly different effect can be expected. The shadows cast by the maxillary teeth would tend to accentuate any horizontal overlap or protrusion that might exist.

Lateral view of a pair of casts. For the lateral view, the electronic flash is positioned on the side of the lens facing the incisor teeth—maximizing textures and prominences from anterior to posterior. No reflector is required.

Dental Photography

(Left) For this lateral view, electronic flash was positioned on the side of the lens nearest the incisor teeth. The photos below show an occlusal view of a pair of dental casts. (Below left) Note vertical orientation of frame and top lighting. (Below right) White paper reflectors placed below the casts provide fill illumination.

Occlusal views. For the occlusal view, top lighting is preferred. A paper reflector is suggested just outside the base of the vertically oriented frame.

Photographing Highly Reflective Objects. Highly polished objects are frequently encountered when items of dental interest are photographed. The use of conventional photographic techniques often yields disappointing results and fails to record important detail that is descriptive of the subject. The problem is two-fold. On the one hand, reflections of the light source produce broad highlights wherein

Dental Photography

no useful detail remains. Color film is simply incapable of recording broad subject brightness ranges. Secondly, shadow forms are produced against the typical background, which are both distracting and unaesthetic. The solution, therefore, must be directed towards reducing the subject brightness range (contrast ratio) to one that is compatible with the film being used, and eliminating shadows that are not helpful in explaining the subject. The use of an easily improvised paper tent setup, as shown in the illustration on the following page, will attenuate, if not completely solve, both of these problems. For

Small, highly reflective objects such as these must be photographed with tent lighting to reduce excessive highlights and eliminate shadows. These photographs were made using the lighting arrangement shown in the illustration on the following page.

Dental Photography

733

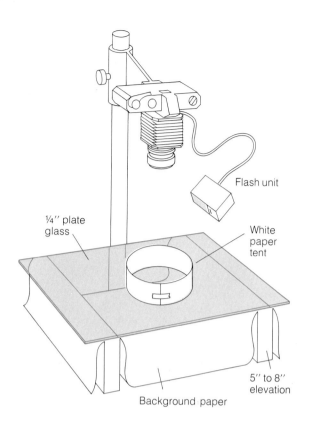

For relatively small, highly reflective objects, this lighting arrangement subdues excessive highlights and produces shadowless backgrounds.

¼" plate glass

Flash unit

White paper tent

5" to 8" elevation

Background paper

further information, see the article SILVERWARE AND JEWELRY, PHOTOGRAPHING.

• *See also:* BACKGROUNDS, ELIMINATING; BIO-MEDICAL PHOTOGRAPHY; CLINICAL PHOTOGRA-PHY; CLOSE-UP PHOTOGRAPHY; ELECTRON MI-CROGRAPHS; ELECTRONIC FLASH; FLASH PHOTO-GRAPHY; MEDICAL PHOTOGRAPHY; PHOTO-MACROGRAPHY; PHOTOMICROGRAPHY; RADIO-GRAPHY; SCIENTIFIC PHOTOGRAPHY; STEREO PHOTOGRAPHY; SILVERWARE AND JEWELRY, PHOTOGRAPHING; THERMAL PHOTOGRAPHY; UL-TRAVIOLET AND FLUORESCENCE PHOTOGRAPHY.

Further Reading: Anderson, Pauline. *Dental Radiology.* Albany, NY: Delmar Publishing, 1974; Manson-Hing, Lincoln R. *Panoramic Dental Radiology.* Springfield, IL: Charles C. Thomas Publishers, 1975; Wuehrmann, Arthur H., and Lincoln R. Manson-Hing. *Dental Radiology,* 3rd ed. St. Louis, MO: C.V. Mosby Co., 1973.

Photography in the dental field is not limited to strictly clinical subjects. Here, a screening examination is documented for a community-service project.

Dental Photography

Depth of Field

When a lens is focused at a given distance, the most sharply imaged objects will be those exactly at that distance. However, other objects—some closer to the lens, some farther away—will also appear to be sharp. This is because the eye cannot detect very small degrees of unsharpness. The distance from the nearest objects to the farthest objects that appear sharp in the final print, slide, or projected image is a zone of sharpness called *depth of field*.

Most discussions of depth of field are based on a geometrical construction called "circle of confusion." The limiting circle-of-confusion size is the largest diameter circle that each subject point can be imaged without the eye being able to detect the difference in sharpness.

The circle of confusion is not actually a circle of more or less uniform brightness, as, say, a glowing poker chip. With reasonably small negatives, where

Close subject distances and wide lens apertures, often required in product photographs, both diminish depth of field. Use of the view camera makes it easy to place the zone of sharpness on the most important part of the subject. Photo by Stephen Stuart, Ad Team, Inc.

A wide aperture (f/4) was used for this close-up still life. Unsharp detail in the background directs full attention to the elaborately decorated watchcase. Photo by Norm Kerr.

resolution is measured in thousandths of an inch, the circle of confusion consists of a bright central dot, surrounded by alternating dark and light concentric rings. The central dot is usually less than half the size that would be predicted geometrically for the circle of confusion as a whole, but it contains the greater part of the light directed to that area. The first surrounding ring is very much dimmer, and all the remaining rings are so dim as to be of negligible importance. Thus, if the exposure is kept to the practical minimum, only the central dot will be recorded on the film, and this is less than half as big

A smaller aperture (f/32) brings the entire picture into sharp focus, deemphasizing individual elements and thereby redirecting the viewer's attention. Photo by Norm Kerr.

as the circle of confusion that would be expected from geometric considerations. Therefore, the image produced by any lens is usually better than would be expected from geometric theory.

The depth of field attainable with camera lenses is proportional to the square of the magnification (or reduction). Thus, in the case of miniature cameras, the reduction is much greater than that produced by larger format cameras, and the depth is still greater, in proportion to the square of the reduction. Likewise, as objects are at greater distances from the camera, the depth of field increases by the square of

Depth of Field

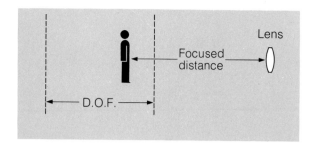

Depth of field (D.O.F.) is a zone of acceptable sharpness that begins before the focused distance and extends beyond it. The amount of depth depends on the aperture setting and the image size, which is determined by lens focal length and lens–object distance.

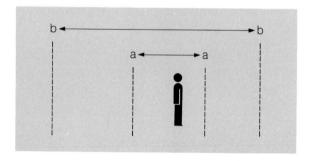

Depth of field increases, as from a–a to b–b, when the aperture is made smaller, or when the image is made smaller either by moving farther from the subject (increasing focused distance), or by changing to a shorter focal length lens at the same distance.

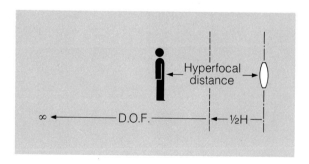

When the lens is focused at the hyperfocal distance for a particular aperture, depth of field begins at one-half the hyperfocal distance and extends to infinity. The hyperfocal distance is different for each aperture setting of a given focal length lens.

the distance, until the lens is focused at a point called the *hyperfocal distance* (H). At that point, the depth of field extends from half that distance to infinity.

When lenses are used at the same *f*-stop, but have different focal lengths, the depth of field is the same for both lenses, *for equal image size*. Thus, if a 2-inch lens and a 5-inch lens are both used at *f*/8 and at the same distance from the subject, and if the image made with the smaller lens is subsequently enlarged 2½ times, the depth of field in both pictures will be the same. Or, if the 5-inch lens is used at 2½ times the subject distance, and at the same *f*-stop, the image sizes will be the same, and the depth of field will be the same.

Most photographers use a rule of thumb that under ordinary circumstances, about one-third of the available depth lies in front of the object plane, and two-thirds of the depth lies behind it (others use figures like two-fifths and three-fifths). The fact is, there is no fixed ratio between the depth in front of and behind the plane of focus, as simple examination of the formulas in this article should indicate. It is possible that at one particular distance, the ratio of one-third to two-thirds will be found, and at another distance, one may find a ratio of two-fifths to three-fifths. But calculation shows that the ratio is continually varying, from one-to-one when object and image size are equal, to a depth of ½H-to-infinity when focused at the hyperfocal distance.

Most camera lenses carry depth-of-field scales in connection with their focusing scales, and these scales are amply precise for all ordinary photographic work. To calculate your own tables, use the following formulas.

The second method works well with normal-focal-length lenses, but gives variable results when used with a variety of focal lengths used on the same camera format size.

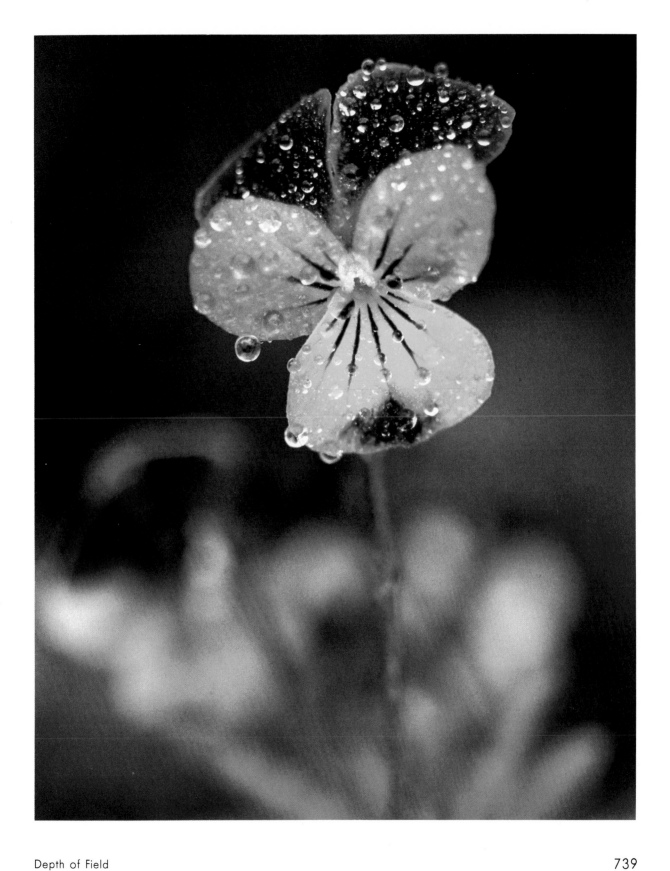

Depth of Field

Method A, Fixed Circle of Confusion

F = focal length of lens
f = f-number or relative aperture
H = hyperfocal distance
u = distance for which camera is focused
d = diameter of circle of confusion

Camera	Fixed circle of confusion most widely used (in inches)
Regular 8 mm movie	.00050
Super 8 mm movie	.00065
16 mm movie	.00100
135 (24 × 36 mm)	.00200
126 (28 × 28 mm)	.00200
Roll-film	.00500
4″ × 5″ and larger	F_n/1720 critical use or F_n/1000 liberal use

where F_n is the normal focal length, equal to the diagonal of the film format.

Near limit of depth of field
(measured from camera lens) $= \dfrac{H \times u}{H + (u - F)}$

Far limit of depth of field
(measured from camera lens) $= \dfrac{H \times u}{H - (u - F)}$

The hyperfocal distance (near limit of depth of field when lens is set at infinity) is:

$$H = \frac{F^2}{f \times d}$$

Method B, Circle of Confusion a Fraction of the Focal Length of the Lens

u = distance focused upon
θ = angular size of circle of confusion. For critical definition, θ is 2 minutes of arc and the linear size of the circle of confusion is approximately F/1720 (tan 2′ = .00058).
L = effective diameter of lens $= \dfrac{F}{f}$

Near limit of depth of field
(measured from plane focused upon) $= \dfrac{u^2 \tan\theta}{L + u \tan\theta}$

Far limit of depth of field
(measured from plane focused upon) $= \dfrac{u^2 \tan\theta}{L - u \tan\theta}$

If the angular circle of confusion for critical focus is taken to be 2 minutes of arc, then tan 2′ = .00058 and the formulas reduce to simply:

Near limit of depth of field
(measured from plane focused upon) $= \dfrac{.00058\, u^2}{L + .00058\, u}$

Far limit of depth of field
(measured from plane focused upon) $= \dfrac{.00058\, u^2}{L - .00058\, u}$

Usually by selectively controlling depth of field, you can place the emphasis where you want it in your pictures. For example, you can use a larger lens opening to intentionally throw the foreground or background out of focus.

To get the maximum depth of field for a particular lens opening, focus your camera lens on the hyperfocal distance (defined in the following text). The easiest way to do this with a camera that has a depth-of-field scale is to set the far limit indicator for the lens opening you are using opposite the infinity mark on the focusing scale. Infinity is usually indicated on the focusing scale by "INF" or "∞". The infinity setting focuses the lens for distances beyond

the maximum distance in feet (or metres) marked on the focusing scale.

Hyperfocal distance is just a special application of depth of field. When a lens is focused at infinity, the distance beyond which all objects are in satisfactory sharp focus is the hyperfocal distance. If you focus a lens on the hyperfocal distance, objects from half of the hyperfocal distance to infinity will appear in sharp focus.

For example, first focus a 35 mm focal-length lens on infinity. Set the lens opening at f/11. The depth-of-field scale shows that all objects from 11 feet to infinity will look sharp. The hyperfocal distance is therefore 11 feet. But when you focus the

Out-of-focus backgrounds are frequently used in portraiture, where the center of attention is, most logically, the subject's face. The blurred background, obtained by using a wide lens opening, provides color without distracting details. Photo by Norm Kerr.

A smaller aperture focuses with equal clarity on subject and background. Trees and a bench in the background become distracting elements; the large tree behind the subject appears to be growing out of her head. Photo by Norm Kerr.

Depth of Field

When photographing a subject of considerable depth, use of a small aperture insures great depth of field.

lens at 11 feet, all objects from 6 feet to infinity are sharp. This gives you the greatest depth of field for this lens opening. As you open the lens diaphragm to larger apertures, the hyperfocal distance increases.

Many photographers waste depth of field without realizing it. In the example just described, if you had focused your camera lens at 50 feet (instead of the hyperfocal distance) for a subject 50 feet away,

your depth of field would be from 10 feet to infinity. This would result in a 4-foot loss in background sharpness. The *KODAK Professional Photoguide* has three depth-of-field dials for use with 6 × 6 cm to 8″ × 10″ formats, one each for normal, telephoto, and wide-angle lenses.

• *See also:* DEPTH OF FOCUS; FOCAL RANGE; HYPERFOCAL DISTANCE; LENSES; OPTICS.

Depth of Focus

On the object (subject) side of a lens, there is a zone of acceptable sharpness (the depth of field) that extends in front of and behind the plane actually focused on. On the image side of the lens, there is a corresponding zone of acceptable sharpness on each side of the plane where the image is formed. This zone is the *depth of focus;* it is known as "focal range" in astronomy and microscopy.

Depth of focus is extremely shallow; it increases slightly as the lens aperture is made smaller. In a camera, the film plane must lie within the depth of focus for the recorded image to appear in focus.

Thus, depth of focus represents the permissible limits of error in film location and flatness, or in the accuracy of the lens mounting and its focusing mechanism. In fixed-lens cameras, this must be calculated on the widest aperture of the lens.

Depth of focus is given by the formula:

$$d = \frac{cvf}{F}$$

where d is the depth on either side of the plane of correct focus, c is acceptable circle of confusion, v is the distance from lens to image plane, f is the f-number or lens aperture, and F is the focal length of the lens.

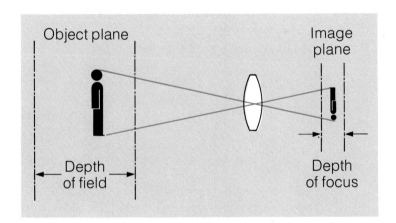

This diagram illustrates the relationship between depth of field and depth of focus.

For maximum sharpness, the position of the film should coincide with the plane of best focus; however, the image will be acceptably sharp if the film is situated within the limits of the depth of focus. (A) Inaccurate positioning of the lens or film will cause the entire image to be out of focus. (B) Lack of film flatness will cause the image on those portions that curve or bulge outside the depth of focus to be unsharp.

The total depth of focus is twice the value obtained by the previous formula; that is, 2d. It differs from depth of field, in that focal range or depth of focus is equal on both sides of the plane of best focus.

Depth of focus is of little interest to practical photographers; it is most used as a measure of acceptable error or aberration by both lens and camera designers.

• *See also:* DEPTH OF FIELD; FOCAL RANGE; LENSES; OPTICS.

Desensitizing

Desensitizers are substances, usually dyestuffs, that reduce the sensitivity of photographic emulsions to such an extent that they can be developed in relatively bright light without danger of fog, although most of them do not render the emulsion entirely insensitive to light. Generally, desensitization makes it possible to develop panchromatic emulsions under bright-green safelight, slow orthochromatic emulsions under subdued white light, and fast ortho materials under orange safelight.

Most desensitizers can be used either as a preliminary bath before an exposed film is developed, or as an additive to the developer. Usually 2 or 3 minutes are sufficient for desensitizing in a preliminary bath, which should be done under a safelight or preferably in total darkness, especially for panchromatic emulsions, to avoid fog. Partial or total destruction of the latent image will take place if the desensitized emulsion is exposed to yellow, orange, or red light before development begins, or if several hours elapse between desensitizing and development. When the desensitizer is added to the developer, the emulsion should not be exposed to bright light until development has progressed for three or four minutes.

Mercuric-cyanide, an inorganic desensitizer, cannot be used as a forebath, but must be added to the developer in the ratio of 1 part to 3000 parts of the developer. It is not suitable for use with pyro. It is a deadly poison.

Phenosafranine is used as a preliminary bath in the ratio of 1 part to 2000 parts water, or in the developer in the proportion of 1 to 5000. It stains the gelatin, but the stain does not affect the printing quality of the negative. The stain can be removed by bathing the negative for a few minutes, after washing, in a five percent solution of sodium hydrosulfite (sodium dithionite). Phenosafranine does not reduce the sensitivity enough to permit its use with panchromatic emulsions of high color sensitivity.

Basic scarlet N is used as a preliminary bath at a strength of 1 to 5000. It is less efficient than the pinakryptols, but has less tendency to fog and is non-staining.

Pinakryptol green is usually used as a preliminary bath at a concentration of 1 to 10,000 for a period of 2 minutes. Greater concentration, or more time, is likely to produce fog and deterioration of the latent image. Pinakryptol green is sometimes added to developers, but is likely to be precipitated in developers containing hydroquinone if used at a concentration greater than 1 to 50,000.

Pinakryptol yellow is used as a preliminary bath in the ratio of 1 to 2000. It cannot be used in a developer because it is destroyed by sodium sulfite. As it causes no stain, it is particularly adaptable for use with color plates or films. It is an extremely efficient and clean-working desensitizer, and gives little or no chemical fog, although it does cause slight reduction of the density of the image.

Pina White is claimed to be non-staining, but otherwise is much the same as the other two versions.

Another approach to desensitization is to convert the silver bromides in the emulsion to iodide, which is much less sensitive to light, and allows development of the image in bright light. If an exposed emulsion is bathed for several minutes in the following bath it could be developed even in full sunlight, using an amidol (diaminophenol) developer freshly compounded with sodium carbonate.

Potassium iodide	10.0 grams	(145 grains)
Sodium sulfite (desiccated)	10.0 grams	(145 grains)
Potassium thiocyanate	30.0 grams	(1 oz)
Water to make	1.0 litre	(32 oz)

There is some question whether this will work with modern, high-speed, dye-sensitized emulsions; it should not be tried on a valuable exposure.

• *See also:* DEVELOPERS AND DEVELOPING.